For Michael —
With Baroque best wishes,
Charlie
May, 1989

RUBENS

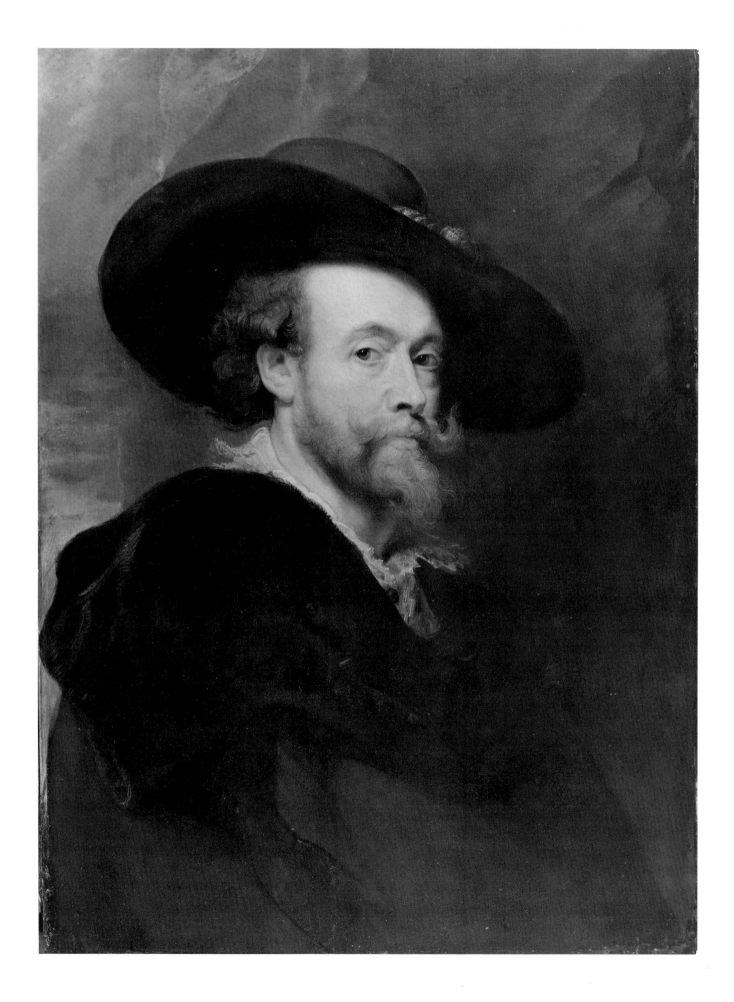

PETER PAUL
RUBENS

TEXT BY
CHARLES SCRIBNER III

—————————◆—————————

HARRY N. ABRAMS, INC., PUBLISHERS, NEW YORK

To my parents, Joan and Charles Scribner, Jr., and to my wife, Ritchie

ACKNOWLEDGMENTS

I wish to express my deep appreciation to John Rupert Martin, who first introduced me to the art of Rubens and for the past fifteen years has shared with me the fruits of his abundant scholarship and enthusiasm; to Julius S. Held, whose vast contributions to the field of Rubens studies have been matched by his personal generosity and critical observations; and to Jacques Barzun, who also read the final manuscript and offered many incisive editorial comments. I am grateful as well to Catherine Scallen for her help in the bibliographic research and for her thoughtful suggestions; to Sara Tucker, for her skillful preparation of the typescript; and to Barbara Lyons and Pamela Bass, who obtained the illustrations. Special thanks are owed to Paul Gottlieb, president of Abrams, who commissioned this publication; to Charles Miers, for his editorial sensitivity and perspicacity; and to Doris Leath, who designed a beautiful book.

PHOTOGRAPH CREDITS

© ACL, Brussels: 24, 25, 29, 39, 45, 51, 59; Artothek, Planegg/Munich: Cpls. 6, 11, 12, 13, 14, 17; Bayerische Staatsgemäldesammlungen, Munich: 15, 32, 62; Blondé, Wommelgem, Belgium: Cpl. 8; Calzolari, Studio Fotografico, Mantua: 14; Ludovico Canali, Rome: 19, 20; Departments of the Environment and Transport, London: Cpl. 33; Lichtbildwerkstatte "Alpenland": 6, 49; Quattrone Mario, Florence: Cpls. 9, 41; MAS, Barcelona: 54; Jacques Mayer, Grasse: 12; Otto Fotostudio, Vienna: Cpls. 24, 42; Potsdam-Sanssouci, Bildergalerie: 5; Rijksvoorlichtingsdienst, The Hague (Foto Bart Hofmeester): 80; Service Photographique de la Reunion des Musées Nationaux, Paris: 7, 35, 47, 48, 64, 72, 76, Cpls. 15, 20; Stadt Antwerpen: 2, 42; University of Rochester, Rare Book Library: 69; Georges Van Pelt, Antwerp: 79, Cpl. 43; Atelier Walter Wachter, Vaduz: 28, 38.

Editor: Charles Miers
Designer: Doris Leath
Photo research: Pamela Bass

Frontispiece: *Self-Portrait*. 1623. St. James's Palace, London

Library of Congress Cataloging-in-Publication Data

Scribner, Charles.
 Rubens.

 1. Rubens, Peter Paul, Sir, 1577–1640 —
Criticism and interpretation. I. Title.
N6973.R9S35 1989 759.9493 88–34275
ISBN 0–8109–1569–3

Text copyright © 1989 by Charles Scribner III
Illustrations copyright © 1989 Harry N. Abrams, Inc.

A Times Mirror Company

Printed and bound in Japan

CONTENTS

Pietro Pauolo Rubens

BAROQUE ARTIST, RENAISSANCE MAN

Peter Paul Rubens is an artist's artist. His influence over the centuries is legendary: Van Dyck, Jordaens, Watteau, Boucher, Fragonard, Reynolds, Gainsborough, Delacroix, Renoir—each owed an essential debt to the Flemish master and paid him homage with their brushes. Even such unlikely heirs as Cézanne and Matisse studied Rubens and painted copies of his masterpieces.

Yet the painter's Rubens represents but one side of this multifaceted genius. His contemporary and friend General Ambrogio Spinola said of him: "Of all his talents, painting is the least." Indeed, Rubens was renowned throughout Europe as a diplomat. He successfully negotiated peace between England and Spain in 1630, an achievement for which he was knighted by King Charles I of England. He was also a dedicated scholar and Christian humanist, a learned classicist and antiquarian, a prodigious correspondent (in several languages), an amateur architect—in short, a true Renaissance man. His nephew Philip described his life as "but one long course of study." The court chaplain in Brussels eulogized him as "the most learned painter in the world"—an epitaph that still holds true three centuries later.[1]

Rubens was a shrewd businessman, an organizational genius who assembled and presided over the most famous painter's studio in Europe, where scores of pupils, assistants, and collaborators, many of them accomplished artists, assisted the master in translating his conceptions onto canvases or into sculpture, tapestries, and engravings. Rubens was an impresario of vast decorative programs and multimedia productions without peer in northern Europe; for his equivalent we must look south, a generation later, to Gian Lorenzo Bernini. Rubens's powers of invention were matched by his tireless energy and extraordinary versatility. The Danish royal physician Otto Sperling recalled a visit to Rubens's studio, where the master was at work on a painting "in the course of which he was read to from Tacitus while, at the same time, he dictated a letter. As we did not disturb him by talking, he began to speak with us, carrying on his painting without stopping, still being read to and going on with the dictation."[2]

Rubens was a devout Catholic, a loyal subject of the Spanish Hapsburgs, a devoted husband, the father of eight children, a prosperous, energetic, life-loving, thoroughly balanced man who lived in harmony with his society and, we may assume, with himself. No one could be further from the modern conception of the struggling artist who pays dearly—economically, spiritually, and socially—for exerting his genius. To some degree, it must be admitted, the very qualities with which Rubens was blessed tend to detract from his popular appeal today. We prefer to find genius in a tormented Michelangelo, a rebellious Caravaggio, a withdrawn and introspective Rembrandt: Hollywood has yet to exploit Rubens's exemplary life on the screen.

The collaborative nature of his studio productions runs counter to the notion of solitary genius. His erudition, steeped in the classical tradition, also at times presents barriers to our appreciation. Like Shakespeare, Rubens drew deeply from a once common wellspring of imagery and allusions—biblical, theological, and mythological—much of which is unfamiliar today. To experience the essential Rubens, to appreciate the profound interpretative powers underlying his shimmering surfaces, requires a familiarity with his symbolic vocabulary of images. He was as much a great narrative and allegorical artist as he was a master of color and form. The eighteenth-century archaeologist Johann Winckelmann compared him to Homer in view of his "great fertility of imagination." His art, like his life, reveals the epic, heroic quality of a man who towers over his own time, indeed over the entire history of painting.

The circumstances attending Rubens's birth and childhood were far from auspicious. He was born in 1577 in the small German town of Siegen, in Westphalia, to parents living in exile. His father, Jan Rubens, came from a prosperous Flemish family of spice merchants. Educated in Padua and Rome, Jan had been a successful lawyer and an alderman of the city of Antwerp before he fell casualty to the religious wars that engulfed the Low Countries, or Netherlands (much of present-day Netherlands, Belgium, and Luxembourg), during the second half of the sixteenth century.

In the sixteenth century the Netherlands were included within the far-flung Hapsburg dominions known as the Holy Roman Empire. Under the Emperor Charles

V, who had been educated in the Netherlands, the Dutch and Flemish provinces enjoyed a degree of self-government and religious tolerance despite the political and religious upheavals of the Protestant Reformation. But in 1555 Charles abdicated and gave the Netherlands to his only son, Philip, who succeeded him a year later as king of Spain. (Charles's Austrian dominions were subsequently transferred to his brother Ferdinand, who was duly elected emperor.)

Unlike his father, the new King Philip II was exclusively Spanish in his education and experience and implacably anti-Protestant in his policies and passions. Religious strife in the Netherlands erupted in full force, intensified by a military campaign led by the Protestant Prince William ("the Silent") of Orange to gain independence for the provinces from Spanish—and Catholic—rule. In 1566 an outbreak of Protestant rioting and iconoclasm ravaged Antwerp's Catholic churches: a wholesale destruction of ecclesiastical art fueled by religious passions—for political purposes. Philip responded the following year, sending the merciless duke of Alva and his bloodthirsty troops to pacify Flanders. It was at this point that Jan Rubens, who had openly espoused Calvinism, decided to flee with his family to a safer political climate. In 1568 Jan and his wife, Maria Pypelinckx, and their four children moved to Cologne, where Jan served as legal adviser to the prince of Orange's estranged wife, Anne of Saxony. The jaded princess sought more from Jan than his legal opinions, and he succumbed—with disastrous results. The prince had him arrested in 1571 and imprisoned in the castle of Dillenburg, where he faced a sentence of death. But Maria came to his rescue. Invoking the spirit of Christian forgiveness, combined with persistence and payments of family funds (she too came from a prosperous line of Antwerp merchants), she finally obtained her husband's release on bail. Jan was reunited with his family in 1573 but was required to live under house arrest in Siegen. Later that year a son, Philip, was born, followed four years later by a younger brother, Peter Paul, on June 28, 1577.

In 1578 Jan Rubens was granted a full pardon and returned with his family to Cologne, where Peter Paul was raised until he was ten. In 1587 Jan died, and Maria returned to Antwerp with three children remaining in her care—Philip, Peter Paul, and their elder sister Blandina. The fact that Rubens thereafter avoided any mention of Siegen as his birthplace suggests the extent to which his father's disgrace and the troubled circumstances of his early childhood left an indelible mark. The memory doubtless contributed to his burning sense of ambition and his thirst for respectability and propriety. As an infant in Siegen, he had been baptized in a Lutheran church; but in Cologne he was raised a Catholic by his mother. Unlike his father, he remained unwavering in his faith and became the Church's leading proponent in the realm of art. We may only speculate on how his father's shortcomings may have prompted the future course of his life.

At the age of eleven, Rubens was enrolled in Rombout Verdonck's school near Antwerp's towering Gothic cathedral. There he received a solid classical grounding in Latin and Greek literature and met a crippled student who became his lifelong friend: Balthasar Moretus, heir to the great Plantin Press, which had been founded in Antwerp by his grandfather Christopher Plantin in 1555. Rubens was later to design elaborate title pages for Moretus and to contribute extensively to his publications, a unique collaboration in the history of arts and letters between a painter and a publisher. "I knew him from his childhood," Moretus later reminisced, "and I loved this young man who had the most perfect and the most amiable character."

At the age of thirteen, in 1590, Rubens left school and was sent by his mother to serve as a page in the household of Marguerite de Ligne-Arenberg, the widow of Philip, count of Lalaing. The stultifying life at this provincial court must have been frustrating to the young man, who probably already felt called to a career in art. Rubens was never to revise his dim view of court life, but the year at Oudenarde taught him valuable lessons in the etiquette and diplomacy of serving noble patrons; with little else to do, he had frequent opportunities to practice

1. Peter Paul Rubens. *Promenading Couple after Holbein's "The Dance of Death."* c. 1590. Pen and ink on paper, 4⅛ × 3″ (10.61 × 7.62 cm).

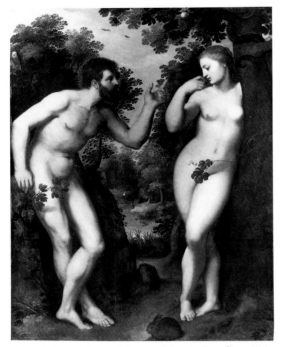

2. Peter Paul Rubens. *Adam and Eve in Paradise.* 1599. Oil on panel, 71 × 62¼″ (180 × 158 cm). Rubenshuis, Antwerp

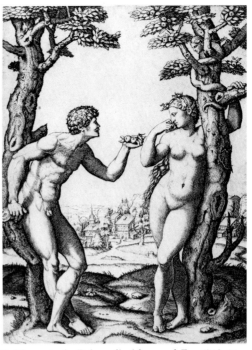

3. Marcantonio Raimondi. *Adam and Eve.* 1512–14. Engraving, 9⅜ × 6⁵⁄₁₆″ (23.9 × 16 cm). Reproduced by courtesy of the Trustees of The British Museum, London

drawing from life and to copy prints by northern artists such as Tobias Stimmer, Albrecht Dürer, and Hans Holbein. His early drawing after a woodcut in Holbein's book *The Dance of Death* probably dates from this time (fig. 1).

Rubens's formal artistic training began in 1591 with his apprenticeship to Tobias Verhaecht, a landscape painter of modest talent and a kinsman by marriage. A year later Rubens moved on to the studio of Adam van Noort, also the teacher (and later the father-in-law) of Jacob Jordaens. There he remained for approximately four years before being apprenticed to Antwerp's leading master of the day, Otto van Veen, dean of the painters' Guild of St. Luke. Unlike Verhaecht and Van Noort, Van Veen (or Vaenius, as he latinized it) made a notable contribution to Rubens's early style and development. His influence extended beyond the formal aspects of painting. Van Veen was a member of the Romanists, a brotherhood of Flemish painters who had studied in Italy. He combined a sober and refined (if uninspiring) style influenced by Barocci, Michelangelo, and Raphael with a strict adherence to the principles of Renaissance human-ism. The author of several books on emblems, he imbued the young Rubens with a lively sense of painting as a lofty, humanistic endeavor. He was also a devout Catholic and a Hapsburg loyalist, two lifelong commitments shared by his most famous pupil.

We know all too little about Rubens's earliest works: most have disappeared—or remain to be identified. His

Portrait of a Young Man (plate 1) is the first dated work, inscribed 1597. His *Adam and Eve in Paradise* (fig. 2) was painted a year or so later. Based on an engraving by Marcantonio Raimondi (fig. 3) after a lost composition by Raphael, it reveals the young Rubens's early interest in—and dependence on—Renaissance engravings. But it is hardly a slavish copy. In his translation of the print into a full-scale and richly colored oil painting, Rubens al-ready displayed his characteristic tendency to edit and reinterpret the prototype. He brought the couple closer together: Adam no longer holds the forbidden fruit but now points admonishingly toward Eve and the fatal Tree of Knowledge. Between mankind's classically idealized ancestors Rubens inserted a vista of Flemish paradise.

According to his nephew Philip's biography, Rubens's first paintings were very close in appearance to Van Veen's. This affinity continues to pose problems of identification. The *Allegory of Youthful Temptations* (fig. 4), despite bearing Van Veen's monogram, was tentatively reascribed to his more talented pupil at Rubens's four-hundredth anniversary exhibition in Antwerp in 1977. A more convincing reattribution, again from Van Veen to Rubens, is the tumultuous *Battle of the Amazons* in Pots-dam (fig. 5), which includes a background landscape painted by Jan Brueghel.[3] The explosive, multifigured composition foreshadows Rubens's definitive treatment of the subject two decades later (plate 11). Rubens and Van Veen undoubtedly collaborated on several works, and while separating the two hands is a speculative venture, in

4. Otto van Veen. *Allegory of Youthful Temptations*. 1590–95. Oil on panel, 57½ × 83½″ (146 × 212 cm). Nationalmuseum, Stockholm

6. Otto van Veen and Peter Paul Rubens. *Archduke Albert as Cardinal*. c. 1597. Oil on paper, 19¼ × 14¼″ (48 × 36 cm). Albertina, Vienna

5. Peter Paul Rubens and Jan Brueghel I. *The Battle of the Amazons*. c. 1599. Oil on panel, 37 × 48⅞″ (94 × 124 cm). Bildergalerie, Potsdam

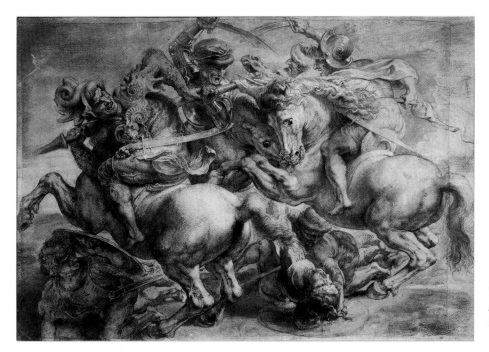

7. Peter Paul Rubens. *The Battle of Anghiari*. 1612–15. Chalk with pen and ink on paper, 17¾ × 25⅛″ (45.2 × 63.7 cm). The Louvre, Paris

one instance the juxtaposition is telling: Van Veen's pen-and-wash portrait of Archduke Albert dressed in his cardinal's robes (fig. 6), a preparatory drawing for an engraving of 1597, is framed by decorative architecture, garlands, and festive putti added by the young Rubens.[4] On a far grander scale, Rubens probably assisted his former master in executing the triumphal structures—an amalgam of paintings, sculpture, temporary architecture, and tableaux vivants—that adorned the streets of Antwerp in 1599 for the *Blijde Intrede* (Joyous Entry) of the new regents, the Archdukes Albert and Isabella, who had been sent by King Philip II to rule—semi-autonomously—the Spanish Netherlands. It was Rubens's first exposure to a monumental mode of decoration, of which he would eventually become the undisputed master. By this time, Rubens had completed his apprenticeship: he had been admitted into the Guild of St. Luke in 1598. He was now entitled to set up his own studio, and in fact he already had a pupil, Deodat van der Mont (or del Monte, as he later italianized it), son of a silversmith. Yet Rubens may have continued to work in Van Veen's studio, for by now he probably had set his sights on a journey to Italy.

In May 1600 Rubens headed south with his pupil Deodat—who accompanied him throughout the eight-year sojourn—arriving in Venice sometime in July. There he absorbed the luminosity and dramatic expressiveness of Titian, Tintoretto, and Veronese's paintings.[5] On a more practical level, he encountered a member of the court of Vincenzo I Gonzaga, duke of Mantua, and was promptly introduced to the prodigal and pleasure-loving duke, a cousin of the Archduke Albert. Rubens proceeded to Mantua, where another Fleming, Anthonis

Mor, had earlier been court painter and where the current music master was Claudio Monteverdi, the father of Italian opera. (Also among Gonzaga's close acquaintances in the arts and sciences were the poet Tasso and the astronomer Galileo.) Rubens's chief duties were to make copies of Renaissance paintings, especially portraits of court beauties. There were compensations: access to a gallery of masterpieces by Titian, Mantegna, Correggio, Raphael and his leading pupil, Giulio Romano. Giulio's Palazzo del Tè in Mantua, a crowning achievement in Mannerist architecture and fresco decoration, must have been an overwhelming experience for the Flemish artist. Years later, Rubens's designs for his own house and garden in Antwerp would grandly reflect it (fig. 30).

In October 1600 Rubens accompanied the duke to Florence to attend the marriage by proxy of Gonzaga's sister-in-law Maria de' Medici to King Henry IV of France, a scene Rubens was to recreate a quarter-century later for the bride (by then a widow) in the Medici cycle (fig. 47). In Florence, he visited Michelangelo's Medici tombs, which he later recalled in *Samson and Delilah* (plate 5), and he may have studied copies of Leonardo's unfinished and subsequently destroyed *Battle of Anghiari* fresco for the Palazzo Vecchio, known today chiefly through Rubens's pen-and-wash drawing in the Louvre (fig. 7). By the end of his first year with the duke, Rubens had traveled throughout Italy, sketchbook in hand. He finally arrived in Rome in August 1601, where he had been sent to paint copies. The timing could not have been more propitious. The Eternal City was being transformed by the Counter-Reformation popes into the artistic capital of Europe, a propagandistic assertion of their spiritual—and temporal—primacy.

8. Annibale Carracci. *Polyphemus and Galatea.* 1599–1600. Fresco. Palazzo Farnese, Rome

Rubens's arrival in Rome coincided with the dawn of the Baroque style heralded by the Carracci and by Caravaggio. Their fusion of a new naturalism, or verisimilitude, in painting with a classical revival of the heroic, High Renaissance contours of Michelangelo and Raphael was quickly assimilated by Rubens. A year before his arrival, the Carracci's monumental frescoed ceiling in the Palazzo Farnese had been unveiled. Its combination of sensuality and erudition (fig. 8) anticipated Rubens's distinctive approach to classical mythology (plates 7 and 12) as well as his orchestration of spatial illusions, fictive architecture, and grisaille sculpture-in-paint. It is such visionary yet rationalized assaults on the senses, the integration of real and fictive space, and the impassioned—often ecstatic—emotional content that characterize the Baroque style and, above all, the art of Rubens. At precisely the same time, Caravaggio was completing his lateral wall paintings of St. Matthew's life for the Contarelli Chapel in S. Luigi dei Francesi, an overpowering debut for his dramatic chiaroscuro, which was also to leave its mark on Rubens. An early sheet of drawings by Rubens (fig. 9), pen-and-ink sketches for a painting of the Last Supper, reveals both a quotation from Caravaggio's *Calling of St. Matthew* for one of the seated apostles and a disciple "lifted" (and reversed) from Caravaggio's contemporaneous *Supper at Emmaus* (National Gallery, London) for another. These sketches provide an example of the process by which Rubens compiled his vast visual vocabulary.

Rubens's drawings of Michelangelo's Sistine Chapel and Raphael's Vatican Stanze and Farnesina frescoes re-

veal his reverence for the two Renaissance masters. His *Ignudo* after Michelangelo (fig. 10) seems, in its sensuous rendering, to have been drawn from a live studio model—not, as was the case, copied from a ceiling fresco some sixty feet overhead. Similarly, his studies of ancient sculpture appear as though sketched from life, not marble (fig. 11). Like the mythical sculptor Pygmalion, Rubens infused the statues with a sense of immediacy; he drew them from unusual vantage points, charging the familiar images with dramatic intensity. In his posthumously published treatise *De imitatione statuarum* (On the Imitation of [Ancient] Statues), Rubens wrote that while a thorough study and understanding—"nay, a complete absorption"—of ancient statues is essential "in order to attain the highest perfection in painting," one must "make judicious use of them and, above all else, avoid the effect of stone."[6] Throughout his myriad transformations of antiquity—in drawings, paintings, and designs for title pages—Rubens exemplified this underlying credo, his belief in what might be termed artistic metamorphosis.

Rome was not only a place of study. It was there Rubens received his first major commission, a series of three large paintings for the Chapel of St. Helena in the crypt of Sta. Croce in Gerusalemme. Before the Cardinal-Archduke Albert's marriage to the Infanta Isabella, Sta. Croce had been his titular church in Rome (fig. 6). Through the good offices of Jean Richardot, the Flemish ambassador to the Holy See and a close friend of Rubens's brother Philip, the commission fell to Peter Paul. For the side walls he painted a *Crowning with Thorns* and a *Crucifixion;* over the altar, a visionary *St. Helena with the*

9. Peter Paul Rubens. *Three Groups of Apostles in a Last Supper*. 1601–1604. Pen and brown ink on paper, 11½ × 17⅛″ (29.3 × 43.5 cm). The J. Paul Getty Museum, Malibu

True Cross (fig. 12). The regal saint, mother of the Emperor Constantine, stands before a Roman triumphal arch as she receives a heavenly crown. With the cross at her side, she is accompanied by a host of angels and putti carrying emblems of the Passion. Rubens's juxtaposition of Helena with the ornate and twisted Solomonic columns in the background (so named because their marble prototypes were believed to have come from the ancient Temple of Solomon) symbolically sets the scene in Jerusalem and anticipates Bernini's statue of St. Helena beside his bronze Solomonic columns of the *Baldacchino* a quarter-century later in St. Peter's.

After completing the commission, Rubens returned to Mantua in April 1602. A few months later he met up with his brother Philip and a fellow Fleming, Jan Woverius, both of whom had been students at Louvain of the great Neo-Stoic philosopher Justus Lipsius—an intellectual kinship commemorated a decade later in Rubens's *Four Philosophers* (plate 9). The following spring, Rubens received his first diplomatic assignment. Gonzaga sent him on a mission to Spain to present to the new king, Philip III, and his prime minister, the duke of Lerma, a shipment of princely gifts, including sixteen copies (not by Rubens) of paintings by Raphael and Titian and a coach with six prize horses. The journey was tedious, expensive (the duke ordered the horses be given wine baths!), and inexplicably indirect: via Florence and Pisa to Livorno, before setting sail. After disembarking at Alicante, Rubens trailed the royal court from Madrid to Valladolid. The paintings were ruined in transit by torrential rain—twenty-five days of it—and Rubens was obliged to undertake a major job of restoration with the aid of some local Spanish painters. He wrote back to the duke's secretary, Annibale Chieppio, in Mantua: "I agreed to this, but I am not inclined to approve of it considering the short time we have, as well as the extent of the damage of the ruined pictures; not to mention the incredible incompetence and carelessness of the painters here, whose style (and this is very important) is totally different from mine. God keep me from resembling them in any way!" He added, moreover, that he would not collaborate with them "by a mixture of hands" on the same canvases, "for I have always guarded against being confused with anyone, however great a man"[7]—a view he was to modify, a decade later, when working with *Flemish* collaborators such as Frans Snyders (fig. 33) and Jan Brueghel (plate 13).

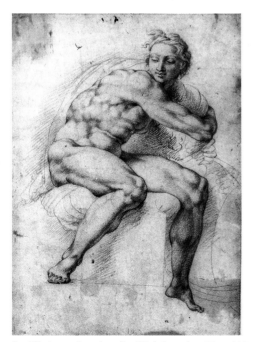

10. Peter Paul Rubens. *Ignudo, after Michelangelo*. 1601–1605. Chalk on paper, 15¼ × 10⅞″ (38.7 × 27.7 cm). Reproduced by courtesy of the Trustees of the British Museum, London

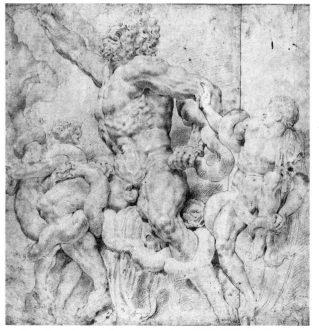

11. Peter Paul Rubens. *Laocoön and Sons*. 1605–1608. Chalk on paper. Biblioteca Ambrosiana, Milan

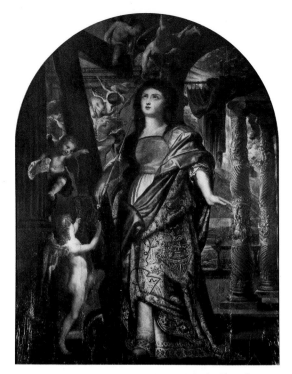

12. Peter Paul Rubens. *St. Helena with the True Cross.* 1601–1602. Oil on panel, 99 × 74″ (251 × 187 cm). Old Cathedral of Notre-Dame, Grasse

Rubens soon discovered the treacherous realities of seventeenth-century diplomatic service, for at the official presentation of gifts to the king the neophyte artist-envoy was shunted aside by Gonzaga's jealous agent at the Spanish court, Annibale Iberti, who alone took credit. It was a lesson Rubens would never forget throughout his career as a diplomat: his eyes had been opened early. Nor did he refrain from defending his honor in his dispatches back to Mantua.

For Philip's all-powerful minister, the duke of Lerma, Rubens painted his first major equestrian portrait (fig. 13). In this animated portrayal of Lerma in military splendor as captain-general of the Spanish cavalry—a charge rages in the background—Rubens took the Venetian tradition of equestrian portraiture established by Titian and Tintoretto a giant step forward in the expression of physical presence and psychological confrontation. The duke, astride his spirited white stallion, advances toward the picture plane—and viewer. Horse and rider are combined, centaurlike, in a single spiraling image of dynamic power. The slightly inclined pose is counterbalanced by the tree trunk and arching palm branches overhead, an emblem of victory and nature's version of a ceremonial baldachin. Rubens proved in paint that King Philip's prime minister was "no less well served than His Majesty." This groundbreaking portrait clearly pleased his patron. Even Rubens's nemesis Iberti was forced to concede its unqualified success. The tradition of Baroque equestrian portraiture, advanced several

decades later by Velázquez and Van Dyck, consequently owes its origins to Rubens, who was to return to this heroic formula many years later (plate 23) for another king's favorite at a rival court.

Rubens's newly retouched copies were accepted as originals. As for true originals, Rubens saw in the king's collection "so many splendid works of Titian, of Raphael and others, which have astonished me, both by their quality and quantity . . . but as for the moderns, there is nothing of any worth." (So much for Spanish painting.) Rubens was instructed to go to France to copy a series of portraits for Gonzaga's "Gallery of Beauties," but he balked at "wasting more time, travel, expenses, salaries . . . upon works unworthy of me, and which anyone can do to the duke's taste. . . . I beg him earnestly to employ me, at home or abroad, in works more appropriate to my talent."[8] Rubens had already achieved a strong sense of his artistic worth; at the same time he revealed his low view of the mechanical aspects of copying, a task for which he would later assemble an entire workshop of assistants.

Early in 1604 Rubens returned to Mantua and was soon at work on a commission commensurate with his abilities: three large paintings for the chancel of the Jesuit Church in Mantua, SS. Trinità. The church was dedicated to the Holy Trinity, and Rubens's tripartite program accordingly combined three trinitarian epiphanies: on the side walls, two biblical subjects, the *Baptism* and *Transfiguration;* and in the center, above the high altar, an allegorical scene, the *Gonzaga Family Adoring the Holy Trinity* (fig. 14). The altarpiece was badly mutilated by Napoleon's troops in 1801, and the canvas was later reassembled in an awkward patchwork. Enough remains of it, however, to reveal Rubens's brilliant invention. The noble family is shown kneeling on a terrace framed by Solomonic columns, which recall the *St. Helena* altarpiece (fig. 12) and which establish the vision within the Heavenly Jerusalem; at the same time they associate the church's sanctuary with the Holy of Holies, the dwelling place of God in the Hebrew Temple. The Trinity is the centerpiece of a *double* illusion: it is depicted on a tapestry (within a painting) held aloft by "real" angels. Rubens was to revive this combination of sacred architecture and illusionistic tapestry a quarter-century later in his Triumph of the Eucharist (plates 26 and 27).

Toward the end of 1605 Rubens began his second stay in Rome. There he met his brother Philip, now librarian to the influential Cardinal Colonna. Together they lodged near the Piazza di Spagna and undertook an intensive study of ancient art and philology, which resulted in the 1608 publication of Philip's *Electorum libri II,* illustrated by Peter Paul. Their happy collaboration

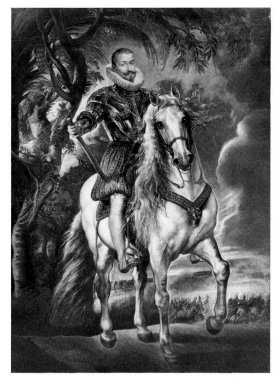

13. Peter Paul Rubens. *Duke of Lerma.* 1603. Oil on canvas, 111⅜ × 78¾" (283 × 200 cm). Prado, Madrid

marked the beginning of Rubens-as-antiquarian: he was to return to Antwerp with a sizable collection of Roman sculpture, reliefs, portrait busts, and ancient coins.[9] Among the artists he befriended in Rome was the promising but emotionally troubled young German painter Adam Elsheimer, whose untimely death in 1610 profoundly distressed him. "Surely after such a loss," Rubens later wrote, "our entire profession ought to clothe itself in mourning. It will not easily succeed in replacing him; in my opinion he had no equal in small figures, in landscapes, and in many other subjects."[10] Rubens owned several of Elsheimer's small paintings (fig. 15) and emulated his lyrical landscape style and his sublime effects of nocturnal lighting (plate 10).

On December 2, 1606, Rubens wrote to Gonzaga's secretary Chieppio explaining that he could not yet return to Mantua since he had to finish various commissions accepted "out of pure necessity"—the duke had been sorely in arrears in paying the artist's salary. Foremost among these commissions was "the finest and most splendid opportunity in all Rome . . . the high altar of the Chiesa Nuova [New Church] of the Priests of the Oratory, called Sta. Maria in Vallicella—without doubt the most celebrated and frequented church in Rome today." Rubens added that although he had not actually begun work on the painting, "personages of such rank are interested in it that I could not honorably give up a contract obtained so gloriously over the pretensions of all the leading painters of Rome." His brother Philip's

Flemish—and his own Genoese—connections in Rome may have been helpful in securing the commission, but there can be no doubt that the final decision of the Oratorian fathers was based on the young painter's demonstrable virtuosity. The altarpiece (plate 4) was designed to enshrine a miraculous icon of the Madonna and Child, which Rubens exploited as a picture within a picture, recalling the similar device in the SS. Trinità altarpiece (fig. 14). Rubens was granted a six-month extension in Rome to complete the painting, a monumental *sacra conversazione* of saints before a triumphal arch (like St. Helena's in fig. 12) on top of which the framed painting is adorned by cherubs with festoons—a classically Roman vision for a triumphantly Roman church.

In July 1607, the work almost completed, Rubens was called north by Gonzaga to Genoa, where he painted a series of portraits of Genoese nobility. His *Marchesa Brigida Spinola-Doria* (fig. 16 and plate 3), painted the year before, established a new canon for aristocratic por-

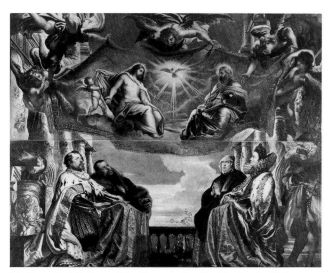

14. Peter Paul Rubens. *The Gonzaga Family Adoring the Holy Trinity.* 1604–1605. Oil on canvas, 151 × 189" (384 × 481 cm). Palazzo Ducale, Mantua

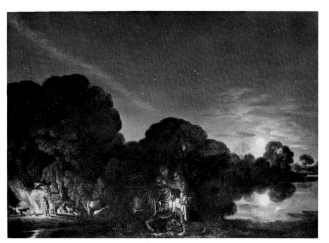

15. Adam Elsheimer. *The Flight into Egypt.* 1609. Oil on copper, 12³⁄₁₆ × 16⅛" (31 × 41 cm). Alte Pinakothek, Munich

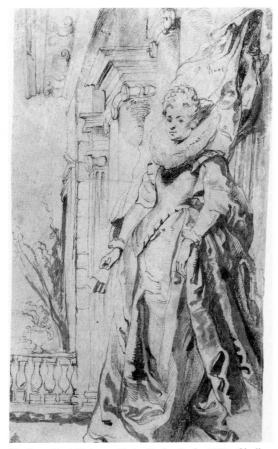

16. Peter Paul Rubens. *Portrait of a Lady.* 1606. Chalk and pen-and-ink on paper, 12⁷⁄₁₆ × 7¹⁄₁₆″ (31.5 × 18.5 cm). The Pierpont Morgan Library, New York. Gift of a Trustee

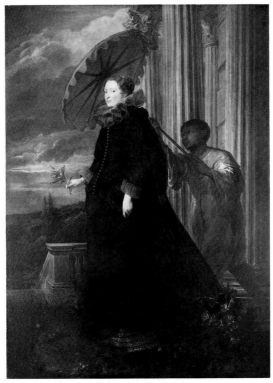

17. Anthony van Dyck. *Elena Grimaldi, Marchesa Cattaneo.* 1623. Oil on canvas, 97 × 68″ (246.4 × 172.7 cm). National Gallery of Art, Washington, D.C. Widener Collection, 1942

traiture that was to be followed by Van Dyck (fig. 17) and his English successors Reynolds and Gainsborough. During that summer at the duke's resort in San Pier outside Genoa, Rubens established important contacts with Genoese noblemen, probably through the duke's banker Nicolò Pallavicini, who was later to serve as godfather to the artist's second son. It was for an unidentified group of Genoese gentlemen ("*alcuni Genovesi gentilhuomini*"—perhaps the Pallavicini brothers) that Rubens was, a decade later, to design his first cycle of tapestries, the Decius Mus series (figs. 37 and 38). He avidly studied the city's architecture and collected plans of the richly decorated façades, which he eventually published as a book of engravings entitled *Palazzi di Genova* (Antwerp, 1622). It was his hope, as he explained in his introduction to the book, that the Italianate style of architecture would be transplanted north to Flanders (figs. 18 and 30).

By late August, Rubens had gained leave to return to Rome to finish the Chiesa Nuova altarpiece. On February 2, 1608, he wrote to Chieppio that the finished painting had "turned out very well, to the extreme satisfaction of the fathers and also (which rarely happens) of all the others who saw it. But the light falls so unfavorably on this altar that one can hardly discern the figures." The Oratorians presumably asked Rubens to paint a copy on a nonreflective material; Rubens offered to sell the first altarpiece to Gonzaga, who had yet to acquire a major painting by him for his own collection. The duke declined with what must have seemed a graceless rebuff to his court painter, who had just recently persuaded him to buy Caravaggio's *Death of the Virgin* (which itself had been rejected by the clergy of Sta. Maria della Scala).

18. *Palace in Genoa.* Engraving from Peter Paul Rubens, *Palazzi di Genova*, Antwerp, 1622. The British Library, London

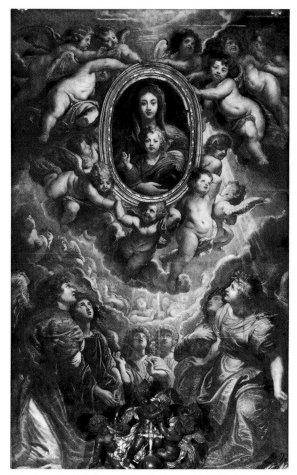

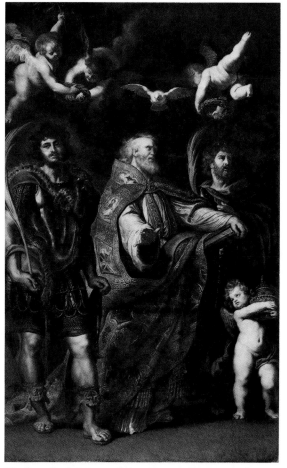

19. Peter Paul Rubens. *The Madonna di Vallicella and Angels.* 1608. Oil on slate, 191 × 105½″ (485 × 268 cm). Sta. Maria in Vallicella, Rome

20. Peter Paul Rubens. *Saints Gregory, Maurus, and Papianus.* 1608. Oil on slate, 162½ × 101⅛″ (413 × 257 cm). Sta. Maria in Vallicella, Rome

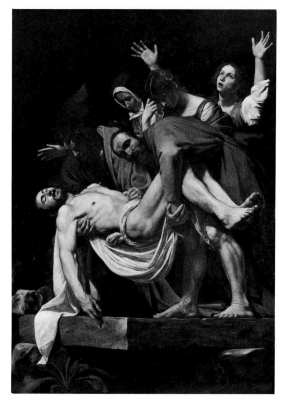

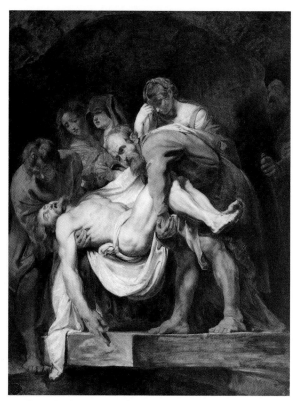

21. Caravaggio. *The Entombment.* 1602–1604. Oil on canvas, 118⅛ × 79¹³⁄₁₆″ (300 × 203 cm). Vatican Museum, Rome

22. Peter Paul Rubens. *The Entombment.* 1613–15. Oil on panel, 34¾ × 25¾″ (88.3 × 65.4 cm). National Gallery of Canada, Ottawa

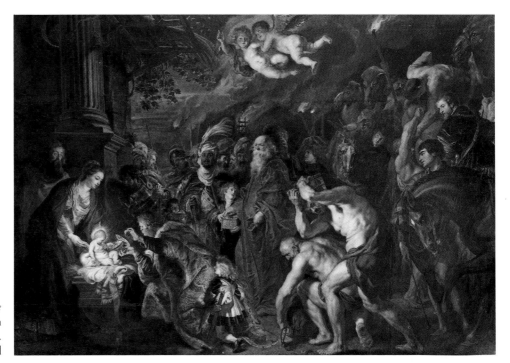

23. Peter Paul Rubens. *The Adoration of the Magi*. 1609. Oil on canvas, 126 × 180″ (320 × 457 cm). Prado, Madrid

Rubens nevertheless proceeded with his new altarpiece, to be painted on slate. He declined to copy his own work, choosing instead to recast the entire altar decoration in a more ambitious, expansive form, a series of three separate panels. Above the high altar he conceived an apotheosis of the icon (fig. 19) carried heavenward by a host of putti—a thoroughly Baroque conceit later translated into sculpture by Bernini for his Maria Raggi memorial in Sta. Maria sopra Minerva.[11] The side panels are devoted to the Early Christian—and gravely Roman—saints (fig. 20), who turn inward toward the miraculous apparition above the altar, spiritually charging the space of the sanctuary across which the metaphysical drama is staged.

Like the painter Cavaradossi in Puccini's *Tosca*, Rubens executed the final altarpiece in situ, so as to take into account the full effects of the natural lighting. Each day he passed the Vittrici chapel containing Caravaggio's *Entombment* (fig. 21). His close study and admiration of this revolutionary masterpiece are revealed in his interpretative "copy," painted several years later (fig. 22). Rubens's revisions display a classical restraint in the suppression of the Magdalene's upraised arms, at the same time revealing a more Baroque approach to spatial effects. Rubens's Christ is shown about to be lowered below the protruding stone slab and into the viewer's own space, a reinterpretation that recalls the location of Caravaggio's original above the stone altar of the Vittrici chapel—and above the heads of the worshipers.

On October 27, 1608, Rubens received word from Antwerp that his mother was critically ill. The next day, "mounting horseback" (as he penned in a postscript), he dashed off a letter to Mantua, explaining his sudden departure for home. The "three great pictures" for Chiesa Nuova were finished—"the least unsuccessful work by my hand," in his modest appraisal. He was never to see them unveiled. Rubens arrived in Antwerp to discover that his mother had died and had been buried in the Abbey of St. Michael. Over her tomb he placed his first version of the Chiesa Nuova altarpiece. In her will Maria returned to him his paintings, which he had given to her on the eve of his departure for Italy eight years earlier; she noted with a mother's pride that they were beautiful. Yet in retrospect these early works were but glimmerings of the rich harvest his years under the Italian sun were about to yield.

Despite the personal loss that occasioned the journey, Rubens's arrival home could not have been more timely. In January 1609 his brother Philip was appointed secretary of the city of Antwerp. Negotiations for the Twelve Years' Truce were being concluded between the United Provinces (the Dutch separatists) and Spain, which raised the prospects of lasting peace and economic recovery for war-torn Flanders. Antwerp, once a bustling port and center of commerce, had suffered as a result of the Dutch naval blockade of the river Scheldt. In this seventeenth-century tale of two cities, Antwerp's fortunes steadily declined as Amsterdam succeeded it as the chief northern port and center of maritime commerce. But in 1609 the outlook for Antwerp seemed unusually bright. Rubens was commissioned by the burgomaster Nicolaas Rockox to paint for the Chamber of States (*Staatenkamer*) in the town hall, where the truce was to be signed in April, a celebratory *Adoration of the Magi* (fig. 23). Rubens's epiphany of the Prince of Peace (the infant

Christ) commemorated, by analogy, the signing of the truce by the latter-day Wise Men. The nocturnal setting and multiple sources of illumination—moonlight, burning torches, and the miraculously glowing Christ Child—were derived from Adam Elsheimer. To the painting's pervasive Venetian aura of Tintoretto and Veronese, Rubens added a reference to antiquity: the muscular servant carrying a chest is a quotation of the *Farnese Atlas* bearing the world on his shoulders. This painting quickly established Rubens's reputation at home and introduced a theme of stately adoration on which he was to compose variations over the following two decades (plate 21).[12]

At the time of the truce, Rubens still yearned for Italy: "I have not made up my mind whether to remain in my own country or to return forever to Rome," he wrote on April 10. "The Archduke and the Most Serene Infanta have had letters written urging me to remain in their service. Their offers are very generous, but I have little desire to become a courtier again. . . . Antwerp and its citizens would satisfy me, if I could say farewell to Rome." To their everlasting credit, the regents made Rubens an offer he could not refuse. As their new court painter (an honor shared also by Van Veen and Jan Brueghel), Rubens was exempted from all taxes, guild restrictions, and court duties in Brussels. He could remain in Antwerp and organize his own studio. Rubens had ensured that the honorific gold chain of office he received from the archdukes would in no way bind him to his royal patrons. His diplomatic skills in negotiating with princes had been honed early in his career.

The same year, 1609, his brother Philip was married. "It was a fortunate hour," reported the younger brother, "when he laid aside the scholar's gown and dedicated himself to the service of Cupid. . . . I myself will not dare to follow him, for he has made such a good choice that it seems inimitable."[13] But Cupid had other plans. On October 3, two weeks after his appointment as court painter, Rubens married his new sister-in-law's niece, the nineteen-year-old Isabella Brant, and celebrated their happy union in his famous double portrait under a honeysuckle bower (plate 6).

The Twelve Years' Truce prompted a full-scale refurbishing of Antwerp, especially of her many churches, and major commissions immediately fell to Rubens. Among the earliest (1609–10) was the altarpiece for the Dominican Church: the *Glorification of the Holy Sacrament* (fig. 24), which displays Rubens's rearrangement—with pronounced Counter-Reformation accents—of Raphael's *Disputa* in the Vatican Stanze. Rubens's grouping of the voluminous Church Fathers within a columned apse surrounding the high altar, all

illuminated by a burst of heavenly light and with angels overhead, anticipates by a half-century Bernini's *Cathedra Petri* in the apse of St. Peter's in Rome.

Rubens similarly transformed his Netherlandish heritage in the first of his two great Antwerp triptychs, the *Raising of the Cross*, commissioned in June 1610 for the high altar of the parish church of St. Walburga (fig. 25). Transcending the limitations inherent in the triptych form, Rubens's heroic Crucifixion extends beyond the central panel to embrace the two flanking wings. Christ's muscular torso incorporates features of the *Laocoön* (fig. 11)—Rubens established the pose in his vivid chalk drawing of a studio model (fig. 26). Reflections of Tintoretto and Caravaggio are combined with Flemish realism—the faithful representation of the natural world—in this dramatic affirmation of redemptive suffering. The upturned eyes were originally directed toward a painting of God the Father located above the triptych, as Rubens continued to explore the spatial relations begun at the Chiesa Nuova. Eugène Delacroix, on first seeing the painting in 1850, noted in his *Journal*: "At last I have seen the famous *Raising of the Cross*: I was most deeply moved!

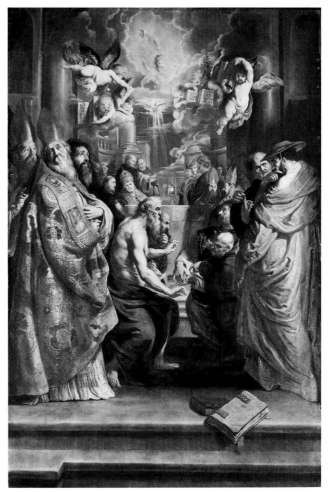

24. Peter Paul Rubens. *The Glorification of the Holy Sacrament*. 1609–10. Oil on panel, 148⅜ × 95⅝" (377 × 242.8 cm). St. Paul's Church, Antwerp

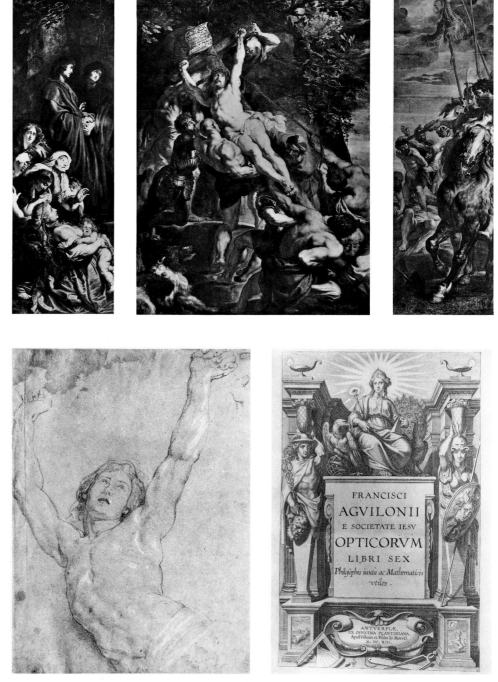

25. Peter Paul Rubens. *The Raising of the Cross.* 1610–11. Oil on panels, 181⅞ × 133½" central panel (462 × 339 cm); 181⅞ × 59⅜" each wing (462 × 151 cm). Cathedral of Our Lady, Antwerp

26. Peter Paul Rubens. *Study for the Figure of Christ.* 1610–11. Black chalk, charcoal, and white chalk on buff antique laid paper, 15¾ × 11¹¹⁄₁₆" (40 × 29.8 cm). The Harvard University Art Museums. Fogg Art Museum. Gift of Meta and Paul J. Sachs

27. Peter Paul Rubens and Theodoor Galle (engraver). Title page for Franciscus Aguilonius's *Opticorum libri sex.* 1613. Engraving

In many ways it is akin to Géricault's *Raft of the Medusa.* . . . Full of Michelangelo. . . . Seeing this picture has raised Géricault in my estimation." The Romantic painter concluded that "Rubens was no imitator; he was always Rubens."[14]

Rubens was no less proficient on a small scale. He provided a series of illustrations for the *Roman Missal* (published in 1613) and *Roman Breviary* (1614). He also began a secondary career as a designer of title pages for his old schoolmate Balthasar Moretus—a series of magnificent emblematic, miniature architectural and sculptural constructions that he evolved over the next three decades.[15] Rubens's title page for Franciscus Aguilonius's book on optics (fig. 27), to which he contributed several

illustrations as well, introduces the learned Jesuit's scientific treatise with an erudite yet witty assemblage of mythological optical allusions: the beheaded Argus, whose many eyes were transferred to the tail of Juno's peacock, and the petrifying head of Medusa on Minerva's shield. The sight of Medusa turned men to stone, but in this early "sculpted" title page, as in his drawings of statues, Rubens successfully "avoids the effect of stone." He transformed the static, emblematic formulas of Van Veen and his predecessors into sensuous, living allegories, graphic counterparts to such early mythological paintings as his *Ganymede* (plate 7) and *Discovery of the Infant Erichthonius* (fig. 28). In the latter, two background sculptures provide allegorical footnotes to Ovid's myth.

The garden herm of a satyr alludes to the uncontrollable lust through which the infant Erichthonius was accidentally conceived, while his mother, Earth (*Gaia*), is included at the right as an overtly fertile fountain.

It was burgomaster Rockox again who helped to secure for Rubens in 1611 the commission for his second major triptych, the *Descent from the Cross* (plate 8) for the altar of the Harquebusiers' (Musketeers') Guild in the transept of the cathedral. By contrast with the *Raising of the Cross* (fig. 25), this triptych is more classical and restrained. The wings are now unified not compositionally—by an extension of the central scene—but iconographically via the "Christ-bearing" leitmotif. It is an example of Rubens's vigorous renewal of the Early Netherlandish iconographic tradition established by Jan van Eyck, Hans Memling, and Roger van der Weyden. The widespread fame of this composition was ensured by

the publication of an engraved reproduction by Lucas Vorsterman; among its future admirers—and imitators—was the young Rembrandt. For Rockox's eventual tomb in the Church of the Recollects, Rubens painted his most Caravaggesque triptych, the *Incredulity of St. Thomas* (fig. 29). "Blessed are they who have not seen yet believe," Christ reproved the doubting Thomas. Rubens favorably applied the biblical text to his patrons, Rockox and his wife, Adriana Perez, whose pious gestures of belief frame the central scene.

In 1610 Rubens bought a piece of land on the Wapper (now the Rubensstraat), near the canal and fashionable section of Antwerp (fig. 30). There he designed a magnificent Italianate studio, portico, and classical garden pavilion with statues of Ceres, Bacchus, and Hercules (fig. 62). The house was finally ready six years later: a Genoese suburban villa transplanted to the heart of

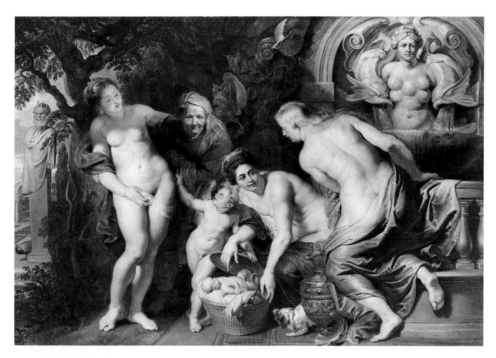

28. Peter Paul Rubens. *The Discovery of the Infant Erichthonius.* c. 1615. Oil on canvas, 85¾ × 124⅞″ (217.8 × 317.3 cm). The Collections of the Prince of Liechtenstein, Vaduz

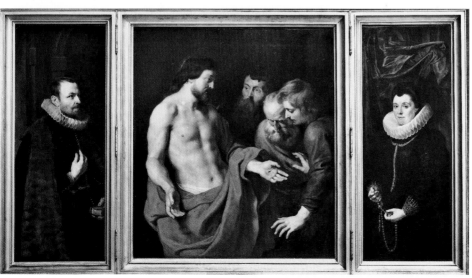

29. Peter Paul Rubens. *The Incredulity of St. Thomas.* 1614–15. Oil on panels, 56¼ × 48½″ central panel (143 × 123 cm); 57½ × 21¾″ each wing (146 × 55 cm). Koninklijk Museum voor Schone Kunsten, Antwerp

30. J. Harrewijn. *Rubens's House.* 1684. Engraving,
11⁹⁄₁₆ × 14″ platemark (29.4 × 35.7 cm). Reproduced by
courtesy of the Trustees of The British Museum, London

Antwerp. In 1611 his first child, Clara Serena, was born,
and his brother Philip died. Rubens became guardian of
Philip's two small children and memorialized his brother
in the *Four Philosophers* (plate 9). The same year, Rubens
won a competition—overtaking his former master Van
Veen—to paint an *Assumption of the Virgin* for the cathe-
dral's high altar. His preliminary *modelli* (fig. 31) sub-
mitted to the judges were accepted, but the altar (fig. 51
and plate 25) was not completed for another fifteen years,
by which time its design had undergone a series of
metamorphoses.

The decade from 1610 to 1620 witnessed an enor-
mous production of altarpieces: Assumptions, Adorations
of Shepherds and Magi, Lives of the Saints, Nativities,
Crucifixions, Last Judgments. Rubens had already be-
come the chief artistic advocate of Counter-Reformation
spirituality in the north. Yet his output of secular
pieces—mythologies (fig. 28 and plate 12), hunting
scenes (plate 17), portraits (plate 9), history (figs. 37 and
38), and allegory (fig. 34)—remained undiminished,
thanks to his studio of assistants, students, collaborators,
and highly skilled engravers, including Cornelis and
Philip Galle, Lucas Vorsterman, Boetius and Schelte à
Bolswert, and Paulus Pontius. Their prints guaranteed
the wide dissemination of Rubens's compositions
throughout Europe. Among the important foreign com-
missions he received was the *Large Last Judgment,* or-
dered in 1615 by Count Wolfgang-Wilhelm for the Jesuit
Church in Neuburg (fig. 32). A Baroque reinterpretation
of Michelangelo's Sistine Chapel fresco, Rubens's *Dies
Irae* is conceived as an oval of flesh, a crescendo of
corporal salvation and damnation. Executed in large part
by assistants, it offers a monumental example of Rubens's
harmonious coordination of studio hands. Already in 1611
Rubens wrote that he had to turn away "over one hun-
dred" prospective students and assistants—"even some of

my own relatives or my wife's and not without causing
great displeasure among many of my best friends."[16]

The new studio across the courtyard from the art-
ist's house was designed by Rubens himself in emulation
of the Genoese palaces he had admired so much a decade
earlier (figs. 18 and 30). The portico of arches and
banded Tuscan columns linking the studio to the main
house evoked Giulio Romano's Palazzo del Tè in Mantua.
Inscribed with verses by Juvenal (such as *"Mens sana in
corpore sano"*—a healthy mind in a healthy body) and
crowned with statues of Minerva (goddess of wisdom and
patron of arts and sciences) and Mercury (god of elo-
quence and patron of ambassadors and businessmen as
well as painters), it also spanned the sides of Rubens's
personality—scholar and artist, diplomat and en-
trepreneur. Lamenting Adam Elsheimer's recent death,
Rubens prayed God would "forgive Signor Adam his sin
of sloth, by which he has deprived the world of the most
beautiful things . . . whereas with his own hands he could
have built up a great fortune and made himself respected
by all the world."[17] Rubens would never succumb to
anything resembling sloth; nor did he perceive any inher-
ent conflict between the highest artistic pursuits and
worldly success.

On his visit to Rubens's studio in 1621, the Danish

31. Peter Paul Rubens. *The Assumption and Coronation of the
Virgin.* 1611. Oil sketch on panel, 41¾ × 30¾″ (106 × 78 cm).
Hermitage, Leningrad

physician Otto Sperling (then a medical student) recalled seeing "a large hall that had no windows but was lighted through an opening in the ceiling. In this hall were a number of young painters, all at work on different pictures for which Rubens had made the drawings in chalks indicating the tones here and there that Rubens would afterwards finish himself. The work would then pass for a Rubens."[18] Several of his outside collaborators were themselves distinguished painters, such as the landscape artist Jan Wildens and the animal specialists Paul de Vos and Frans Snyders, whose Olympian eagle gnaws eternally at Rubens's Prometheus (fig. 33). Closest to him personally—despite being nine years Rubens's senior—was the fellow Romanist and court painter Jan Brueghel, whose floral creations with Rubens (plate 13) mark the Baroque zenith of artistic collaboration. For Rubens, such collaboration was a matter of choice, not necessity. Rubens's eagle abducting Ganymede (plate 7) clearly required no intervention by Snyders. (He admitted Snyders's superiority only in depicting *dead* animals.) Rubens's *Four Continents* (fig. 34), an autograph assemblage of ample figures and wildlife, his Munich *Lion Hunt* (plate 17), the *Landscape with Carters* (plate 10), and his sketches from nature (fig. 35) reveal the master's proficiency in these areas of specialization. Rubens was his own most gifted studio hand.

Among his assistants was the young Anthony van Dyck. Twenty-two years younger than Rubens, Van Dyck was still an apprentice when he arrived at his studio, probably in 1616. He stayed until 1620, by which time he had assisted Rubens on his two most ambitious projects to date, his first tapestry cycle and a series of thirty-nine ceiling paintings. A true prodigy—if somewhat facile and self-conscious—Van Dyck quickly absorbed Rubens's style (fig. 36), as Rubens had Van Veen's, and faithfully imitated it when executing full-scale works under the master's supervision.

In 1616 Rubens received a commission from a group of Genoese merchants to design a tapestry cycle depicting the life of the legendary Roman consul Decius Mus. The story, taken from Livy's *History*, tells of Decius sacrificing his life to save Rome. Rubens divided the narrative into six episodes, beginning with Decius addressing his troops (fig. 37) and culminating in his death in battle (fig. 38)—a secular martyrdom that was followed by a stately Roman funeral. Rubens's choice of this obscure subject—never before illustrated on a monumental scale—reveals his profound interest in classical literature and antiquities. The composition of the *Adlocution* (fig. 37) is based on an imperial relief on the Arch of Constantine, here translated into painterly flesh and blood. For Rubens there was no conflict, no ultimate

separation, between the ideals of ancient Rome and the Christian faith of papal Rome, to which he adhered wholeheartedly. Rome remained Rome; history was a continuum of tradition and revelation.

For each scene Rubens painted a *modello* (fig. 37) rendered as a mirror image of the intended tapestry, owing to the design's reversal in the weaving process. His assistants then enlarged the *modello* into a full-scale cartoon (fig. 38) to which Rubens added final touches before

32. Peter Paul Rubens. *The Large Last Judgment.* 1615–16. Oil on canvas, 240 × 181 1/16" (610 × 460 cm). Alte Pinakothek, Munich

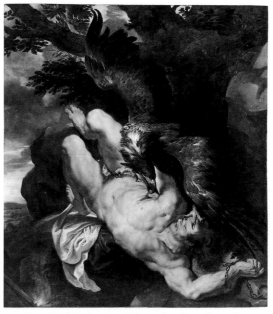

33. Peter Paul Rubens and Frans Snyders. *Prometheus Bound.* 1611–14. Oil on canvas, 95 5/8 × 82 1/8" (242.9 × 208.6 cm). Philadelphia Museum of Art. W.P. Wilstach Collection

23

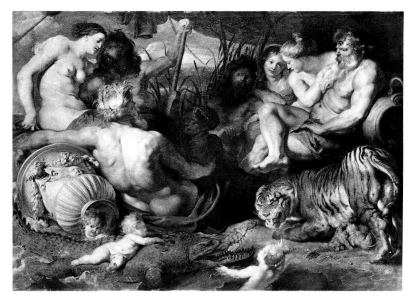

34. Peter Paul Rubens. *The Four Continents.* c. 1615. Oil on canvas, 82¼ × 112″ (209 × 284 cm). Kunsthistorisches Museum, Vienna

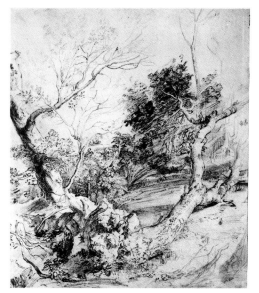

35. Peter Paul Rubens. *Landscape with a Fallen Tree.* c.1616. Chalk and pen and ink on paper, 22⅞ × 19¼″ (58.2 × 48.9 cm). The Louvre, Paris

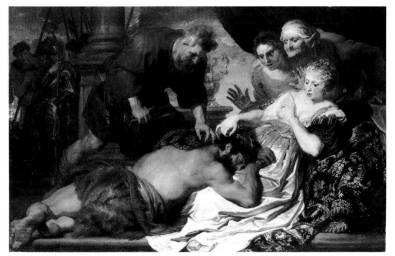

36. Anthony van Dyck. *Samson and Delilah.* 1618–20. Oil on canvas, 59⅝ × 90¾″ (151.4 × 230.5 cm). Reproduced by permission of the Governors of Dulwich Picture Gallery, London

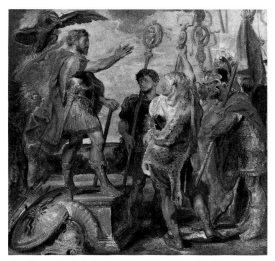

37. Peter Paul Rubens. *The Adlocution: Decius Mus Addressing the Legions.* 1617. Oil sketch on panel, 31¾ × 33¼″ (80.7 × 84.5 cm). National Gallery of Art, Washington, D.C. Samuel H. Kress Collection

sending it off to the weavers. (According to the seventeenth-century biographer Giovanni Pietro Bellori, it was Van Dyck who executed the Decius cartoons.[19]) The *Death of Decius* (fig. 38), a tour de force of charging soldiers and horses, compares favorably with such autograph masterpieces as his *Lion Hunt* (plate 17) and *Battle of the Amazons* (plate 11). The unusual medium of oil on canvas for these cartoons (instead of tempera on paper) reveals the artist's intention that they be preserved as finished paintings—despite their compositional reversals, or "left-handedness"—once their preparatory function for the tapestries had been served.

At this moment Rubens himself was dealing with questions of studio collaboration, originality, and relative worth in his extended negotiations with the English ambassador to The Hague, Sir Dudley Carleton. The Englishman had approached Rubens through an intermediary, offering him a diamond necklace in exchange for one of his paintings. Rubens flatly refused, his price for a picture being as firm "as the laws of the Medes and Persians," according to Carleton's daunted agent. As the deal progressed, Rubens sought to exchange a large group of his paintings for Carleton's "rare collection of antiquities" to augment the ancient statues, reliefs, busts, coins, and gems he had brought back from Italy and for which he had recently designed a semidomed gallery—a miniature Pantheon—in his new house. Rubens was an astute salesman: "Your Excellency may be assured that I shall put prices on my pictures, just as if I were negotiating to sell them for cash. . . . I find that at present I have

in the house the flower of my stock, particularly some pictures which I have kept for my own enjoyment; some I have even repurchased for more than I had sold them to others. . . . But the whole shall be at the service of Your Excellency, because I like brief negotiations where each party gives and receives his share at once. To tell the truth, I am so burdened with commissions, both public and private, that for some years to come I cannot commit myself." He drew up a list of pictures in which he scrupulously distinguished among works of true collaboration ("A Prometheus bound on Mount Caucasus . . . original, by my hand, and the eagle done by Snyders [fig. 33]"), wholly autograph works ("original by my hand"), one executed by Van Dyck but finished by Rubens, a studio series after his designs, and so on.[20]

Carleton wanted only the "originals." Rubens stated that he was "perfectly satisfied," but then pointedly added: "Yet Your Excellency must not think that the others are mere copies, for they are so well retouched by my hand that they are hardly to be distinguished from originals. Nevertheless, they are rated at a much lower price." Rubens persisted in his desire to pay with pictures, not cash: "The reason I would deal more willingly in pictures is clear: although they do not exceed their just price in the list, yet they cost me, so to speak, nothing. . . . I am not a prince, but one who lives by the work of his hands." When Carleton sought to acquire tapestries as part of the exchange, Rubens offered to send the dimensions of his Decius cycle, currently being woven in Brussels, with a telling observation of relative values: "One evaluates pictures differently from tapestries. The latter are purchased by measure, while the former are valued according to their excellence, the subject, and number of figures." At the conclusion of the negotiations Rubens announced, "In short, in exchange for marbles to furnish one room, Your Excellency receives pictures to

adorn an entire palace, in addition to the tapestries." (In fact, Carleton's antiquities would have furnished a small *museum*.) Virtually overnight, Rubens became a preeminent collector. His bravura in business was as sure as his brushwork.

Rubens's interest in sculpture was not limited to collecting—or copying. Although he never wielded a chisel (so far as we know), a catalogue of sculptures designed by him, modeled solely by his pen and brush, would describe an impressive exhibit of Flemish Baroque sculpture. The seventeenth-century biographer Filippo Baldinucci credited Bernini as being "the first to unite painting, sculpture, and architecture in such a way that together they form a pleasing whole."[21] The claim might in fact be made for Rubens in view of his multiple contributions—in all three media—to the new Jesuit Church in Antwerp. The church's foundation was dedicated in 1615, and over the next six years Rubens was to participate in every important aspect of its design and adornment. The Jesuits were in the vanguard of the Counter-Reformation, and their close papal ties warranted a building that consciously evoked the splendor of the new Baroque churches in Rome, especially their mother church, the Gesù. Having completed the Italianate additions to his own house, Rubens now turned to the most ambitious ecclesiastical commission north of the Alps.

Angels blowing trumpets signal the triumphal message over the main portal (fig. 39), above which a host of animated putti carry the Jesuit's insignium (fig. 40), a dynamic motif recalling Rubens's high altar of the Chiesa Nuova (fig. 19). The faithful but sober translation of Rubens's preparatory drawings into stone was wrought probably by the De Nole family of Flemish sculptors, collaborators of Rubens's who captured the form but not the intoxicating spirit of his draftsmanship. Rubens's

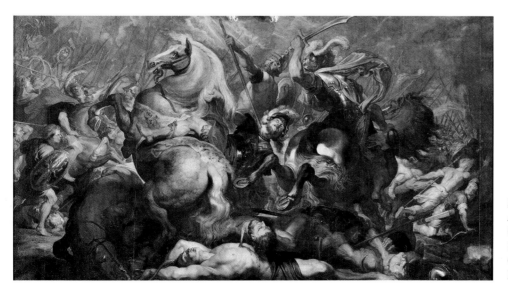

38. Peter Paul Rubens. *The Death of Decius Mus.* 1617. Oil on canvas, 114⅛ × 183⅛" (290 × 465 cm). The Collections of the Prince of Liechtenstein, Vaduz

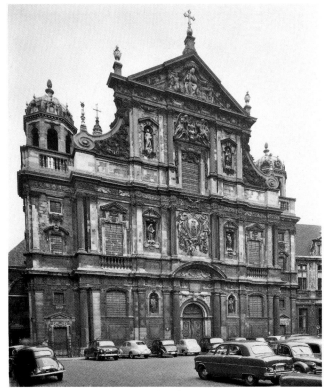

39. *Façade of Antwerp's Jesuit Church.* 1617–21

40. Peter Paul Rubens. *Cartouche Carried by Angels.* 1617–20. Chalk and pen or brush and ink and wash on paper, 14⅝ × 11⅝″ (37 × 29.5 cm). Reproduced by courtesy of the Trustees of the British Museum, London

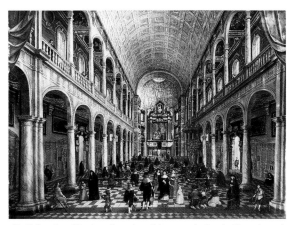

41. Sebastian Vrancx. *Interior of Antwerp's Jesuit Church.* n.d. Oil on panel, 20½ × 28″ (52 × 71 cm). Kunsthistorisches Museum, Vienna

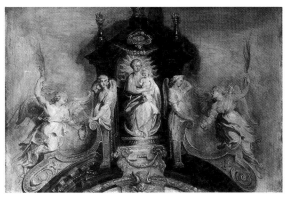

42. Peter Paul Rubens. *Design for Crowning Section of Jesuit Church High Altar.* 1617–18. Oil sketch on panel, 17⅜ × 25⅛″ (44.1 × 63.8 cm). Rubenshuis, Antwerp

designs for the high altar (figs. 41 and 42), the focal point and sculptural finale of the basilica, bear out his claim, apropos of an earlier altarpiece, that he had "put considerable effort into drawing up the plan of the entire work, as much for the marble ornamentation as for the picture."[22]

Crowning the altar, in the heavenly zone of alabaster and light, Rubens's statue of Virgin and Child in a niche (fig. 42) enshrines the Jesuits' dual patrons, Mary and her Son, while two flanking angels reclining on pediments proffer palms and laurel wreaths on behalf of the Jesuit candidates for sainthood, Ignatius of Loyola and Francis Xavier (who were finally canonized in 1622). The saints are the subjects of Rubens's two propagandistic and liturgically interchangeable altarpieces (figs. 43 and 44) painted between 1616 and 1618. Both paintings illustrate miracle workers of the highest order: the Jesuits' founder, Ignatius, standing before an altar in St. Peter's, Rome, casts out demons; Francis Xavier, the missionary to India, China, and Japan, is placed before an operatic fantasy of an oriental temple as he summons divine intervention to destroy pagan idols. As holy mediator, Francis Xavier heals the lame, cures the blind, and even raises the dead: the prostrate male at the lower left is a recapitulation of the Lazarus figure rising from the grave in the *Large Last Judgment* (fig. 32)—an example of Rubens's characteristic reuse of visual motifs with consistent meanings.

Despite the absence of clear documentation, it

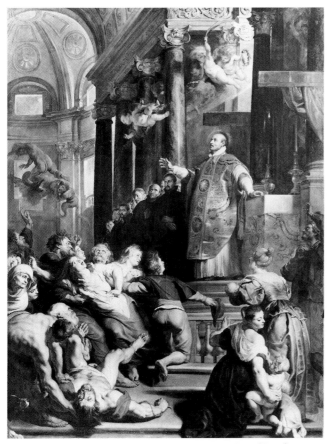

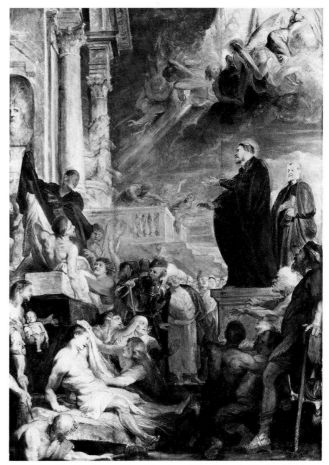

43. Peter Paul Rubens. *The Miracles of St. Ignatius of Loyola.*
1617–18. Oil on canvas, 210½ × 155½″ (535 × 395 cm).
Kunsthistorisches Museum, Vienna

44. Peter Paul Rubens. *The Miracles of St. Francis Xavier.* 1617.
Oil sketch on panel, 41⅛ × 28½″ (104.5 × 72.5). Kunsthistorisches
Museum, Vienna

seems likely that Rubens played a key role in the architec-
tural design as well. The high altar was covered by a
coffered semidome and dramatically illuminated by an
oculus, recalling Rubens's recently completed sculpture
rotunda at his home. Equally telling are the ornate towers
flanking the façade (fig. 39), which derived from Sta.
Maria di Carignano in Genoa, whose plan Rubens was
soon to publish in his *Palazzi di Genova* (1622). His
drawing of the vault of the Lady Chapel, adorned with
emblematic relief sculpture, reveals the scope of his deco-
rative contributions to the architecture of the church.

In March 1620 Rubens contracted to furnish the
aisles and galleries with a series of thirty-nine ceiling
paintings (fig. 41), for which he undertook to paint the
preparatory oil sketches himself. The full-scale canvases
were to be executed by Van Dyck (the only other artist
mentioned by name in the document) and other as-
sistants. The ceiling paintings—the first northern revival
of the Venetian soffitti of Titian, Tintoretto, and Vero-
nese—perished by fire in the eighteenth century. But
fortunately most of Rubens's autograph *modelli* are pre-
served (plates 15 and 16). They offer revealing glimpses
into his creative genius and extraordinary verve—what
Bellori called *"la gran prontezza e la furia del pennello,"*[23]

or the great speed and frenzy of his brush. In accordance
with the terms of the contract, the thirty-nine pictures
were finished by January 1621.

The day after the dedication of the Jesuit Church in
September 1621 Rubens wrote to William Trumbull, an
agent of James I of England and his son Charles, prince of
Wales: "I confess that I am, by natural instinct, better
fitted to execute very large works than small curiosities.
Everyone according to his gifts; my talent is such that no
undertaking, however vast in size or diversified in sub-
ject, has ever surpassed my courage."[24] Brave words.
Having tasted success in the Jesuit "Marble Temple,"
Rubens was already lobbying for the commission to
decorate Inigo Jones's recently designed Banqueting
House for Whitehall Palace in London. He would have to
wait a decade for the commission to materialize. In the
meantime, new decorative cycles were to validate his
prophetic boast.

From 1615 to 1620 there was a gradual but notice-
able shift in Rubens's style—from the sculptural, pol-
ished forms of the *Descent from the Cross* (plate 8) and the
Large Last Judgment (fig. 32) toward a broader, more
painterly expression already discernible in the *Rape of the
Daughters of Leucippus* (plate 12) and the *Battle of the*

Amazons (plate 11). In these two dynamic configurations of flesh and drapery, the inherent tension of a composition seemingly about to burst its geometric construction is heightened by animated brushwork and vibrant colors. By the close of the decade the Michelangelesque Christ of the *Incredulity of St. Thomas* (fig. 29) had been modulated into the more sensuous lyrical figures of *Christ and the Penitent Sinners* (plate 14). The two great Antwerp triptychs (fig. 25 and plate 8) may be similarly compared with Rubens's consummate interpretation of the Passion, commissioned by Nicolaas Rockox for the high altar of the Church of the Recollects: the so-called *Coup de Lance* (fig. 45), in which Rubens described with extraordinary drama and pathos the moment immediately following Christ's death. Crucified between two thieves, Rubens's Savior is an icon of triumphant suffering. The Roman soldier Longinus pierces His side with a lance—and is instantly converted. The Virgin and St. John stand at the foot of the cross as the heavens are rent and the sun is eclipsed. This poignant *Stabat Mater,* an oratorio in paint, heralds Rubens's full-blown High Baroque style of the 1620s, the decade of his vast decorative cycles and international commissions.

In March 1621 King Philip III of Spain died and was succeeded by his son, Philip IV. In April the Twelve Years' Truce expired. Albert and Isabella had diligently sought to negotiate an extension, but the stringent terms cynically proposed by their superiors in Madrid proved unacceptable to the Dutch, and open hostilities resumed. King Philip and his ministers were in fact eager to return to the battlefield to quash the Dutch rebels, and they sent the brilliant Italian general Ambrogio Spinola to lead the Spanish forces. The archdukes, meanwhile, still hoped to achieve a diplomatic settlement, but in July Albert died. Since he and Isabella had produced no heirs the Netherlands irrevocably reverted to the Spanish crown. Albert's widow was now demoted from regent to governor, serving on behalf of her nephew, the young Philip IV, and his prime minister, Count Olivares, who ruled him as completely as the duke of Lerma had his father. About this time—we do not know precisely when—Rubens was engaged by the infanta as her confidential agent in the clandestine and thoroughly Byzantine diplomatic maneuvers in search of peace between the two Netherlands. Rubens's widespread fame as "the painter of princes and prince of painters" permitted him to travel freely among royal courts while minimizing speculation as to ulterior motives for his meetings with sovereigns and their ministers, who were included among his most avid patrons and who frequently discussed matters of state while sitting for their portraits.[25]

In January 1622 Rubens was called to Paris by the dowager queen of France, Maria de' Medici, to draw up plans for the decoration of the two main galleries in her new Luxembourg Palace designed by Salomon de Brosse. The queen mother, widow of Henry IV, had recently been reconciled—tenuously—with her son, the young King Louis XIII. Having returned to Paris from exile, she sought to promote, through Rubens's persuasive brush, herself, her former regency of France, and her late husband's triumphs—in that order. A true Medici by birth, Maria was a devoted lover of art and its powers of aggrandizement. She was also on friendly terms with the Infanta Isabella, who may have been instrumental in securing this prestigious commission for her court painter. There can be little doubt that even at this early date the artist's visit involved deeper political and diplomatic motives, a suspicion that was not to escape Cardinal Richelieu, who by now virtually ruled both the French king and his kingdom.

While in Paris, Rubens met Nicolas-Claude Fabri de Peiresc, the distinguished antiquarian from Provence who was to be his long-distance friend and correspondent. Rubens's letters to Peiresc provide extraordinarily vivid glimpses of the artist as scholar and as diplomat. They discussed regularly and in fascinating detail subjects ranging from ancient cameos, coins, and architec-

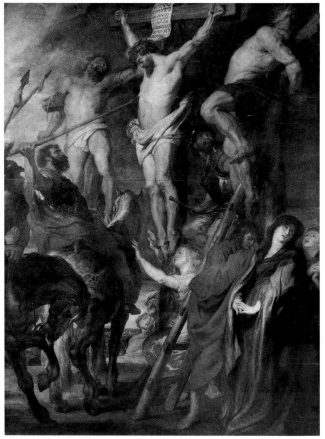

45. Peter Paul Rubens. *Le Coup de Lance.* 1620. Oil on panel, 168½ × 123″ (427 × 312 cm). Koninklijk Museum voor Schone Kunsten, Antwerp

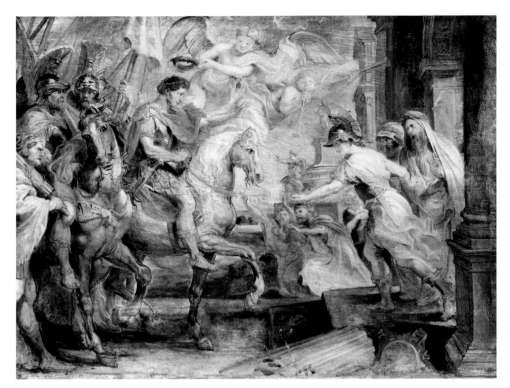

46. Peter Paul Rubens. *The Triumphal Entry of Constantine into Rome.* 1622. Oil on panel, 19 × 25½″ (48.3 × 63.5 cm). Indianapolis Museum of Art. The Clowes Fund Collection

ture to scientific matters (including a new design for a perpetual-motion machine) to the current political kaleidoscope of diplomacy, intrigue, and military maneuvers. Peiresc may have been responsible for initiating Rubens's second tapestry commission, the Constantine cycle (fig. 46 and plate 18).

Surviving documents suggest that the Constantine tapestries were designed "on speculation," a joint venture between Rubens and the Parisian weavers and a new departure for the Flemish impresario.[26] Evidently the tapestry manufacturers had hoped from the start to sell the series to Louis XIII. The story of the first Christian emperor provided a fitting—and flattering—theme to adorn the young king's palace walls at the very time Rubens was planning a propagandistic cycle for the queen mother. In the end, the royal rivalry may explain the fact that, for all its magnificence, the incomplete Constantine cycle was given away by the king soon after it was eclipsed by his mother's Medici cycle. In 1625 King Louis presented the seven woven panels to the papal legate, Cardinal Francesco Barberini, who took them back to Rome, where the series was eventually finished by Pietro da Cortona and woven on the Barberini looms.

As a large narrative cycle of paintings devoted to a historical ruler—in this case, a living though diminished heroine—Rubens's Medici cycle (figs. 47 and 48 and plate 20) represents an outgrowth of his two preceding tapestry series. The biographical subject was again treated in epic fashion, although Maria's admittedly melodramatic and often embarrassing life required an unprecedented dose of poetic license and allegory—a

panoramic display of Rubens's fertile powers of invention. Comprising twenty-four scenes (twice as many as in the Constantine series), the cycle was prepared by two sets of autograph oil sketches and was further clarified by detailed figure drawings before being enlarged by assistants into the definitive canvases. These were then thoroughly retouched by the master himself so as to become, on the final surface, autograph works. The queen mother's adviser, the Abbé de Saint-Ambroise, who collaborated on the diplomatically sensitive program, commented that "two Italian painters would not carry out in ten years what Rubens will do in four." (In fact, he took only three.[27])

Rubens exploited his encyclopedic knowledge of classical mythology, emblems, and allegory to raise Maria's thwarted career to the stage of grand opera, to a mythic plane on which mortals mingle freely—and often casually—with the Olympian gods (plate 20). Only one scene is, strictly speaking, a factual rendition: the *Marriage by Proxy* (fig. 47), an event that the artist himself had attended in Florence in the company of Vincenzo Gonzaga. The final episode of the cycle reveals Time uplifting Truth (fig. 48). Seated above Father Time and his ample daughter, Queen Maria and her son Louis are joined in a touching emblem of concord. But naked Truth was not the prevailing principle in this cycle. During the installation of the pictures in 1625, Rubens wrote to Peiresc that "the Queen Mother is very well satisfied with my work. . . . The King also . . . showed complete satisfaction with our pictures, from the reports of all who were present, particularly M. de Saint-Am-

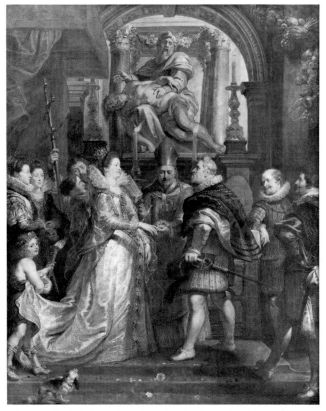

47. Peter Paul Rubens. *The Marriage by Proxy.* 1622–23. Oil on canvas, 155¹⁄₁₆ × 116⅛″ (394 × 295 cm). The Louvre, Paris

48. Peter Paul Rubens. *Time Uplifting Truth.* 1623–25. Oil on canvas, 155¹⁄₁₆ × 63″ (394 × 160 cm). The Louvre, Paris

broise. He [the abbé] served as interpreter of the subjects, changing or concealing the true meaning with great skill."[28]

Referring to his plans for the second gallery devoted to the life of Henry IV, Rubens added: "For the future I believe there will not fail to be difficulties over the subjects of the other gallery, which ought to be easy and free from scruples. The theme is so vast and so magnificent that it would suffice for ten galleries. But Monsieur the Cardinal de Richelieu, although I have given him a concise program in writing, is so occupied with the government of the state that he has not had time to look at it even once." Although initially supportive of the queen mother, Richelieu was by now in the enemy camp; he recognized in Rubens a potential diplomatic adversary. Already in 1625 Rubens sensed these shifting winds, concluding to Peiresc that "in short, I am tired of this court, and unless they give me prompt satisfaction, comparable to the punctuality I have shown in the service of the queen mother, it may be (this is said in confidence *entre nous*) that I will not readily return."

Two days before penning these words, Rubens had attended the marriage by proxy of King Louis's sister, Henrietta Maria, to Charles I of England, whom Rubens had described as "the greatest amateur of paintings among the princes of the world." He later sent Charles his *Self-Portrait* (frontispiece), since the king had requested it "with such insistence that I found it impossible to refuse him."[29] In Paris, Rubens met George Villiers, duke of Buckingham (fig. 49), who had been sent to escort Henrietta Maria back to London. A vainglorious and headstrong man, Buckingham was to precipitate a sad series of political and military disasters. Like his sovereign, however, he was a first-rate connoisseur, and he wasted no time in persuading Rubens to paint his portrait (plate 23)—the High Baroque fulfillment of the early equestrian portrait of Lerma (fig. 13). Its heroic bravado and flair reflect little of Rubens's private view of the sitter: "When I consider the caprice and arrogance of Buckingham," Rubens later confided, "I pity that young king who, through false counsel, is needlessly throwing himself and his kingdom into such an extremity. For anyone can start a war when he wishes, but he cannot so easily end it."[30]

On the eve of his departure for Paris to install the Medici cycle, Rubens complained that he was "the busiest and most harassed man in the world."[31] The Constantine tapestries and Medici cycle accounted for the majority of his artistic production from 1622 to 1625; yet during these years he continued to accept important commissions from churches and private patrons. His climactic *Adoration of the Magi* (plate 21) was installed in 1624 at

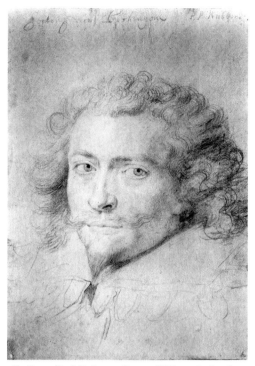

49. Peter Paul Rubens. *George Villiers, Duke of Buckingham.* 1625. Chalk on paper, 15⅛ × 10½″ (38.3 × 26.6 cm). Albertina, Vienna

50. Hans van Mildert. *St. Michael Defeating Satan.* 1624. Alabaster. Church of Saint Trudo, Groot Zundert (Netherlands)

of portraiture and landscape. The 1620s gave rise to masterly portraits of his physician and friend Ludovicus Nonnius (plate 28), his future sister-in-law Susanna Fourment (plate 19), and the double portrait of his sons Albert and Nicolaas (plate 22) following the death of their elder sister in 1623. His development as portraitist was paralleled by an expansive, narrative approach to landscape. The *Landscape with Philemon and Baucis* (plate 24) presents a cataclysmic view of nature; only the faint beginnings of a rainbow at the far left suggest abatement and the restoration of benign order.

In the summer of 1625 the first sign of a rainbow appeared over the Spanish Netherlands. After a long siege, the city of Breda finally fell in June to the forces of General Spinola, whose portrait in shining ceremonial armor (fig. 52) Rubens painted soon thereafter. The Dutch defeat at Breda was viewed at the time as a major turning point in the war, and the Infanta Isabella journeyed there in person to view the surrender. On her return, she visited Rubens's studio and sat for her state portrait (fig. 53) dressed in the Franciscan robes of the Poor Clares, which she had donned at the death of her husband as a sign of perpetual mourning. It was probably during this sitting that the infanta discussed with Rubens her grandest commission for him, the tapestry cycle

51. Adriaen Lommelin. *High Altar of the Cathedral of Our Lady.* n.d. Engraving, 18½ × 116⅛″ (47 × 295 cm). Bibliothèque Royale Albert Ier, Brussels

the high altar of the Abbey of St. Michael in Antwerp, crowned by freestanding sculptures of St. Michael (fig. 50), St. Norbert, and a Madonna and Child designed by Rubens and carved in alabaster by Hans van Mildert. For the high altar of Antwerp's cathedral he designed a marble portico (fig. 51), which was set in place in 1624 to frame his definitive *Assumption of the Virgin* (plate 25), originally commissioned in 1611 and finally completed in situ in 1627. Nor did Rubens neglect smaller-scale works

52. Peter Paul Rubens. *Ambrogio Spinola*. 1625–27. Oil on panel, 46⅟₁₆ × 33½" (117 × 85 cm). National Gallery, Prague

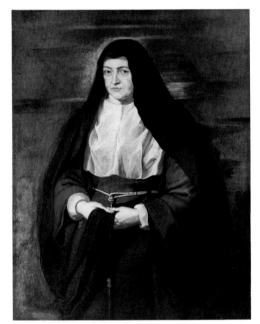

53. Peter Paul Rubens. *Infanta Isabella Clara Eugenia*. 1625. Oil on panel, 54½ × 34⅞" (138.4 × 88.6 cm). Norton Simon Art Foundation, Pasadena

known as the Triumph of the Eucharist (figs. 54 and 55 and plates 26 and 27).

Constituting more than twenty separate hangings, the Eucharist cycle represents not only Rubens's largest tapestry series but also his most elaborate and complex program of liturgical art. The tapestries were intended as a gift—probably as a thanksgiving for Breda—to the royal convent of the Descalzas Reales in Madrid, an order in which Isabella had spent part of her childhood and

whose habit she now wore. Rubens's religious epic contained Old Testament prefigurations of the Sacrament, allegorical victories and triumphs of the Eucharist (fig. 54 and plates 26 and 27), a procession of heralds and defenders, and finally a visionary apotheosis above the high altar (fig. 55). In previous tapestry series, Rubens had designed only the figural scenes, leaving the elaboration of the decorative borders to the workshops. Here he applied to the whole cycle a two-tiered architectural framework within which he depicted illusionistic tapestries—in other words, *tapestries within tapestries,* an unprecedented display of Baroque illusionism. In view of the several preparatory stages of design (including *bozzetti, modelli,* cartoons), as well as the enormous expense of the weavings, which were parceled out to several Brussels workshops, the cycle of allegory and propaganda may be seen as the sacred equivalent of the Medici cycle and as Rubens's most ambitious, thoroughly Baroque testament to his Catholic faith.[32]

In August 1625 Rubens moved his family to an inn at Laeken, just outside of Brussels, in order to escape the outbreak of plague in Antwerp. There he worked on designing the tapestries and intermittently undertook several diplomatic assignments for the infanta. Hopes for a negotiated peace in the Netherlands following the death of Prince Maurice of Nassau, leader of the Dutch forces, the succession of his son Frederick Henry, and the subsequent Spanish victory at Breda had dissolved. A virtual stalemate ensued. Buckingham, meanwhile, pursued his anti-Spanish policies. His abortive naval attack on the port of Cádiz convinced Rubens that the foolhardy duke was "heading for the precipice." In June 1626 Rubens's domestic life was suddenly rent by the death of his wife, Isabella, whose frail visage he had sketched a few years earlier (fig. 56). A month after her death, he confided: "Truly I have lost an excellent companion, whom one could love—indeed had to love, with good reason—as having none of the faults of her sex. She had no capricious moods and no feminine weakness, but was all goodness and honesty. . . . Such a loss seems to me worthy of deep feeling, and since the true remedy for all ills is Forgetfulness, daughter of Time, I must without doubt look to her for help. But I find it very hard to separate grief for this loss from the memory of a person whom I must love and cherish as long as I live. I think a journey would be advisable to take me away from the many things which necessarily renew my sorrow."[33] With a heavy heart, Rubens embarked on a diplomatic odyssey.

Buckingham had visited Rubens in 1625 on his way to The Hague to align England in an aggressive pact with Denmark and the Dutch republic. He sought from the artist more than his promised equestrian portrait (plate

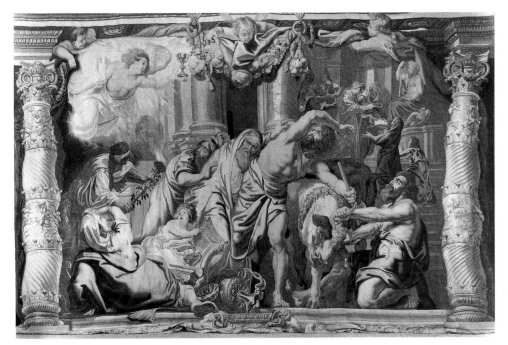

23). The duke coveted Rubens's entire collection of antiquities, the majority of which had been acquired from his fellow countryman Sir Dudley Carleton only seven years before. Buckingham's offer—100,000 florins—was too good to refuse, even considering the fact that in the end Rubens had to include thirteen of his own pictures within the total collection of paintings, sculptures, coins, cameos, and jewels. (He did, however, keep from the sale "some of the rarest gems and most exquisite medals," as he later confessed to Peiresc.) The lengthy negotiations were conducted by the duke's agent and master-of-the-horse, Balthasar Gerbier, with whom Rubens corre-

sponded frequently. They arranged to meet in the Dutch city of Delft—in "enemy territory" (for Rubens)—in July 1627. The proposed sale disguised the real purpose of their meetings: to seek a diplomatic formula for peace among England, Spain, and the Dutch republic. Gerbier was by birth a Fleming and by training an artist—a mediocre portraitist. He represented the very antithesis of Rubens, his diplomatic counterpart. He was duplicitous, scheming, and temperamentally disloyal. Yet Gerbier's, like Buckingham's, genuine love of art helped him quickly establish a personal bond with Rubens. Initially, Philip IV was aghast that such delicate diplomacy be entrusted to Rubens, a mere *painter,* and he reproved his aunt Isabella accordingly: it would gravely compromise the dignity of the kingdom and the king's prestige would "necessarily suffer if a man of so little importance must be approached by ambassadors,"[34] Olivares explained. Yet the infanta prevailed, and Rubens persevered, fully aware of the Spanish intransigence that had heretofore precluded a peaceful settlement in the Netherlands. "If Spanish pride could be made to listen to reason," he wrote in May 1627, "a way might be found to restore Europe (which seems all in chains together) to a better temperament. Secret negotiations with the Hollanders are still maintained here, but you may be sure that Spain has not given orders to deal with them in any way, in spite of the fact that our princess and the Marquis Spinola are very much in favor of it, both for the public welfare (which is dependent upon peace) and for their own peace of mind." Rubens despaired for Antwerp: "We find ourselves rather without peace than at war; or, to put it better, we have the inconvenience of war without the advantage of peace. This city, at least, languishes like a

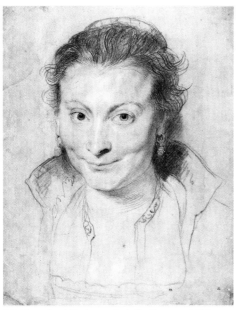

56. Peter Paul Rubens. *Isabella Brant*. c.1622.
Chalk, wash, and pen and ink on paper, 15 × 11⅝″
(38.1 × 29.5 cm). Reproduced by courtesy of the
Trustees of the British Museum, London

consumptive body, declining little by little. Every day
sees a decrease in the number of inhabitants, for these
unhappy people have no means of supporting themselves
either by industrial skill or by trade. One must hope for
some remedy for these ills."[35] His descriptive powers
were not limited to his brush.

In July Rubens met Gerbier in Delft and spent a
week touring different towns, "looking at pictures." To be
sure, he took time off from diplomacy to meet several
leading Dutch painters—Abraham Bloemaert, Hendrik
Terbrugghen, Cornelis Poelenburgh, and Gerard
Honthorst—accompanied by the young German painter
and historian Joachim von Sandrart, who recorded this
memorable visit in his biography of Rubens published in
1675.[36] Rubens's diplomatic progress was soon dealt a
severe blow by the news that a secret treaty had been
signed several months earlier between France and Spain
calling for a joint invasion of England. The treaty was
sheer folly, a combination of Olivares's innate aggressive-
ness and Richelieu's cynical attempts to drive a wedge
between England and Spain. Yet, despite the appearance
of double-dealing, no one on the English side accused
Rubens of acting in bad faith. Paradoxically, Buck-
ingham's embarrassing naval defeat by Richelieu at La
Rochelle in November 1627 finally set the stage for serious
peace negotiations between England and Spain. In Au-
gust 1628 Rubens left for Madrid, ostensibly to paint a
portrait of King Philip—but deceiving few about the real
purpose of the trip.

Shortly before Rubens departed he saw unveiled at
the high altar of Antwerp's Augustinian Church his tow-

ering *Virgin and Child Enthroned with Saints* (fig. 57),
completed in June 1628. This colorful chorus represents
the culmination of two decades of altarpieces—a *sacra
conversazione* that ultimately harks back to Rubens's first
altarpiece for the Chiesa Nuova (plate 4). The surging
sweep of saints, beginning at the lower right and rising,
spirallike, around the raised pedestal of the Virgin, cre-
ates an initial impression of spontaneity. Rubens was
renowned for his rapid powers of execution. But the
extensive preparatory studies that have survived—no
fewer than four oil sketches and several pen-and-ink
drawings—dispel any notion of *fa presto* design. In trans-
lating inspiration into composition Rubens was a
Beethoven, not a Mozart: his thematic ideas were care-
fully developed through a series of experimental sketches
prior to their virtuosic arrangement in the definitive
version. The bright, shimmering palette of this altarpiece
reflects Rubens's already mature mastery of Titianesque
color on the eve of his reacquaintance with Titian's origi-
nals in Madrid.

Spinola had preceded Rubens to Spain, and for
several months the general attempted—in vain, as it
turned out—to persuade the king and his council (above
all, Olivares) to abandon their uncompromising hostility

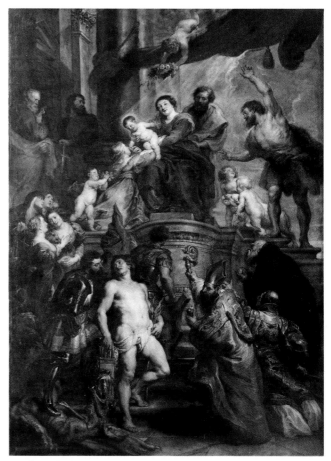

57. Peter Paul Rubens. *Virgin and Child Enthroned with Saints*.
1627–28. Oil on canvas, 221½ × 157½″ (562 × 402.5 cm). Church
of Saint Augustine, Antwerp

toward the Dutch and to negotiate an armistice as a first step toward peace. Rubens harbored no illusions: "I believe the Spaniards think they can treat this sagacious man as they are in the habit of treating all those who go to that court for any business: all are dismissed with empty promises and kept in suspense by vain hopes that are finally frustrated without having settled anything."[37] A month later Rubens was to join Spinola at that court of empty promises.

By the time Rubens arrived in mid-September 1628, Buckingham had been assassinated by a Puritan fanatic in Portsmouth. Rubens was crestfallen: the hoped-for peace talks with England appeared in jeopardy. Indeed there was to be no encouraging word from England for several months. Rubens returned to his art. He wrote to Peiresc: "Here I keep to painting, as I do everywhere, and already I have done the equestrian portrait of His Majesty, to his great pleasure and satisfaction. He really takes an extreme delight in painting, and in my opinion this prince is endowed with excellent qualities. I know him already by personal contact, for since I have rooms in the palace, he comes to see me almost every day."[38]

Rubens took full advantage of the royal gallery of paintings, especially the extensive collection of Titian's art, which he had not seen since his first visit as a young courtier in the service of Gonzaga twenty-five years before. He proceeded to paint copies after Titian, to whose style he was now completely attuned. Rubens explored and thoroughly absorbed the great Venetian's brushwork and luminous modeling, studying such masterpieces as *Venus and Adonis* (fig. 58), *Rape of Europa*, and *Adam and Eve*. These works, copied as always with subtle variations and sensitive editing by Rubens, were to serve as the fount of inspiration throughout the last decade of his life (plates 35 and 40).[39] Looking over his shoulder was Philip IV's young court painter, Diego Velázquez, not yet thirty years old. According to Velázquez's father-in-law, Francisco Pacheco, Rubens "spent little time with our painters, and the only friendship he formed was with my son-in-law, with whom he had corresponded before."[40] Evidently Rubens's view of Spanish painters had not altered over the years. In a matter of months Velázquez was to embark on his first artistic pilgrimage to Italy, surely at Rubens's urging and perhaps as a result of his intercession with the king. We have no record of Rubens's advice to the young painter, but in matters of art the master doubtless preached what he had so fruitfully practiced.

Rubens himself hoped to "make a tour of Italy" on his return home, but the voyage was precluded by the news in April 1629 that England was ready to negotiate

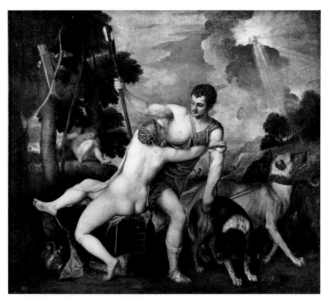

58. Titian. *Venus and Adonis*. 1554. Oil on canvas, 73¼ × 81½" (186 × 207 cm). Prado, Madrid

peace with Spain and was calling for an exchange of ambassadors. Philip IV gave Rubens the title "Secretary of the King's Privy Council of the Netherlands," along with a diamond ring, in order to elevate the standing of his painter-envoy at the foreign court: in the eyes of his Spanish masters, Rubens was never to eradicate the stigma attached to one who "lived by the work of his hands." Rubens traveled north in haste, but he managed an overnight stay in Paris, where he revisited Maria de' Medici—and his Medici cycle. In Brussels he stopped briefly to confer with the infanta and there received news of a recently concluded peace treaty between England and France, which gave the new envoy a greater sense of urgency and steeper diplomatic hurdles to clear. Four years earlier, anticipating a trip to England, Rubens had declared that "in public affairs I am the most dispassionate man in the world, except where my property and person are concerned. I mean that, all other things being equal, I regard the whole world as my country, and I believe that I should be very welcome everywhere."[41] Accompanied by his brother-in-law Hendrik Brant, Rubens now set out to justify that claim. They boarded an English ship at Dunkirk on June 3, 1629. Attached to his passport Rubens carried an auspicious commendation from King Charles's secretary Sir Francis Cottington: "The king is well satisfied, not only because of Rubens's mission, but because he wishes to know a person of such merit."[42]

Despite the king's apparent—and quite sincere—desire for peace with Spain, Rubens soon discovered the baroque maze of court factions and foreign intrigues through which he had to feel his way. In an early dispatch to Olivares he candidly described his situation: "I am

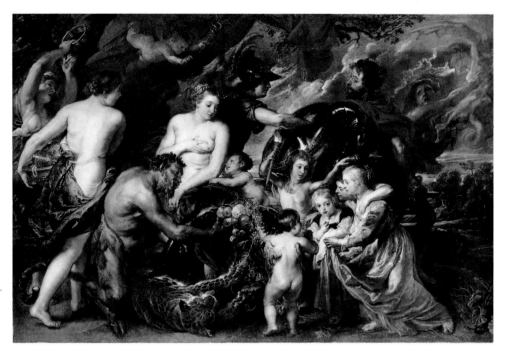

59. Peter Paul Rubens. *Allegory of Peace and War*. 1629–30. Oil on canvas, 80¼ × 118″ (203.5 × 298 cm). The National Gallery, London

very apprehensive as to the instability of the English temperament. Rarely, in fact, do these people persist in a resolution, but change from hour to hour, and always from bad to worse . . . for whereas in other courts negotiations begin with the ministers and finish with the royal word and signature, here they begin with the king and end with the ministers."[43] In addition to the intrigues of the French, who were dedicated to thwarting Rubens's efforts, he faced severe opposition from the representatives of the Dutch republic and of Venice, as well as duplicity on the part of several English courtiers. He was dismayed by the governing power of the purse at a court where "the first thing to be noted is the fact that all the leading nobles live on a sumptuous scale and spend money lavishly, so that the majority of them are hopelessly in debt. . . . That is why public and private interests are sold here for ready money. And I know from reliable sources that Cardinal Richelieu is very liberal and most experienced in gaining partisans in this manner."[44] But Rubens was not without English allies, foremost among whom (in addition to Cottington) was his old friend Sir Dudley Carleton, now secretary of state. By late September Rubens had prevailed—despite Madrid's endemic procrastination. An exchange of ambassadors was agreed upon, and he was duly thanked by Olivares "in the name of His Majesty for the zeal, the solicitude, and the attention with which he reported all that happened in this affair." Rubens, nonetheless, had several more months to spend in England before he was granted leave to return to Antwerp.

In September as well Rubens heard from his friend Jan Caspar Gevaerts that his son Albert had recovered from a serious illness. News of Albert was not the only reminder of mortality—and of past grief—to punctuate his diplomatic concerns: "I hesitate to remind you of the loss of your dear wife," he replied to Gevaerts. "I should have written to you immediately; now it will seem like nothing more than a painful duty and a needless renewal of your grief, when it would be better to forget, rather than to recall the past." Rubens concluded with a rare offering of his personal philosophy: "I shall only add this, as a poor kind of comfort: that we are living in a time when life itself is possible only if one frees himself of every burden, like a swimmer in a stormy sea."[45]

Still, there were stretches of fair weather ahead. In October he was awarded an honorary master of arts degree from Cambridge. In London, awaiting the arrival of the Spanish ambassador, Rubens stayed at the home of Gerbier and his family. There he painted his *Allegory of Peace and War* (fig. 59). The painting featured Gerbier's wife in the guise of the nurturing goddess Peace, accompanied by the Gerbier children enjoying the fruits thereof, together with an allegorical supporting cast that included Minerva banishing Mars and the Fury Alecto; a satyr; a bacchante; Cupid and Hymen (god of marriage); and a playful leopard. This painterly effusion over the success of the long diplomatic quest, symbolized by the putti flying overhead with Mercury's caduceus, joyfully commemorates the initial—and ultimately fruitful—meetings between the artist, Gerbier, and Buckingham, his late master.

In London, Rubens met the Dutch philosopher and physicist Cornelis Drebbel (inventor of the microscope and the first navigable submarine) and the archaeologist

Sir Robert Bruce Cotton. He visited the Arundel collection of ancient sculpture ("I have never seen anything in the world more rare," he noted) and his own former collection at the palace of the late duke of Buckingham, which, he happily reported, was "still preserved intact, the pictures as well as the statues, gems, and medals." He found contentment in England: "I feel consoled and rewarded by the mere pleasure in the fine sights I have seen on my travels. This island, for example, seems to me to be a spectacle worthy of the interest of every gentleman, not only for the beauty of the countryside and the charm of the nation; not only for the splendor of the outward culture, which seems to be extreme, as of a people rich and happy in the lap of peace, but also for the incredible quantity of excellent pictures, statues, and ancient inscriptions that are to be found in this court."[46] By late November, however, he was clearly restless: "My brother-in-law," Rubens wrote, "is losing his patience at having to leave all the work to his colleagues for so long, and it also distresses him to be so long deprived of the society of the girls of Antwerp. Probably in the meantime they will all have been snatched away from him."[47] Was Rubens speaking only for Brant?

Even after the Spanish ambassador's arrival in early January 1630, Rubens was required to stay on several weeks longer. It was probably during this time that he painted the idyllic *Landscape with St. George* (Buckingham Palace, London), wherein he gave the king's features to England's chivalric patron saint and the queen's to the rescued princess; the background featured a view of the river Thames. He also secured the commission he had originally sought eight years earlier—the Whitehall ceiling (plate 33), nine vast canvases of royal propaganda. His preliminary oil sketch (fig. 61) for the central scene and four surrounding ovals was probably painted in England.

The day before he set sail, Rubens deliberately overstepped his diplomatic bounds and paid a surprise call on the Dutch ambassador, Albert Joachimi. With the announcement of peace between England and Spain imminent, Rubens argued, the time was ripe for a settlement between the two Netherlands. But the Hollanders had enjoyed considerable success on the battlefield and were in no mood to negotiate. Rubens's initiative underscored his personal motive throughout the English mission: to find peace for his war-torn homeland. On the eve of departure, Charles I fêted the painter-diplomat at a royal banquet, gave him a jeweled sword and a diamond ring, and knighted him. In return, Rubens presented the king with his *Allegory of Peace and War* (fig. 59), a spectacular souvenir of diplomatic achievement and an anticipation of the rhetorical finale Charles had commissioned for the Banqueting House in Whitehall.

Back in Antwerp, Rubens devoted himself to his "beloved profession" ("*la mia dolcissima professione*") and to two major series: the Henry IV cycle for the queen mother of France (fig. 60) and the Whitehall ceiling. Work on the Henry IV cycle was beset by technical problems, mainly changes in dimensions and proportions dictated by the Abbé de St. Ambroise. With prophetic clarity, Rubens viewed "so many obstacles at the beginning of this work . . . a bad omen for its success" and

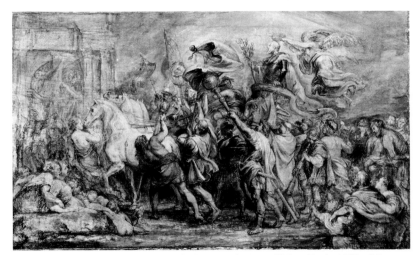

60. Peter Paul Rubens. *The Triumphal Entry of Henry IV into Paris.* 1630. Oil sketch on panel, 19½ × 32⅞″ (49.5 × 83.5 cm). Metropolitan Museum of Art, New York. Rogers Fund, 1942

61. Peter Paul Rubens. *The Apotheosis of King James I.* 1630. Oil sketch on panel, 37⅜ × 24⅞″ (95 × 63.2 cm). On loan to The National Gallery, London, from the Glynde Place Collection

found his "courage cast down."[48] Political upheavals in France were soon to confirm his premonitions.

In the meantime, he received sad news from Italy. In July 1630 the city of Mantua fell to imperial Hapsburg troops, with heavy casualties among its citizenry. "This grieves me deeply," Rubens penned in a nostalgic postscript to Peiresc, "for I served the House of Gonzaga for many years, and enjoyed a delightful residence in that country in my youth."[49] In a brighter, final postscript to his long, learned letter discussing the finer points of ancient tripods—which he later illustrated in his *Feast of Venus* (fig. 65)—Rubens noted with fatherly pride that "the passages from ancient authors have been added by my son Albert, who is seriously engaged in the study of antiquities and making progress in Greek letters. He honors your name above all. . . ." Albert, the artist (but for modesty) might have added, also honored his father by pursuing an interest in classical antiquity.

On September 25, 1630, Ambrogio Spinola died at the siege of Casale in northern Italy, where he had been sent by Philip IV to fight the French. Rubens considered the general "the most prudent and sagacious man I have ever known," and felt he had lost "one of the greatest friends and patrons I had in the world."[50] But he soon had double cause for celebration: a treaty was signed in November between England and Spain, followed by a still more joyous alliance—Rubens's marriage on December 9 to Helena Fourment, the youngest daughter of the silk and tapestry merchant Daniel Fourment and the sister of Susanna, whose engaging portrait (plate 19) he had painted several years earlier. Rubens was at the time a widower of fifty-three; Helena, a girl of sixteen. Explaining his reasons—four years after the fact—to Peiresc, the artist confided: "I made up my mind to marry again, since I was not yet inclined to live the abstinent life of the celibate, thinking that, if we must give the first place to continence, we may enjoy licit pleasures with thankfulness. I have taken a young wife of honest but middle-class family, although everyone tried to persuade me to make a court marriage. But I feared Pride, that inherent vice of

62. Peter Paul Rubens. *The Walk in the Garden.* c. 1631. Oil on panel, 38¾ × 51⅝" (98.5 × 131 cm). Alte Pinakothek, Munich

the nobility, particularly in that sex, and that is why I chose one who would not blush to see me take my brushes in hand."[51] Far from blushing, Helena was to inspire some of the most personal and poignant portraits of Rubens's career (fig. 67 and plate 36). This twilight decade also witnessed some of the most exuberant works of the rejuvenated master.

The marriage was as fruitful as it was blissful, producing five children—the fifth, a daughter, was born eight months after Rubens's death. In his *Walk in the Garden* (fig. 62), Rubens promenades arm-in-arm with Helena down the main path from his Antwerp house and studio toward the sculpture pavilion; his son Nicolaas follows a few steps behind. In the background the cupid-and-dolphin fountain symbolizes love's swiftness, while in the foreground the peacocks, traditional marriage symbols, underscore the theme of conjugal harmony. Complementing this thoroughly domesticated "love garden," the artist's own, is Rubens's poetic *Garden of Love* (fig. 63 and plate 29), in which the central young woman looking out at the viewer has been given Helena's visage. Though hardly lifted from the artist's family album, Rubens's most cultured (and enigmatic) vision of a social paradise—an allegory of marriage—is clearly imbued with

63. Christoffel Jegher. *The Garden of Love* (two sections). 1632–33. Woodcut, 18¼ × 23¾" each (46.4 × 60.3 cm). Metropolitan Museum of Art, New York. Harris Brisbane Dick Fund, 1930

personal significance. Venus presides over the gathering of lovers in the form of an inventive sculpture, as she was to reappear a century later in Watteau's fêtes galantes (fig. 64). In the more archaeological setting of the *Feast of Venus* (fig. 65)—a dual reflection of Titian's *Worship of Venus* and of classical antiquity—the *Venus pudica* presides as a votive statue over a clamorous bacchanal, one of Rubens's most unrestrained pagan celebrations, complete with antique tripod. In the same spirit and tempo is the Flemish *Kermesse* (plate 32), Rubens's resounding evocation of a Pieter Bruegel genre painting. His rapidly penned sketches of dancing peasants (fig. 66) convey the unrestrained *joie de vivre* of Rubens's exuberant homage to his homeland.

If Venus is the reigning goddess of Rubens's late mythologies, she is often identified with Helena Fourment: in *Venus and Adonis* (plate 35), Rubens's rein-terpretation of Ovid in the light of Titian (fig. 58); in the Venus in fur, *Het Pelsken* (or *The Fur*, fig. 67), a classical statue brought to life (cf. fig. 65); and in the *Judgment of Paris* (plate 40). Soon after his marriage, Rubens designed his fourth and final tapestry cycle, the *Life of Achilles* (plate 30), for his new father-in-law, Daniel Fourment. In this Homeric cycle Rubens distilled his extensive experience in tapestry design. The dramatic narrative in eight panels is punctuated by an original framing device, at once decorative, architectural, and sculptural. Pairs of herms bracket the scenes, recalling their grisaille ancestors in the Farnese ceiling (fig. 8) and providing a symbolic commentary on the subject matter, a translation of the early sculpturesque title pages (fig. 27) into monumental decoration.

Rubens soon lost all taste for politics. A month after his marriage he confided to Jan Woverius, one of the

64. Antoine Watteau. *Departure from Cythera*. 1717. Oil on canvas, 50¾ × 76⅜″ (129 × 194 cm). The Louvre, Paris

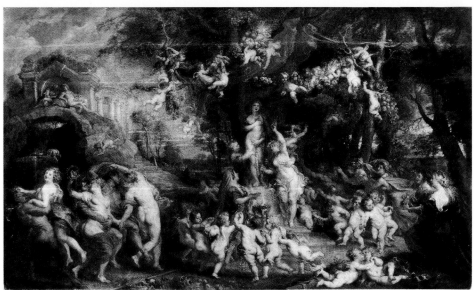

65. Peter Paul Rubens. *The Feast of Venus*. c.1636. Oil on canvas, 85⅜ × 137¾″ (217 × 350 cm). Kunsthistorisches Museum, Vienna

66. Peter Paul Rubens. *Studies for the Kermesse*. 1630–32. Chalk and pen and ink on paper, 19¾ × 22⅞" (50.2 × 58.2 cm). Reproduced by courtesy of the Trustees of The British Museum, London

"Four Philosophers" (plate 9): "I am so disgusted with the court that I do not intend to go for some time to Brussels." He despaired over worsening conditions in the Netherlands and added that he was even tempted to consider "retiring with my family to Paris, in the service of my queen mother, although they say that Cardinal Richelieu is suppressing her little by little. But this would have nothing to do with me."[52] A month later such wishful thinking was dashed: Maria de' Medici was in exile. She turned to the infanta for aid to raise an army and depose the cardinal. Though he must have foreseen the futility of it, Rubens's sense of loyalty—to both royal patronesses—reengaged his diplomatic skills. He composed an impassioned and eloquent plea to Olivares to lend support to Maria, who now dwelled in the realm of the Medici cycle, not in the world of political realities. "The queen mother," Rubens began, "has come to throw herself in the arms of Her Highness, cast out by the violence of Cardinal Richelieu. He has no regard for the fact that he is her creature, and that she not only raised him from the dirt but placed him in the eminent position from which he now hurls against her the thunderbolts of his ingratitude."[53] Rubens envisioned the universal consequences of the queen mother's successful restoration: "It would be desirable," he concluded, "if the affair succeeds, that there should finally be a good general peace, at the expense of the cardinal who keeps the world in turmoil." It was not to be. Spain's eventual financial aid proved insufficient; Maria was no match for Richelieu. Whatever hopes Rubens may have rekindled for the Henry IV cycle were finally extinguished. Except for a few remaining (and equally futile) secret missions to the prince of Orange over the next two years in a desperate search for peace in Flanders, Rubens had effectively retired from his diplomatic career. As he later explained to Peiresc: "I made the decision to force myself to cut this

golden knot of ambition, in order to recover my liberty. . . . I seized the occasion of a short, secret journey to throw myself at Her Highness' feet and beg, as the sole reward for so many efforts, exemption for such assignments and permission to serve her in my own home. This favor I obtained with more difficulty than any other she ever granted me . . . and I have never regretted this decision."[54]

In July 1631 Philip IV knighted Rubens—the only painter so honored by monarchs of both England and Spain. January 1632 brought Rubens a new daughter, Clara Johanna, the first child born to him and Helena. The child's name revived the memory of his first daughter, Clara Serena. The same year witnessed the installation of his most personal ecclesiastical commission—the *Ildefonso* triptych, a radiant, autumnal vision of Counter-Reformation spirituality (plate 31). With his Henry IV project abandoned, Rubens turned his attention to glorifying at Whitehall the life of Charles I's father, James I, who was celebrated in his time as the "New Solomon" (fig. 68). During this decade of his renewed interest in Titian, the Whitehall commission offered Rubens an opportunity to revive as well the Venetian ceilings of Tintoretto and Veronese. In a field of carved and gilded wood frames (plate 33) he enclosed three primary scenes devoted to King James, flanked by six subsidiary allegories (four ovals and two processional friezes of putti). Rubens combined elements from earlier commissions—especially the Jesuit ceiling paintings and the Medici cycle—in a High Baroque fanfare for the Stuart dynasty. It represents the first successful translation of monumental Italianate decorative painting into England, appropriately commissioned to adorn Inigo Jones's seminal masterpiece of Neo-Palladian architecture. During his stay in England in 1629 Rubens had written approvingly—and clearly with some surprise—that "in this island I find

67. Peter Paul Rubens. *Het Pelsken (The Fur)*. 1636–38. Oil on panel, 69¼ × 38″ (175.9 × 83 cm). Kunsthistorisches Museum, Vienna

68. Peter Paul Rubens. *The Unification of the Crowns*. 1632–33. Oil sketch on panel, 25¼ × 19¼″ (64 × 49 cm). Hermitage, Leningrad

none of the crudeness that one might expect from a place so remote from Italian elegance."⁵⁵ The ceiling paintings were completed in 1634 and shipped to London for installation two years later. Italy was thereafter less remote: Rubens had brought Venice to the Thames.

At the opposite end of the scale, Rubens continued to design title pages for the Plantin-Moretus Press in Antwerp, to which he contributed a new colophon and one of his most successful emblems of literary immortality: the title page (fig. 69) for the reigning Pope Urban VIII's volume of poetry. While Urban, the pontiff of the Roman Baroque, is now better remembered as the papal patron of Bernini and the (reluctant) censor of Galileo, his earlier avocation as a poet was celebrated by Rubens in a miniature monument of graphic design. The Plantin edition of *Poemata* (1634) was based on an edition published by the Jesuits in Rome in 1631, which featured a

69. Cornelis Galle I. Title page for Maffeo Barberini's *Poemata*. 1634. Engraving (17.5 × 13.5 cm); title page (23 × 17 cm). Department of Rare Books and Special Collections, University of Rochester Library

title page designed by Bernini. Rubens took Bernini's illustration of David, the psalmist, slaying a lion and in a brilliant biblical substitution replaced it with Samson opening the jaws of a lion. From the lion's mouth comes a swarm of bees, the heraldic image of the pope's family (Barberini) and a flattering biblical allusion to his poems: "Out of the eater came forth meat, and out of the strong came forth sweetness" (Judges 14: 5–14).⁵⁶

Despite unceasing efforts by the infanta and occasional intervention by Rubens, no Solomonic solution was to be found for the Netherlands. Rubens's final diplomatic mission to The Hague on behalf of the infanta

70. Theodoor van Thulden.
The Stage of Infanta Isabella from
the *Pompa Introitus Ferdinandi.*
1642. Etching

71. Theodoor van Thulden.
The Temple of Janus from the
Pompa Introitus Ferdinandi.
1642. Etching

prompted a stinging insult from a chauvinistic Flemish noble, the duke of Aerschot. Rubens defended himself with characteristic tact and firmness. "All I can tell you," replied the duke, "is that I shall be greatly obliged if you will learn from henceforth how persons of your station should write to men of mine."[57] Small wonder that Rubens had previously shied from a "court marriage" and now sought to retire completely from that arena of petty arrogance. When the Whitehall ceiling paintings were finally completed, he sent the rolled-up canvases to London by messenger—owing to his "horror of courts."

In December 1633 the Infanta Isabella died. Rubens had served her for almost twenty-five years. His high regard for Isabella was unqualified: "She is a princess endowed with all the virtues of her sex," he had written in 1628, "and long experience has taught her how to govern these people and remain uninfluenced by the false theories that all newcomers bring from Spain."[58] Yet one newcomer, Isabella's successor, was to be welcomed with unsurpassed grandeur. As a young man Rubens had witnessed and perhaps participated in the triumphal entry of the archdukes into Antwerp in 1599. Now, thirty-five years later, he was given the commission by the city of Antwerp to design a series of triumphal arches and stages to greet the new governor, Isabella's nephew, the Cardinal-Infante Ferdinand. Though he became a cardinal at the age of ten, Ferdinand's clear calling was to the battlefield, not the altar. Flushed with the success of his military victory for the Hapsburgs over the Protestant Swedish forces at Nördlingen—a twilight triumph for the waning Catholic cause in the Thirty Years' War in central Europe—he had arrived in Brussels in November 1634 and planned his entry into Antwerp in January 1635. There a triumvirate of Rubens, Nicolaas Rockox, and Jan Caspar Gevaerts was preparing the most spectacular

Baroque version of the *"Blijde Intrede"* (Joyous Entry) in the history of these state ceremonies (figs. 70 and 71 and plate 34): a series of triumphal arches and stages erected along the processional route through the streets of the city. The dual message of these civic monuments emphasized the citizens' high expectations of their new ruler and recently victorious military leader; at the same time, it dramatized their desperate economic plight arising from the protracted war with the Dutch and from Spain's restrictive trade policies. The two faces of celebration and supplication were reflected, Janus-like, throughout the streets. The *Arch of Ferdinand* (plate 34) presented a Roman military triumph *all'antica,* wherein Rubens recast the classical imagery of his Constantine series (fig. 46) and *Triumph of Henry IV* (fig. 60) for the aborted Henry IV cycle. The *Temple of Janus* (fig. 71), a symbolic revision of the Pantheon, on the other hand, staged as an illusionistic tableau vivant the full horror of the unresolved war. Among those shown desperately attempting

72. Peter Paul Rubens. *Isabella Helena Rubens.* 1636. Chalk on paper, 15⅝ × 11⅝" (39.8 × 28.7 cm). The Louvre, Paris

to close the doors of the temple, from which the blind-folded god of war rushes out in fury, is the late Infanta Isabella. Her personal memorial, the *Stage of the Infanta* (fig. 70), was conceived as a temple façade, crowned by the candelabrum from the Holy of Holies, wherein Rubens framed a painting of her apotheosis. The architectural orders (Solomonic over Tuscan columns) recalled her Eucharist tapestries (figs. 54 and 55 and plates 26 and 27), which Rubens now associated with his patron's own apotheosis. These temporary architectural monuments of wood, sculpture, cutout figures, and paintings—the seventeenth-century equivalent of a Cecil B. deMille production—required an army of carpenters, sculptors, and painters all working under the direction of Rubens. The pace and pressure of the project were reflected in his letter of December 18 to Peiresc: "Today I am so overburdened with the preparation for the triumphal entry of the Cardinal-Infante (which takes place at the end of this month) that I have time neither to live nor to write. . . . The magistrates of this city have laid upon my shoulders the entire burden of this festival, and I

believe you would not be displeased at the invention and variety of subjects, the novelty of the designs and the fitness of their application. Perhaps some day you will see them published, adorned with the beautiful inscriptions and verses of our friend Gevaerts."[59] Unfortunately, neither Peiresc (who died in 1637) nor Rubens was to live to see the magnificent publication of the *Pompa Introitus Ferdinandi* in 1642, through which Rubens's largest—if most ephemeral—undertaking was preserved in the magnificent etchings of Theodoor van Thulden (figs. 70 and 71). Rubens's surviving *modelli*, the finished oil sketches that served as plans for the painters and sculptors, offer colorful reflections of these Baroque *Gesamtkunstwerke*, total artworks of painting, sculpture, and architecture (plate 34).

Though originally planned for January 1635 Ferdinand's entry was postponed until April of that year. According to the eighteenth-century biographer J. F. M. Michel, Rubens was too ill with gout to attend in person. Periodic attacks of the illness, which had begun in Paris a decade earlier and recurred during his diplomatic mis-

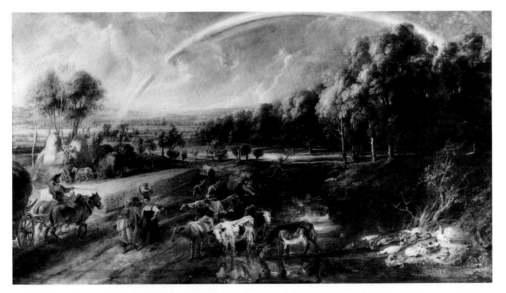

73. Peter Paul Rubens. *Landscape with a Rainbow*. 1636. Oil on panel, 53¾ × 93⅛″ (136.5 × 236.5 cm). Reproduced by permission of the Trustees of The Wallace Collection, London

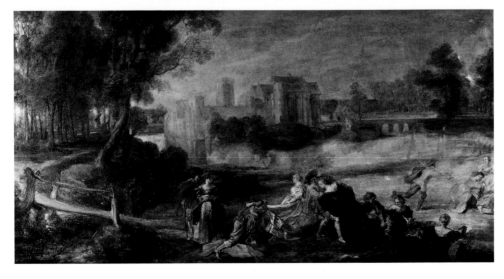

74. Peter Paul Rubens. *Couples Playing Before a Castle*. 1635–36. Oil on panel, 20¾ × 38¼″ (52.7 × 97 cm). Kunsthistorisches Museum, Vienna

sions to Spain and England, grew ever more frequent and severe during the last five years of the artist's life. Six weeks after the procession he wrote to Peiresc that he was finally recovering "by divine grace" from the gout. However severe the attack, it did not prevent him from receiving at his home the grateful cardinal-infante, who came to pay his respects to the impresario the day after the triumphal welcome. The next year he named Rubens his court painter—as his late aunt and uncle had done twenty-seven years before.

In May 1635 a third child was born to Rubens, a daughter whose names together honored Rubens's two wives: Isabella Helena. A pentimento of the child's outstretched hands appears sketched at the right of an unfinished family portrait (plate 36) that might almost be an intimate, impressionistic precursor of Renoir and Cassatt. Rubens was now spending the summer months at his country estate, Het Steen, at Elewijt between Malines and Brussels, which he had purchased the preceding August. There he painted the most expansive and glowing landscapes of his career. The *Landscape with a Rainbow* (fig. 73) and its pendant, *Landscape with Het Steen* (plate 37), offer complementary views of a countryside teaming with life—botanical, animal, and human. They are poetic odes in oil to the natural order of creation, an Arcadian vision of man living in harmony with nature. Rubens not only enjoyed at Het Steen the fruits of his industrious career but also celebrated them on canvases that alone

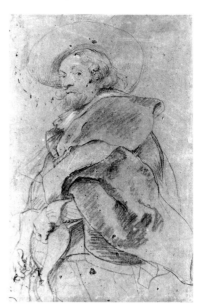

76. Peter Paul Rubens. *Self-Portrait.* c.1638. Chalk on paper, 18⅛ × 11¼" (46.1 × 28.7 cm). The Louvre, Paris

would ensure his fame and influence as a landscapist.[60] Indeed, the English countryside of Constable does not seem far away. Rubens's country estate also inspired such landscape fantasias as his *Tournament Before the Castle of Steen* in the Louvre and *Couples Playing Before a Castle* (fig. 74) in Vienna, an animated transcription of the *Garden of Love* (plate 29).

For Philip IV's new hunting lodge, the Torre de la Parada outside Madrid, Rubens was commissioned in 1636 to paint a vast series of mythologies. It was an enormous undertaking—wall-to-wall Rubens—requiring the employment (as in the recent *Pompa Introitus*) of virtually every able painter in Antwerp. Rubens painted some sixty-odd oil sketches inspired by Ovid's *Metamorphoses.* The final paintings were executed with the assistance of Jacob Jordaens, Erasmus Quellinus, Theodoor van Thulden, Cornelis de Vos, and other, lesser lights of the Rubens school. The commission was ideally suited to Rubens, who was working on additional mythologies and hunts for Philip's palace in Madrid at the time of his death. His interpretations of Ovid's myths spanned his entire career. Now, with his copy of the *Metamorphoses* in hand, he approached afresh these stories of the loves, conflicts, and passions of ancient gods and mortals. The masterly oil sketches for the Torre de la Parada (plates 38 and 39) rank among his liveliest and most spontaneous panels, charged as they are with all the powers of his literary imagination and inexhaustible invention.[61]

Despite frequently suffering incapacitating attacks of gout, Rubens continued to accept a wide range of commissions. In 1638, for Antwerp's Ommegang parade, he

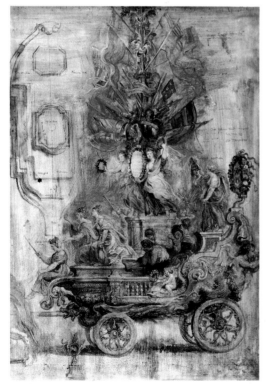

75. Peter Paul Rubens. *Triumphal Car of Calloo.* 1638. Oil sketch on panel, 41½ × 28" (105.5 × 71 cm). Koninklijk Museum voor Schone Kunsten, Antwerp

designed a magnificent ceremonial vehicle in the form of a ship (fig. 75) to celebrate the cardinal-infante's encouraging (though ultimately short-lived) victory over the Dutch forces at Calloo. His definitive oil sketch, complete with a bird's-eye view of the deck, recalls the stage monuments for the *Pompa Introitus* (plate 34) as well as the triumphal carriages of the Eucharist tapestries (plate 27). The recent victory at Calloo notwithstanding, Rubens's own view of the incessant and enervating war in the Netherlands—indeed, of war in general—remained deeply pessimistic, if tempered by stoic resignation, and was vividly summarized in his allegorical *Horrors of War* (plate 41). In 1635 Rubens had expressed his hope to Peiresc that "His Holiness and the king of England, but above all the Lord God, will intervene to quench a blaze that (not put out in the beginning) is now capable of spreading throughout Europe and devastating it."[62] That impassioned view remained undimmed throughout his final years.

At the same time Rubens painted, either for his own pleasure or for private patrons, such glowing mythologies as the *Judgment of Paris* (plate 40). A comparison with his early treatment of the same subject (plate 2) reveals how far he had traveled stylistically through the intervening decades. He also continued to paint portraits. Two masterpieces now in Vienna offer a dramatic contrast between the public man and his private life: the official stately image of his late *Self-Portrait* (fig. 76 and plate 42) and, at the other end of the spectrum, the intimate view of his wife (fig. 67). Rubens presented himself not as an artist but as a knight, wearing the jeweled sword that Charles I had given to him. He is in this painting the self-confident and proud—if now aging and visibly weary—Lord of Steen. In *Het Pelsken* (fig. 67) he admits the viewer to an unguarded moment as Helena modestly wraps herself—but just barely—in fur: a thoroughly Rubensian revival of Titian's *Lady with Fur*, which he had copied in Madrid, and of the ancient *Venus pudica* (fig. 65). One of his last family portraits, which he continued to revise and may have left unfinished at the time of his death, is the *Self-Portrait with Helena and Peter Paul* (fig. 77). Peter Paul, his youngest son, was born in March 1637; the child's appearance suggests that Rubens began the painting in early 1639.[63] The couple strolling in their garden harks back to the *Garden of Love* (plate 29) and perhaps ultimately to one of the first images he copied as a young, aspiring artist, the promenading couple from Holbein's *The Dance of Death* (fig. 1). Despite the idealized, rejuvenated visage Rubens gave to his last self-portrait, he knew death was not far away.

Toward the end of his life Rubens spent more and more time at Het Steen. During these absences from

Antwerp, he placed his studio in the charge of a young sculptor from Malines, Lucas Fayd'herbe. Forty years his junior, Fayd'herbe was treated almost like a surrogate son. (He was in fact about the same age as the artist's second son, Nicolaas.) Rubens's few surviving letters to "My dear and beloved Lucas"—signed, as they are, "your devoted friend" and even "your very affectionate friend and servant"—offer rare, precious glimpses into his private life: "Take good care, when you leave, that everything is well locked up, and that no originals remain upstairs in the studio, or any sketches. Also, remind William the gardener that he is to send us some Rosile pears as soon as they are ripe, and figs when there are some, or any other delicacy from the garden. Come here as soon as you can."[64]

In a professional certificate of recommendation that Rubens wrote for Fayd'herbe a month before his death, he

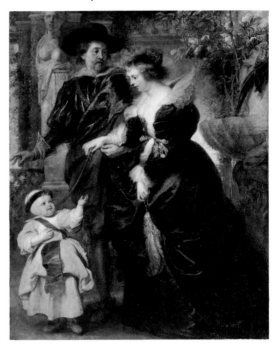

77. Peter Paul Rubens. *Self-Portrait with Helena and Peter Paul*. 1639–40. Oil on panel, 80¼ × 62¼″ (203.8 × 158.1 cm). Metropolitan Museum of Art, New York. Gift of Mr. and Mrs. Charles Wrightsman, 1981

declared that the young sculptor had lived with him for over three years and had been his pupil. Rubens then significantly added that "through the relationship that exists between our arts of painting and sculpture, he has been able, by my instruction and his own diligence and good disposition, to make great progress in his art."[65] Two weeks later, Rubens wrote to the most prominent of all Flemish sculptors, François Duquesnoy, who had gone to Rome in 1618 and had assisted Bernini at St. Peter's, where his statue of St. Andrew was special cause for Flemish pride: "I hear the praises for the statue and I, along with all our nation, rejoice and participate in your

fame. If I were not detained here by age and by gout, which renders me useless, I should go there to enjoy with my own eyes and admire the perfection of works so worthy."[66] Duquesnoy had sent Rubens some sculptural models and plaster casts of putti for an epitaph. "It is nature, rather than art, that has formed them; the marble is softened into living flesh," Rubens proclaimed, echoing his famous admonition to "avoid the effect of stone." Rubens's sensual impact on Flemish Baroque sculpture is brilliantly captured—in miniature—in a saltcellar he had designed to be carved for his table by Georg Petel in 1628: the hard ivory yields the dynamic emergence of Venus from the salty waves (fig. 78), the consummate Baroque successor to Cellini's famous saltcellar for Francis I at Fontainebleau.

It seems fitting that Rubens, the most painterly of painters, should have discussed the subject of sculpture in his last letters. His artistic vision was, in the final analysis, quintessentially Baroque—a merging of painting, sculpture, and architecture in an all-embracing unity of expression. His final surviving letter, of May 9, was to Fayd'herbe, first congratulating the young man on his recent betrothal and then gently reminding him of their collaboration in progress, an ivory child designed to be carved by Lucas: "I have heard with great pleasure that on May Day you planted the may in your beloved's garden; I hope that it will flourish and bring forth fruit in due season. My wife and I, with both my sons, sincerely wish you and your beloved every happiness and complete, long-lasting contentment in marriage. There is no hurry about the little ivory child; you now have other child-work of greater importance on hand."

78. Georg Petel. *Salt Cellar.* 1627–28. Ivory and gilded silver, 17⅜" high (44 cm). The Royal Collections, Stockholm

Following a severe attack of gout, Rubens died on May 30, 1640. He was buried in the parish church of St. James in Antwerp (fig. 79). Over his tomb, in accordance with his wishes, was placed his last and most resonant *sacra conversazione,* the *Virgin and Child with Saints* (plate 43). Installed above the painting, in a niche, is a statue of the Virgin attributed to Fayd'herbe. In his certificate for the young sculptor, Rubens had cited a "figure of Our Lady for the Church of the Beguinage of Malines, which he made alone in my house and carried out so remarkably well that I do not think there is a single sculptor in all the land who could do better." Rubens was evidently taken at his word.[67]

In his will Rubens stipulated that his vast collection of drawings be kept intact until his youngest child reached eighteen, in case any of his sons (or a future son-in-law) should choose a career in art. As fate would have it, none did. The drawings were consequently sold and dispersed in 1657. His eventual successor as Antwerp's premier painter was Jacob Jordaens (Van Dyck died the year after his former master, in 1641). The war in the Netherlands was finally brought to a close in 1648 by the Treaty of Münster, which ratified the de facto independence of the Dutch republic. Ironically, it was Rubens's former collaborator who was commissioned to commemorate the victorious prince of Orange: Jordaens's *Triumph of Prince Frederick Henry* (fig. 80) was completed in 1652 for the Oranjezaal of the Huis ten Bosch in The Hague. Despite its Protestant, Dutch subject matter, the imagery is thoroughly Rubensian in its symbolic, triumphal vocabulary and High Baroque verve. Perhaps *too* Rubensian: having assumed the late master's mantle, Jordaens may have been determined to "out-Rubens Rubens," a posthumous reflection of the latter's domination of northern painting.

Rubens's immediate artistic legacy extended far beyond the Netherlands. In Italy his influence was decisive among such High and Late Baroque masters as Pietro da Cortona, Luca Giordano, and Giovanni Battista Gaulli ("Il Bacciccio"); it may even be detected in the most painterly of sculptors, Gian Lorenzo Bernini. In Spain, Rubens's early impression on the young Velázquez, more personal than stylistic, was superseded by his impact on the art of Murillo, the most Rubensian of Spanish painters. In France, painters who championed color over line and the Baroque over the Classical found in Rubens their model. The leader of the Rubénistes at the French Academy, Roger de Piles, who published Rubens's treatise on sculpture, ranked the Fleming first (in a tie with Raphael) in the entire history of painting. Among Rubens's French Baroque successors were the great history painters LaFosse and Largillière. In England, Sir James Thornhill projected his Rubensian reflections

79. Rubens's Burial Chapel. Jacobskerk, Antwerp

80. Jacob Jordaens. *The Triumph of Prince Frederick Henry.* 1652. Oil on canvas 287⅜ × 295¼″ (730 × 750 cm). Huis ten Bosch, The Hague

onto ceilings of countless country houses and, finally, the Royal Hospital at Greenwich, a Late Baroque magnification of the Whitehall ceiling.

The advent of the Rococo, heralded by the Franco-Fleming Antoine Watteau at the beginning of the eighteenth century, coincided with the triumph of the Rubénistes in the French Academy. Watteau's early master, Claude Audran, was the curator (*"concierge"*) of the Luxembourg Palace, and the hours Watteau spent before Rubens's Medici cycle, sketch pad in hand, transformed his initial genre and decorative modes into the high art of his fêtes galantes (fig. 64). Toward the end of his short life, Watteau's grateful acknowledgment of a Rubens painting summed up the debt: "From the moment I received it, I have not had a moment's repose, and my eyes are never weary of returning towards the easel where I have placed it as if in a shrine."[68]

Toward the close of the century, across the Channel, the president of the Royal Academy, Sir Joshua Reynolds, echoed Watteau's appreciation in resonant imagery: "The productions of Rubens . . . seem to flow with a freedom and prodigality, as if they cost him nothing. . . . The striking brilliancy of his colors and their lively opposition

to each other, the flowing liberty and freedom of his outline, the animated pencil, with which every subject is touched, all contribute to awaken and keep alive the attention of the spectator; awaken in him, in some measure, correspondent sensations, and make him feel a degree of that enthusiasm with which the painter was carried away. To this we may add the complete uniformity in all parts of the work, so that the whole seems to be conducted and grow out of one mind: everything is of a piece and fits in its place."[69]

In the next century the great Romantic colorist Eugène Delacroix noted in his diary that Rubens was quite simply a "magician," and concluded that "by permitting himself every liberty he carries you to heights that the greatest painters barely attain; he dominates, he overwhelms you, with so much liberty and audacity."[70] Rubens's recurrent impact on artists and enduring reputation among critics and connoisseurs ultimately transcended all temporal bounds; his art has proved as universal as the man himself. Painter, diplomat, impresario, scholar, antiquarian, architect, humanist—Peter Paul Rubens embodied the Baroque fulfillment of the Renaissance man.

PORTRAIT OF A YOUNG MAN

1597
Oil on copper, 8½ × 5¾" (21.6 × 14.6 cm)
Metropolitan Museum of Art, New York
Jack and Belle Linsky Collection, 1982

Surprisingly few of Rubens's early works executed before his departure for Italy in 1600 have come down to us. In addition to some drawings he made as copies after prints by northern masters, such as his *Promenading Couple* after Holbein's *The Dance of Death* (fig. 1), only a handful of paintings from this period have been attributed to the young artist with any degree of certainty (fig. 2).[1] More, no doubt, remain to be discovered and correctly identified as Rubens *juvenilia*. In the meantime this *Portrait of a Young Man* remains his earliest dated work, inscribed on the back "Petrus Paulus Rubens" and on the front the date 1597, along with the sitter's age, twenty-six years.[2] The subject's identity and profession remain a mystery. He has been labeled an architect, geographer, astronomer, navigator, goldsmith, or watchmaker—depending upon the various identifications of the objects he holds and displays with a contemplative expression. His right hand, resting on a ledge, holds a square and dividers, the tools of an architect, a cartographer, or a geographer. The gold-chased oval object held by a thin red cord in his left hand has been identified as an astronomer's or navigator's astrolabe or, which is more likely, a watch. Yet the delicacy with which it is suspended, pendulumlike, suggests its iconographic function is not to be an attribute of a watchmaker or goldsmith but instead to be a memento mori in deliberate contrast to the sitter's youthful countenance, which the even younger Rubens (then age twenty) described in glowing layers of oil pigments and sensitive brushwork. Such *vanitas* motifs were common in Netherlandish portraits, in the form of either a skull or timepiece, as a stark reminder of mortality and the transience of youth.

At the time he executed this painting, Rubens had been apprenticed to Otto van Veen for over a year and had another year to go before his admission into the Antwerp Guild of St. Luke in 1598. His immediate debt to Van Veen is evident in the close similarities between this portrait and Van Veen's *Archduke Albert as Cardinal* (fig. 6), a preparatory drawing for an engraving also dated 1597 to which Rubens apparently contributed an allegorical border of putti, garlands, and emblems. The cardinal's left hand (his right, in the intended engraving) similarly rests on a ledge as he turns in three-quarter profile, a sixteenth-century portrait formula established by another Flemish painter, Anthonis Mor.[3]

Here Rubens takes his place within the rich tradition of Netherlandish portraiture, which extended back two centuries to Hans Memling, Roger van der Weyden, and Jan van Eyck, the father of early Renaissance portraits. The northern origins of such independent portraits coincided with the displacement of tempera painting by the more subtle effects of glazing and liquid brush strokes permitted by oils. Rubens's sensitive treatment of the sitter's hands, described in almost translucent skin tones and bluish veins, is complemented by the lively expression in the eyes. The striking white accents in the neck ruff and brocade are juxtaposed with the somber black jacket and obscure background. Rubens was to experiment further with oils on copper, a medium closely associated with Jan Brueghel and Adam Elsheimer, who exploited the jewellike miniature effects afforded by the smooth copper support. But soon after his arrival in Italy, Rubens abandoned this approach in favor of panel or canvas for the remainder of his career.

This early work dispels the notion that Rubens was a late bloomer. Though he was not celebrated as a child prodigy like the young Bernini, he revealed here, while still an apprentice, the expressive qualities—modulating colors, sensuous modeling and draftsmanship, and psychological engagement between subject and viewer—that became the hallmark of his mature style. In view of Rubens's lifelong interest in architecture,[4] it is tempting to associate the young sitter's dividers and square with that sister art, particularly in this portrait that sets the standard by which all future attributions to the young Rubens must be measured.

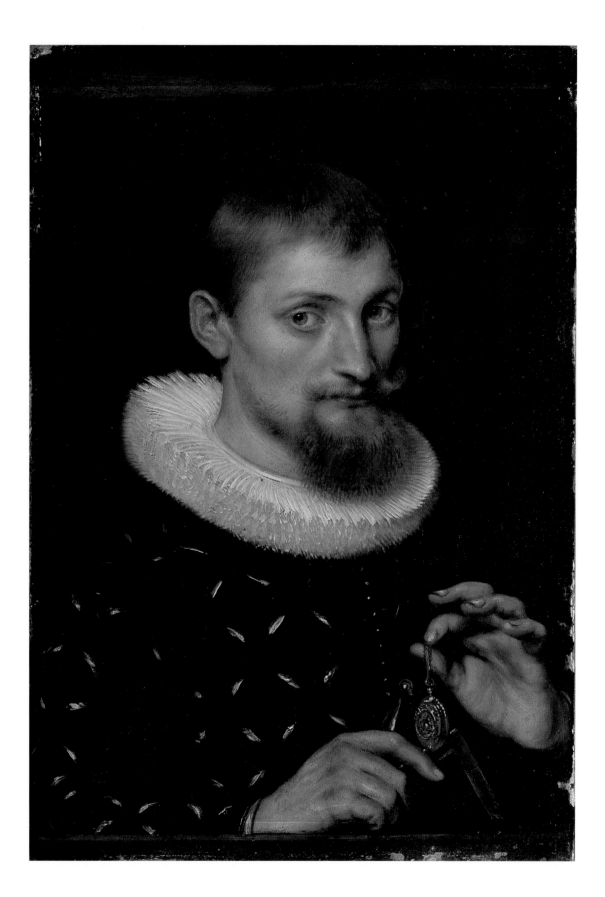

THE JUDGMENT OF PARIS

1600–1601
Oil on panel, 52¹¹/₁₆ × 68¹¹/₁₆" (133.9 × 174.5 cm)
The National Gallery, London

The Trojan War began with a beauty contest. The prize was a golden apple, which Eris (Discordia), the uninvited goddess of discord, had tossed among the Olympian guests at the wedding banquet of Peleus and Thetis. Inscribed "To the fairest," the apple was simultaneously claimed by Aphrodite (Venus), Hera (Juno), and Athena (Minerva). To settle the dispute, the shepherd Paris, son of King Priam of Troy, was asked to be the judge. He awarded the apple to Venus, goddess of love. In return she granted him the hand of the most beautiful woman in the world, Helen, wife of King Menelaus of Sparta, and thus ignited the ten-year-long war between the Greeks and the Trojans.

Rubens's earliest version of the Judgment of Paris instantly proclaims its Renaissance ancestry: the composition is based on an engraving by Marcantonio Raimondi after a lost composition by Raphael; the poses of Paris and Venus, in turn, recall an engraving of Adam and Eve by Sadeler after Martin de Vos; and the pose of Minerva (on the right) was based on a print of Juno after the Italian Mannerist Rosso Fiorentino.[5] Like Rubens's early *Adam and Eve in Paradise* in the Rubenshuis (fig. 2), which was also based on Raphael via Raimondi (fig. 3), the pagan subject offered the young Flemish painter an opportunity to exploit nude figures in their full classical glory—an ideal Rubens was to pursue throughout his career. To the three goddesses and heroic seminudes Paris and Mercury, he added a supporting cast of two woodland satyrs and a nymph and ancient river god— perhaps Paris's lover Oenone with her father, Oeneus—at the right.[6] The rippling musculature of the river god wittily reflects the emblematic water flowing from his urn.

The evident borrowings from engravings have suggested that Rubens painted this picture prior to his departure for Italy in 1600, a hypothesis reinforced by the oak support (more common in the north than in Italy) and the pervasive influence of Otto van Veen in the mannered classicizing of the figure types. Yet several otherwise unexplainable features argue that the work was painted in Italy, perhaps even during Rubens's first stay in Rome in 1601. His preliminary oil-on-copper version in the Vienna Academy suggests he knew the German artist Hans Rottenhammer's *Judgment of Paris* (also on copper) painted in Venice in 1597. More dramatic reflections of Venetian influences appear in Rubens's explosion of golden light surrounding the putti—one holds Venus's doves, another her crown—indicating the early impact of Tintoretto, especially the Venetian's masterpieces in the Scuola di San Rocco, where shafts of golden light cut through dense, atmospheric shadows. Rubens's sky seems far removed from Antwerp. The muscular Paris, viewed from behind, reveals an early familiarity with the *Torso Belvedere* in the Vatican—as well as with Michelangelo's *ignudi* (see fig. 10). The contrapposto turn of the body, which Rubens refined through two pen-and-ink drawings, suggests moreover that he had already seen Caravaggio's *Calling of St. Matthew* in S. Luigi dei Francesi, Rome, from which he sketched a similarly posed young lad and inserted him in a design for a Last Supper (fig. 9). A date of 1600 or 1601 thus seems consistent with the internal evidence of the painting.

In this transitional painting, one of his earliest ventures into mythology, Rubens's reliance on Renaissance engravings was transformed through his rich palette and sensuous modeling into a unique fusion of his Flemish heritage and the evocation of Roman antiquity. To the High Renaissance contours of Michelangelo and Raphael he added the Venetian luminosity of Tintoretto and the chiaroscuro of Caravaggio. Only the Arcadian landscape, a Flemish pastorale, seems as yet undisturbed by the currents of the early Italian Baroque. Venus, the reigning goddess of the painter's mythologies, here makes her Rubensian debut at her moment of triumph, with no hint of the fatal consequences of Paris's judgment (see plate 40). In beauty alone, she appears the preordained victor, as her crowning charges the earthly scene with an intrusion of the transcendental. For Rubens, the boundary between the celestial and the earthly, the sacred and the profane, is dissolved in light.

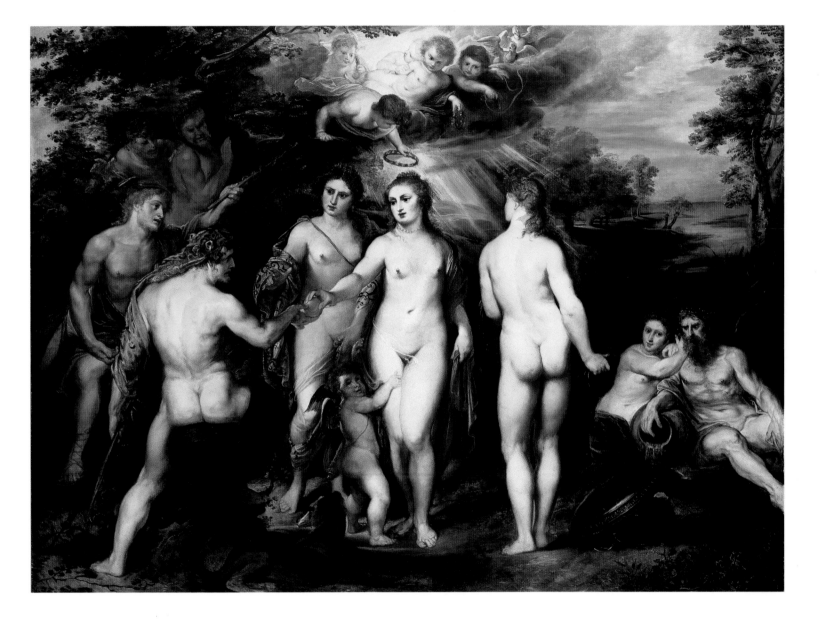

THE MARCHESA BRIGIDA SPINOLA-DORIA

1606

Oil on canvas, 59 × 38⅞" (149.9 × 98.7 cm)
National Gallery of Art, Washington, D.C.
Samuel H. Kress Collection

Among the Italian cities visited by Rubens while he was in the service of Duke Vincenzo Gonzaga, Genoa held a special place in his life and work. A thriving center of banking and commerce, this maritime republic was ruled by an oligarchy—a plutocracy—of intermarrying families among whom Rubens established several fruitful and lasting ties. During visits to Genoa in 1606 and again in the summer of 1607, Rubens painted a series of aristocratic portraits, a virtual *Who's Who* of Genoa, within which Brigida Spinola-Doria literally stands apart.[7] Here Rubens established a new iconography of female aristocratic portraiture. This stunning portrait was originally full-length—the bottom third was trimmed off during the nineteenth century—and somewhat wider than in its present state. For his preparatory pen-and-ink drawing (fig. 16), Rubens used a "stand-in" model—probably one of the marchesa's ladies-in-waiting—while drafting the outlines of his composition.

Originally inscribed on the reverse with the subject's age (twenty-two years) and the year 1606, the picture may be dated more precisely to late March or early April, nine months after the marchesa's marriage to Giacomo Massimiliano Doria in July 1605. Unlike the stiff, frontal predecessors that characterized Renaissance portraiture, the marchesa is shown having passed through the portal and onto the terrace of her villa. Originally visible at the left were the balustrade, background landscape, and open sky, lightly sketched in the drawing (fig. 16) and recorded in a nineteenth-century lithograph. The setting recalls Rubens's recently staged *Gonzaga Family Adoring the Holy Trinity* of 1604–1605 (fig. 14) and ultimately his altarpiece—an "imperial portrait"—of St. Helena painted a few years earlier (fig. 12).

Brigida is dramatically framed by the dark portal and the Ionic columns and fluted pilaster. A sense of movement is evoked by the bright highlights shimmering over her silver-and-gold brocaded satin gown, by the delicately extended, partially open fan held in her right hand, and above all by the fluttering red drapery behind her bejeweled coiffure and stiff neck ruff. Dressed *alla spagnuola*, in high Spanish fashion, the marchesa is placed, like a Renaissance madonna, before a cloth-of-honor backdrop; here the curtain is transformed into a dynamic compositional device that Rubens was to revive for future portraits (plate 9 and fig. 29), altarpieces (fig. 57 and plate 31), and allegorical subjects.

"Since the nobleman reigns in the republic of Genoa," Rubens later wrote in his introduction to his book on Genoese architecture, *Palazzi di Genova* (1622), "his houses are very beautiful and comfortable." The architectural grandeur of the background complements the courtly costume in which, despite its inherent constriction, Rubens's marchesa conveys the impression of comfort—both physical and psychological—and natural bearing that typify his mature portrait style. These are the very qualities that his former assistant Anthony van Dyck imitated and exaggerated upon his arrival in Genoa in 1624, a generation later. Van Dyck's *Marchesa Elena Grimaldi* (fig. 17) proclaims his thorough assimilation of the Rubens prototype. He replaced Rubens's fan with a flower and the cascading cloth with a red parasol held by a young page; the implied movement onto the terrace is now explicit. Yet the corresponding pose, pilasters, balustrade, and aristocratic formula reflect his essential debt to Rubens.

Unlike his successor, Rubens was not to develop the full-length portrait type he had invented; instead he later preferred to paint women either seated or in half-length. But toward the end of his life, he reverted to his earlier conception for a magnificent portrait of his young wife Helena Fourment (Louvre, Paris) standing outside the portal of their stately Antwerp house, itself a conscious evocation of Genoese architecture (figs. 18 and 30). In retrospect, Rubens's *Marchesa* may be seen as the ancestor of an entire tradition of aristocratic female portraiture, from Van Dyck to the eighteenth-century English portraits by Reynolds and Gainsborough and into our own century in the hands of John Singer Sargent and his heirs.

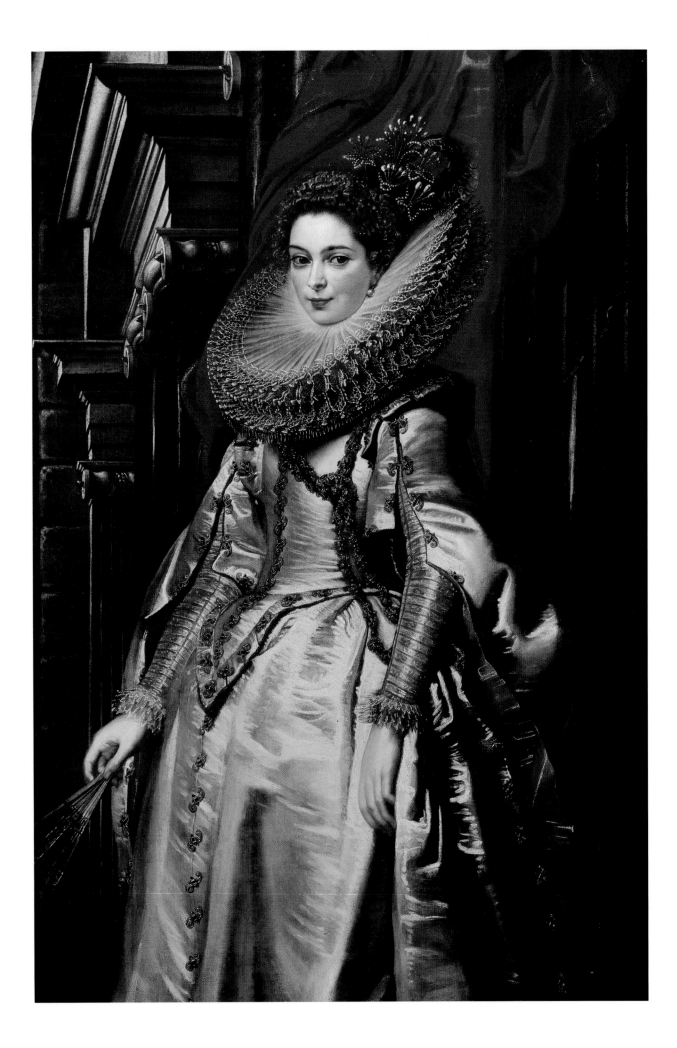

THE MADONNA DI VALLICELLA, ST. GREGORY THE GREAT, AND SAINTS

1607–1608
Oil on canvas, 15'7" × 9'5" (475 × 287 cm)
Musée de Grenoble

On September 25, 1606, Rubens signed a contract for "the finest and most splendid opportunity in all Rome"—the commission for the high altar of Sta. Maria in Vallicella, the so-called Chiesa Nuova (New Church) of the Oratorian priests.[8] Founded by St. Philip Neri, who was in the forefront of the Counter-Reformation's spiritual renewal of Rome, the church had two patron saints, the Virgin and Pope Gregory the Great, and possessed a miraculous icon of the Virgin and Child—all to be featured in Rubens's celebratory altarpiece. Adapting his invention for SS. Trinità in Mantua (fig. 14) and remembering Titian's *Six Saints* (Pinacoteca, Vatican), Rubens arranged the saintly witnesses to the Roman faith before a triumphal arch, on top of which he located his version of the Madonna di Vallicella. The icon is illuminated by a ray of heavenly light, and the arch is bedecked with garlands held by a host of putti, indicating the visionary nature of the scene. Only one Corinthian pilaster is intact, and the left side of the arch is in ruins, a reference to the symbolic supplanting of imperial Rome by the Church, several of whose early saints and martyrs stand before it: Papianus and Maurus on the left; the regal virgin and martyr Domitilla on the right, accompanied by her martyred servants Nereus and Achilleus. Gregory the Great commands the central place of honor as he gazes heavenward. The Dove of the Holy Spirit (from which Pope Gregory reportedly took divine dictation) hovers overhead. His pose is a quotation of the Aristotle—also standing beneath a coffered Roman arch—in Raphael's *School of Athens* (Vatican Stanze), an apt prototype for this pontifical theologian, whom Rubens shows prominently displaying a massive folio of his writings.

Other Roman quotations abound: the martyrs Saints Maurus and Papianus stand in the parallel poses of Roman victors; the partially nude Maurus is derived from an antique statue of Mars Ultor (Capitoline Museum, Rome); the barely visible heads of Nereus and Achilleus closely resemble Roman republican portrait busts. The Church's proclamation of its early Roman heritage was a common theme of Counter-Reformation propaganda, to which Rubens contributed archaeological authenticity. He developed his ideas for the altarpiece through a series of preparatory drawings and a preliminary oil sketch (Staatliche Museen, Berlin-Dahlem). The finished painting is a brilliant mixture of Roman monumentality and the Venetian sensuousness of Titian and Veronese. But, owing to problems of reflected light in the church sanctuary, Rubens's masterpiece was barely visible. Rather than simply copy his own work—on nonreflective slate, this time—he expanded the subject to fill three separate slate panels: on either side of the sanctuary Gregory, Domitilla, and the attendant saints witness the apotheosis of the icon borne aloft by a host of putti (fig. 19), an arrangement that may have been suggested by Annibale Carracci's *St. Gregory* (S. Gregorio al Celio, Rome). Rubens's tripartite solution to the composite themes of the altarpiece—the veneration of an icon, Early Christian martyrs, and St. Gregory—exemplifies his expansive vision and foreshadows his mature High Baroque "altarworks" (plates 25 and 31; figs. 51 and 57).

Upon its removal from the church, Rubens tried to sell the first altarpiece to the duke of Mantua, but Gonzaga could not afford his painter's price, or so Rubens was told. Rubens took it home with him to Antwerp and subsequently installed it over his mother's tomb in the Abbey of St. Michael. (There it remained until Napoleon's army took it to Paris in 1794; later it was sent to Grenoble.) Enframed in an Italianate marble altar, the painting had a profound impact on Antwerp's citizens, clergy, and patrons. Its immediate reflection may be seen in Rubens's own *Glorification of the Holy Sacrament* (fig. 24), painted in 1609 for the Dominican Church in Antwerp. This Counter-Reformation altarpiece likewise features a gathering of Early Christian saints around the central object of adoration and incorporates a prominent quotation from Raphael's *Disputa*, which faces the *School of Athens* in the Vatican Stanze. The host of putti, embroidered gold vestments, and prominent dove recall Rubens's first essay for the Chiesa Nuova, the summation of his Italian study and achievement.

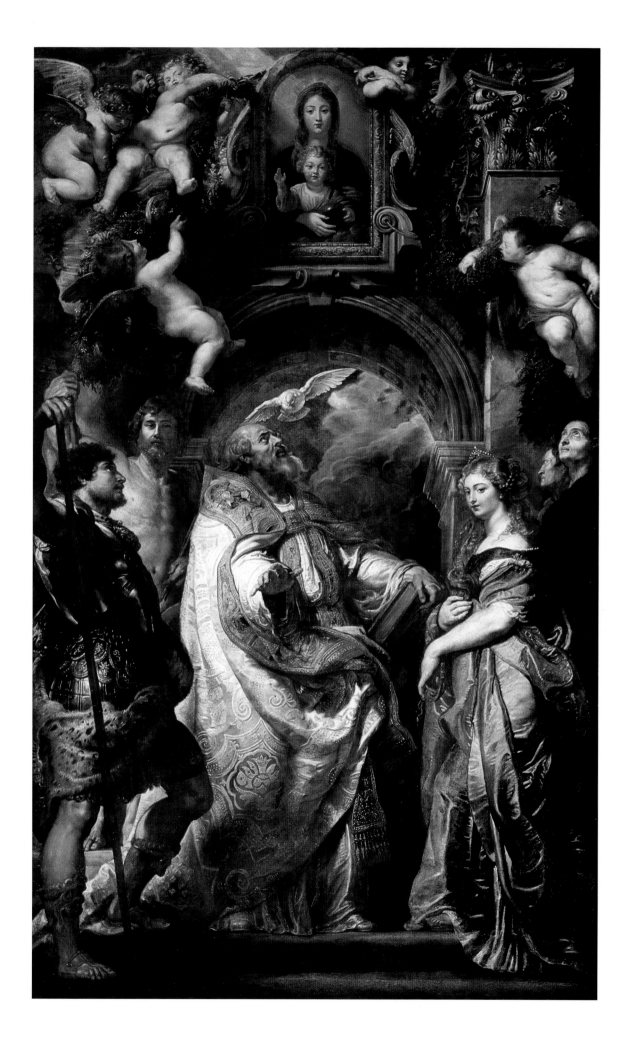

SAMSON AND DELILAH

1609
Oil on panel, 72¾ × 81" (185 × 205 cm)
The National Gallery, London

Having completed his first civic commission, the *Adoration of the Magi* (fig. 23), in time for the signing of the Twelve Years' Truce at Antwerp's town hall in April 1609, Rubens painted this private masterpiece of flickering lights and warm sensuality for his "friend and patron" Nicolaas Rockox, burgomaster of Antwerp, who gave it the place of honor in his art gallery, installing it—most appropriately—above his fireplace. It would be hard to imagine a more dramatic combination of Italianate influences and Rubens's Flemish heritage. The subject is literally the stuff of which dramas—indeed, operas—are made: from Milton's *Samson Agonistes* to Handel's oratorio to Saint-Saëns's *Samson et Dalila*. The Old Testament account of seduction and betrayal elicited Rubens's full range of sensual and heroic contours.

Following the biblical text (Judges 16), Rubens presents Samson asleep on Delilah's knees and "in her bosom"—a salient phrase included in the Catholic Vulgate but discreetly omitted from the Protestant King James version.[9] Having finally extracted the secret of Samson's strength, Delilah calls a barber to cut "the seven locks of his head"; outside the room, the Philistines prepare to capture the now helpless hero. The scene is lit by no fewer than four visible sources: a brazier at the far left; the candle held by an old procuress, a reference to the Bible's suggestion that Delilah was "a harlot"; an oil lamp before the statue-in-niche; and a torch carried by the Philistine soldier at the door. Finally, outside the picture plane, a fifth (invisible) source of raking light casts the sculptural Samson into monumental relief. Rubens's chiaroscuro conjures up shades of Caravaggio, whose revolutionary art he had encountered in Rome. But the multiple light sources, the swag of drapery at the upper left, the antique drinking vessels, and—most important—the intimate setting belying the impending violence of the narrative reflect the influence of the German painter Adam Elsheimer, here projected into the scale and style of the Baroque. The reclining nocturnal temptress is derived appropriately from Michelangelo's personification *Night* in the Medici tombs, which Rubens had studied in Florence. Samson's exaggerated musculature recalls such antique sculptures as the *Farnese Hercules* and the *Torso Belvedere*. Their transformation into flesh and blood vividly illustrates Rubens's injunction, in his treatise *On the Imitation of Statues*, to "avoid the effect of stone."

Scholars have differed widely on Rubens's portrayal of Delilah: to some, she is decidedly sympathetic; to others, simply a "professional." Delilah's passivity, her hand resting tenderly on Samson's back, surely conveys more than indifference or even detachment. The meaning of her inscrutable, stony expression is revealed by the background sculpture of Venus and Cupid, the household gods: Cupid is shown not blindfolded but *gagged* by Venus—this is love silenced, by necessity. Such sculptural commentary is a recurrent iconographic device throughout Rubens's work, from his early title pages to his late mythologies. Here it provides the key to Delilah's mute ambivalence. The overtly erotic scene notwithstanding, Samson was traditionally understood as a prefiguration of Christ. Rubens reinforces this notion by the pietà-like configuration: the sleeping giant already suggests the self-sacrificial conclusion of the story in which Samson pulled down the temple on the Philistines and himself. Rubens was later to illustrate Samson's capture by the Philistines, the present narrative's violent climax that was similarly exploited in High Baroque cadences by Van Dyck (fig. 36) and Rembrandt. The latter raised it to unbearable intensity by focusing on the actual Blinding of Samson (Städelsches Kunstinstitut, Frankfurt), a subject of particular horror to a painter. Rubens's early masterpiece remains all the more evocative as a *prelude* to violence, wherein its psychological overtones reverberate. Thus it was with muted fanfare, trumpets muffled in silk, that the arrival of the Baroque in the north was heralded by the Flemish virtuoso.

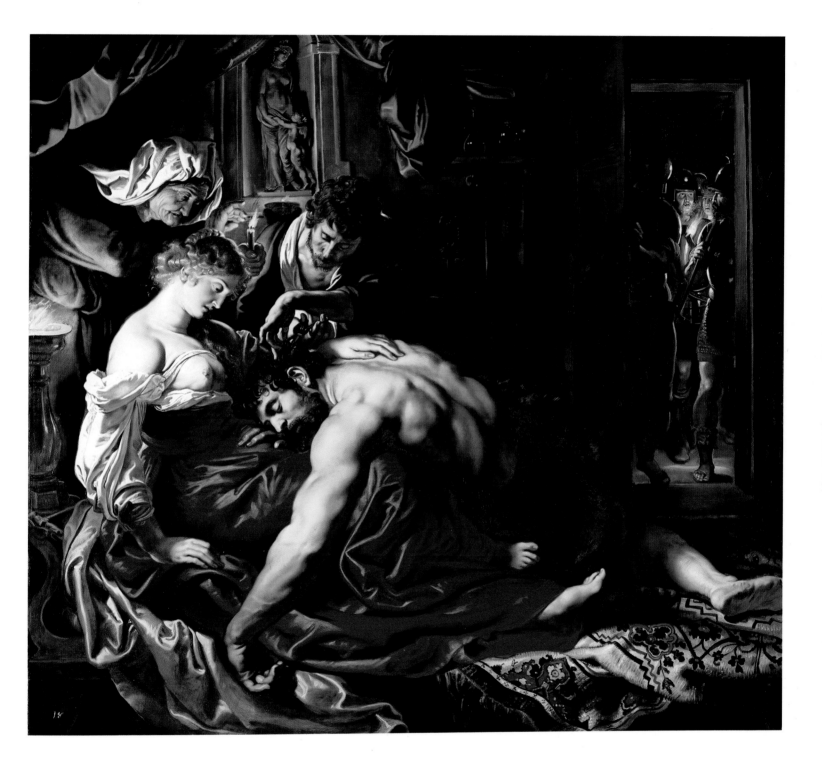

RUBENS AND ISABELLA BRANT UNDER A HONEYSUCKLE BOWER

1609–1610
Oil on canvas, 70⅛ × 53¾″ (178 × 136.5 cm)
Alte Pinakothek, Munich

Upon the marriage of his brother Philip to Maria de Moy in the spring of 1609, Rubens wrote that "my brother has been favored by the Cupids, Juno, and all the gods: there has fallen to his lot a mistress who is beautiful, learned, gracious, wealthy, and well-born," adding pointedly that he himself would "dare not follow him, for he has made such a good choice that it seems inimitable."[10] But within a matter of months, he likewise "dedicated himself to the service of Cupid." Peter Paul Rubens and Isabella Brant, daughter of a lawyer and city alderman Jan Brant (and the nineteen-year-old niece of Rubens's new sister-in-law), were married in the Abbey Church of St. Michael on October 3, 1609. His famous double portrait, painted soon after his marriage, visually dispelled any reservations he may have previously entertained.

The handsome couple are symbolically seated before a honeysuckle bower, an emblem of romantic love, as in Shakespeare's *A Midsummer Night's Dream*: "Sleep thou, and I will wind thee in my arms. . . . So doth the woodbine, the sweet honeysuckle gently entwist. . . . Oh, how I love thee!" Against this botanical backdrop Rubens added another traditional emblem: the couple's joined right hands, the *iunctio dextrarum*, a symbol of marital harmony and concord. Rubens's conjugal masterpiece—like Rembrandt's *Jewish Bride*—inevitably calls to mind its most famous Netherlandish predecessor, Jan van Eyck's *Arnolfini Wedding Portrait* (National Gallery, London). In his Baroque revision of Van Eyck's symbolic imagery, Rubens replaced a sacramental covenant with a poetic union of complements. Yet he retained a sense of medieval hierarchy.[11] Omitting any sign of his profession, Rubens presented himself dressed to the hilt as a prosperous Antwerp gentleman, his left hand resting on a bejeweled sword. Seated on a wooden bench, he placed himself a couple of feet higher than his wife, who sits (presumably on a low stool or perhaps a cushion) in a pose of feminine humility, like a Renaissance *Madonna dell' umiltà*. Her gold-trimmed silks and satins elaborate upon the golden hues of the honeysuckle and the evening

sun glowing through the bower. The meticulous brushwork in her delicate lace neck ruff and cuffs recalls the portrait of Marchesa Brigida Spinola-Doria (plate 3), here translated into a more colloquial Flemish idiom of well-to-do, middle-class assurance. Legs crossed and head slightly inclined—his hat concealing his already receding hairline—Rubens leans protectively toward Isabella, whose tilted straw hat gently reciprocates. The two figures are bound in a parenthetical oval.

Throughout his happy seventeen-year marriage to Isabella, Rubens never again painted their double portrait, but a few years after completing this picture he adapted the formula in the "double portrait" of the mythological painter Pausias and his spouse Glycera (Ringling Museum, Sarasota), an allegory of the marriage of art and nature. A decade later he elevated the motif to Olympian heights in the Medici cycle (plate 20), where Jupiter and Juno, in a rare moment of divine conjugality, look down approvingly on the prospective bridegroom, Henry IV, their hands joined in an emblem of concord. Recollections of the early masterpiece may also be found in Rubens's poetic revival of connubial imagery following his marriage in 1630 to Helena Fourment—the *Garden of Love* (plate 29), the *Walk in the Garden* (fig. 62), and its late recapitulation in his *Self-Portrait with Helena and Peter Paul* (fig. 77).[12] In reworking the latter self-portrait—his last—he artificially added several inches to his height so that, with his hand supporting his wife's, he towered over Helena in a protective, chivalric fashion that recalls his first marriage portrait. By that time, 1639, the *Honeysuckle Bower* was listed in the inventory of his late father-in-law's estate. Was it originally painted for Jan Brant, with whom Rubens and Isabella lived during their first years of marriage? Or did Rubens perhaps give it to Brant after Isabella's death and his remarriage to Helena Fourment? Whatever its original provenance, the fact that Rubens never copied the painting or its precise and personal formulation is a testament to its unique place within his oeuvre.

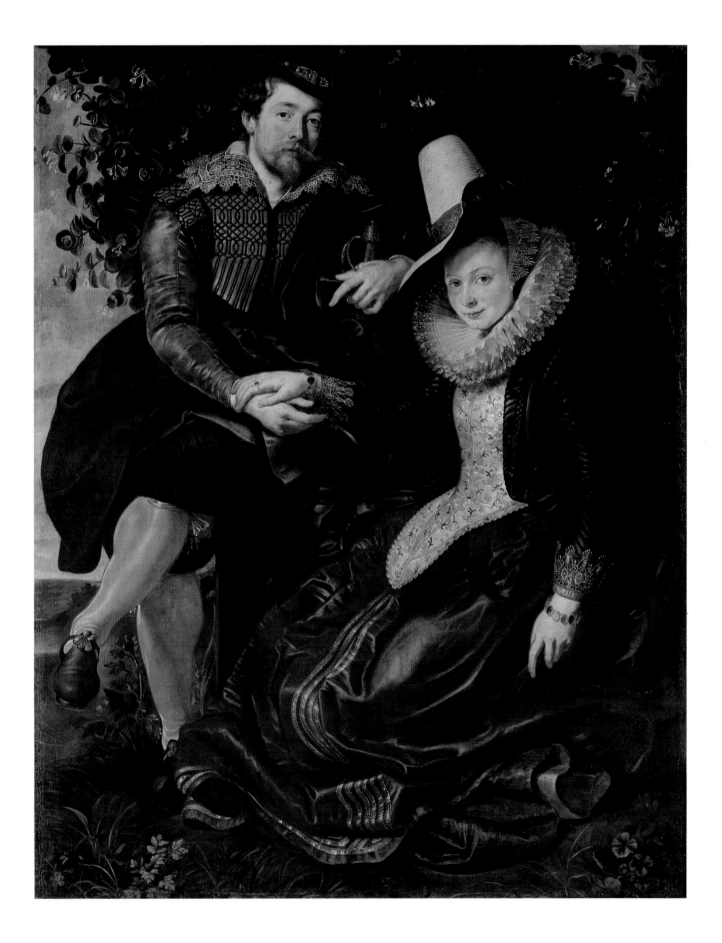

GANYMEDE AND THE EAGLE

c.1611–1612
Oil on canvas, 79⅞ × 79⅞" (203 × 203 cm)
Palais Schwarzenberg, Vienna

Rubens's Ganymede hardly seems the object of an abduction, much less a rape. According to Ovid's account in the *Metamorphoses* (X, 155f.), Jupiter was so infatuated with the young shepherd boy that he assumed the guise of an eagle and swooped down upon the unsuspecting lad, clutching him in his talons and carrying him to Mount Olympus, where Ganymede displaced Hebe as cupbearer to the gods. In Virgil's version in the *Aeneid* (V, 252f.), Jupiter sent his eagle to kidnap the youth. In either myth, Ganymede was traditionally illustrated in a terrified struggle with his captor. The story of Jupiter's homoerotic escapade was later neutralized and allegorized by Christian commentators as the ravishment of the human soul by God and its ecstatic ascent into heavenly bliss. In Michelangelo's famous drawing of the subject for Tommaso Cavalieri, the visual metaphor of the soul's rapture is combined with the artist's sublimated expression of erotic passion. Rubens, on the contrary, conveyed no struggle and no frenzy. His Ganymede rests comfortably on the wing of Jove's eagle, the youth's posture mirroring the bird's, as he gazes at it and reaches up expectantly for the golden cup of Hebe, the nectar of which grants eternal life and youth. (It is not clear which, if either, of the two women attendants here is Hebe.) At the upper left Rubens has inserted, in telescoped perspective, a thoroughly heterosexual Olympian banquet. It is to this divine assembly that Ganymede is being inducted, here described in a timeless, iconic fashion.[13]

Rubens's anticoncupiscent reinterpretation of Ganymede's abduction recalls its antecedent in Annibale Carracci's Farnese ceiling, where the subject is represented as an allegory of celestial love: Carracci's Ganymede, like Rubens's, is a willing participant in his heavenward flight, as he embraces the eagle and gazes into its eyes. Rubens's expressive pose is derived both from Carracci's fresco of the wooing Polyphemus (fig. 8) at the opposite end of the ceiling and from its antique source, the *Laocoön* (fig. 11). The Farnese Gallery itself contained, in one of its niches, an important sculptural precedent: an ancient statue of Ganymede, his arm gently draped over the eagle's wing.

Rubens's classically idealized youth is juxtaposed with a strikingly naturalistic eagle, an early example of the painter's virtuosity in depicting wild beasts and birds. Though Rubens surely had recourse to emblems and illustrated books of ornithology as well as engravings and drawings after antique models, the sheer precision and physical presence of this bird of prey suggest additional study from life, perhaps at the archdukes' aviary in Brussels. By the time he called upon the animal specialist Frans Snyders to contribute an eagle to their collaborative *Prometheus* (fig. 33), Rubens was clearly a master of the genre—and the species.[14]

The circumstances of this early mythology are unknown, the provenance unclear. A recent suggestion that it may have been intended to commemorate the untimely death of the artist's brother Philip in 1611 is appealing in the light of its celestial iconography.[15] Yet the heraldic associations of the prominent eagle may equally suggest a commission from the house of Hapsburg, perhaps even from the court of the archdukes in Brussels. Such imperial allusions are further reinforced by a final antique source for Rubens's iconography: the apotheosis of an emperor, which is found in late Roman cameos illustrating a deified emperor seated on the back of an eagle ascending heavenward.

Twenty-five years after he first took up the Ganymede story, Rubens was to return to the subject for the Torre de la Parada (Prado, Madrid), where he faithfully illustrated Ovid's frightened shepherd boy struggling in the clutches of Jove's talons—a conventionally dramatic abduction. But his first, Neoplatonic and Christianized interpretation anticipates the calmer, classicizing phase in the years following his return to Antwerp and perhaps might best be titled the *Apotheosis of Ganymede*.

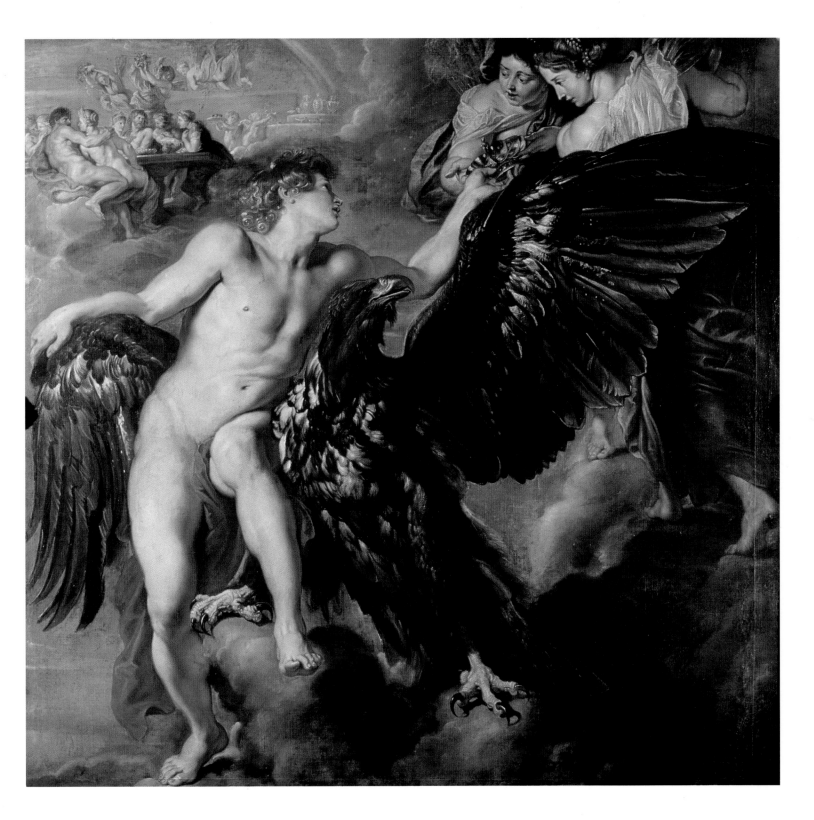

THE DESCENT FROM THE CROSS

1611–1614
Oil on panels, triptych
Central panel: 13'9" × 10'2" (420 × 310 cm); wings:
13'9" × 4'11" (420 × 150 cm) each
Cathedral of Our Lady, Antwerp

Nowhere is Rubens's transformation of his Flemish heritage more profound than in his two great Antwerp triptychs: the *Raising of the Cross* (fig. 25) for St. Walburga (1610) and the *Descent from the Cross* commissioned in 1611 for the altar of the Harquebusiers (or Musketeers—originally the medieval "Bowmen's Guild," later a charitable fraternity) in the cathedral. Today they stand as complementary masterpieces on opposite sides of the cathedral's nave. Though not conceived as a pair, they represent a natural progression.[16] The *Raising* reveals Rubens's early Baroque aspirations, charged with the spirits of Tintoretto, Michelangelo, and the Hellenistic model of heroic suffering, the *Laocoön*. The *Descent*, in keeping with its biblical subject, expresses a stately serenity, poignancy, and classicizing equilibrium. The *Laocoön* (fig. 11) is still the central quotation from antiquity. Rubens has reversed the torso of the suffering Trojan priest, adapting it to the Priest/Victim being lowered from the cross by his disciples. Nicodemus, standing on the ladder at the right, is a corresponding quotation of Laocoön's elder son.

Rubens received the commission in March 1611. The impetus once again came from his "friend and patron" Rockox, the president of the guild. The central panel was installed in the cathedral in September of the following year. The genesis of Rubens's interpretation goes back a decade to his first visit to Rome, to a pen-and-wash drawing (Hermitage, Leningrad) inspired by Daniele da Volterra's *Deposition* in SS. Trinità dei Monti. The definitive composition for the triptych evolved through a series of pen-and-ink sketches, followed by a *modello* (in oil) presented for the guild's approval.

The wings illustrate the Visitation, on the left, and the Presentation in the Temple on the right; and, on the outside shutters, the medieval legend of St. Christopher and the Hermit. (These were not begun until after the central panel had been delivered and were not completed for another two years.) The triptych's unified iconographic program celebrates the guild's patron saint, Christopher. The holy giant is based on an antique sculpture, the *Farnese Hercules*. In keeping with the meaning of his Greek name, Christophoros ("Christ-bearer"), he is shown carrying the Christ Child across a river. Each of the three biblical subjects on the inside panels likewise illustrates the bearing of Christ. On the left, the Virgin carries Christ in her womb as she visits her cousin Elizabeth—a lyrical, pastoral, thoroughly Venetian visualization deriving from Veronese. On the right, the high priest Simeon holds the Christ Child as Mary raises her arms to receive him, a gesture poignantly varied in the central panel, wherein the Mater Dolorosa reaches up to hold her dead Son. Behind Simeon, Rubens has inserted a profile of Rockox, a discreet "donor portrait" honoring the head of the guild.

Together, the three panels present a gradual compositional descent to the right, an effective counterpoint to the central leftward lowering of the dead Christ along a suspended sheet of incomparable whiteness. Upon seeing the work for the first time in 1781, Sir Joshua Reynolds commented that "none but great colorists can venture to paint pure white linen near flesh." He considered Rubens's Christ "one of the finest figures that ever was invented." A century later, Eugène Fromentin offered an eloquent summation: "Everything is restrained, concise, laconic, as if it were a page of Holy Scripture."[17] The central, Eucharistic doctrine of the Counter-Reformation had affirmed both the reenactment of Christ's sacrifice in the Mass and the physical presence of Christ in the sacrament received by the faithful at the altar. Nowhere were those beliefs conveyed with such conviction and pathos as in the triptych that opened over the altar of the Harquebusiers in Antwerp's cathedral.

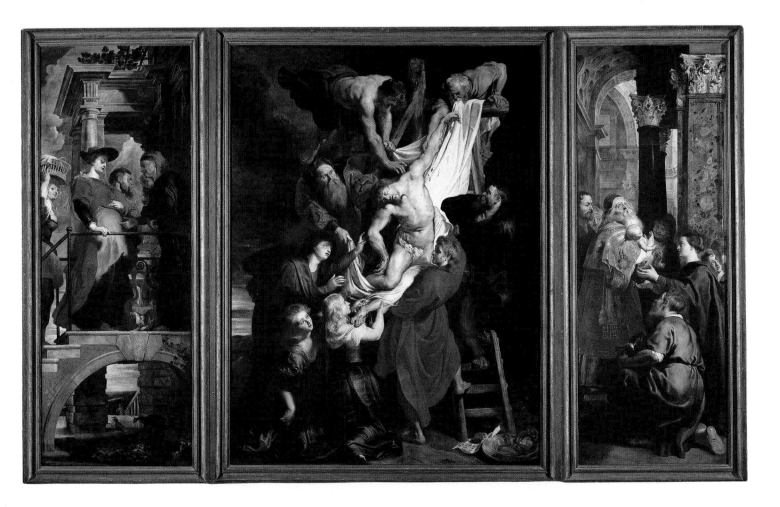

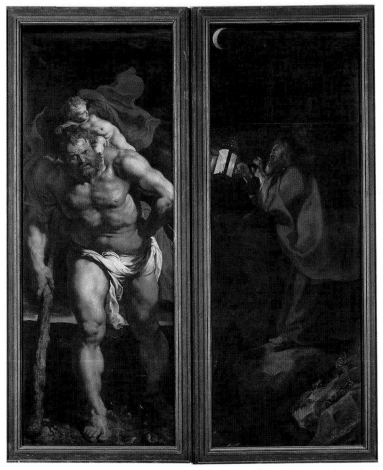

JUSTUS LIPSIUS AND HIS PUPILS ("THE FOUR PHILOSOPHERS")

c.1611–1614
Oil on panel, 65¾ × 56¼" (167 × 143 cm)
Palazzo Pitti, Florence

Rubens's unwavering devotion to the Catholic faith was matched by his lifelong adherence to Christian humanism, the reconciliation of the ancient Greco-Roman philosophers with orthodox Christianity. He was especially attracted to the Neo-Stoic philosophy of the Flemish humanist Justus Lipsius (1547–1606). Developed toward the end of the sixteenth century and based on the works of Seneca, Lipsius's Christianized Stoicism, emphasizing a fatalistic and serene acceptance of adversity, offered a timely spiritual response to the prolonged sufferings inflicted by the war in the Netherlands. In his letters, Rubens frequently echoed this philosophy—despite his disclaimer upon the death of his wife that he had "no pretensions about ever attaining a Stoic equanimity." He gave early witness to his personal commitment in this group portrait—commonly called the *"Four Philosophers"*—in which he included himself within an imagined communion of the master and his disciples.

Dressed in an ermine-trimmed gown, Lipsius sits at a table on which lie leatherbound folios, quills, and an inkwell. His preeminence is symbolically reinforced by the marble column directly behind him. He elucidates a passage in a book, while at the right, listening intently, sits his pupil and executor Jan van den Wouwer (Woverius). Lipsius's Scottish dog, Mopsus, is at his side, an emblem of faithfulness and learning. (Lipsius had routinely brought the dog with him to his university lectures at Louvain and exhorted scholars to "follow the example of the dog and pass day and night without sleep!"[18]) At the left sits Philip Rubens, his raised right hand holding a pen, a reference to his ultimate career as secretary of Antwerp. At the far left, standing before a swag of red drapery, his gloved hand revealing no hint of his profession, is the artist himself. Behind Lipsius in parallel three-quarter profile within a stone niche is a bust of Seneca (or so it was thought to be in Rubens's day); beside it, a vase of four tulips—two in full bloom, two closed—provides the key to the commemorative nature of this group portrait. At the time of its painting, late 1611 to early 1612, both Lipsius and Philip Rubens were dead. The

clematis vine entwined behind Philip is a traditional emblem, like ivy, signifying enduring affection after death. Between the two men there opens up a vista of the Palatine Hill above the Roman Forum. Its function is spiritually, not factually, topographical: Lipsius and his pupils had never met in Rome, except in the reflected realm of discourse.

This imaginary and anachronistic gathering recalls Rubens's earlier humanist group in the so-called *Mantuan Friendship Portrait* (Wallraf-Richartz Museum, Cologne), probably painted in 1604, which also includes a symbolic—and equally anachronistic—portrait of Justus Lipsius. The "Seneca" bust is based on a replica of the Hellenistic sculpture—now thought to represent the Greek poet Hesiod—that Rubens acquired in Rome, took home to Antwerp, and installed in a niche in his sculpture rotunda before he eventually sold it to the duke of Buckingham. Its symbolism is literary: at the time Rubens undertook this painting the Plantin-Moretus Press was preparing a deluxe edition of Lipsius's *Seneca*, with a title page designed by Rubens. It was published in 1615, the same year as Woverius's edition of Philip Rubens's collected writings.[19]

Beyond these mutual associations, the *Four Philosophers* reflects Rubens's deep involvement in the world of books. As a commemorative group portrait, it remains unique in his work, a highly original *sacra conversazione* of scholars. Its compositional source is to be found not within portraiture, but in religious painting: specifically, Titian's *Supper at Emmaus* (Louvre, Paris), which shows the resurrected Christ's reunion with two disciples at a table. Rubens substituted a rhetorical gesture for one of blessing as the sacramental meal is here replaced by a literary feast, with the artist in place of the servant/witness. Shortly afterward, Rubens reapplied the symbolic grouping to a thematically related subject, the *Four Evangelists* (Bildergalerie, Potsdam-Sanssouci), in which the three synoptic authors are seated at a table—books and quills at hand—while the youngest apostle, John, stands at the side.

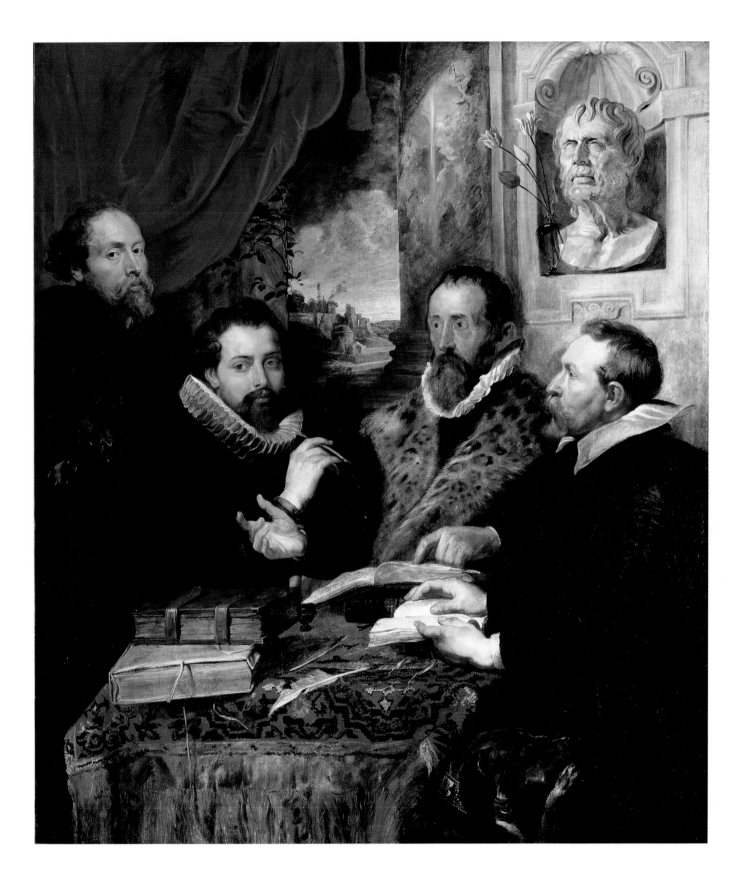

LANDSCAPE WITH CARTERS

c.1617–1618
Panel transferred to canvas, 33⅞ × 49¾" (86 × 126.5 cm)
Hermitage, Leningrad

Of the thirty or more landscapes painted by Rubens, roughly half remained in his estate at the time of his death. His nephew and biographer Philip Rubens considered them to be among his most highly esteemed works. Yet in this genre Rubens was a relatively late bloomer. After alternately delegating his backgrounds to such landscape specialists in his studio as Jan Wildens and offering a few suggestive glimpses of his own (plate 9 and fig. 28), Rubens took up painting independent landscapes about 1616. Beginning with the *Pond* (Liechtenstein Collection, Vaduz), the *Landscape with Boar Hunt* (Gemäldegalerie, Dresden), and the *Prodigal Son* (Koninklijk Museum, Antwerp), these works invariably include figures and an implied narrative. His *Landscape with Carters*, dating a year or so later, is one of his most evocative and resonant creations in the genre and owes as much to the painter's poetic imagination and philosophy as to his direct observation of nature.[20]

Though painted entirely in a studio (artists did not move their easels outdoors until the nineteenth century), the extraordinarily tactile values in the trees, gnarled roots, stumps, and outcropping of rocks that frame the central subject, the carters with their horse-drawn wagon, are based on life studies such as Rubens's magnificent pen-and-ink and chalk drawing of c.1616 in the Louvre (fig. 35). But the landscape itself is to be found nowhere in nature: Rubens has fused *two* landscapes, each with its own time of day and horizon. On the right, the sun casts a golden hue over the plains rolling to the far distant mountains. On the left, night has fallen; a full moon is reflected in the pond, bats fly above the treetops, and two figures sit by a campfire. This juxtaposition of time is compounded by disparate points of view and horizon lines, their juncture artfully concealed by the massive central outcropping of the cleft rock. In front of it, two Flemish carters steer a wagonload of hewn rock precariously down a hill as they attempt to ford a stream. The driver looks back apprehensively at his companion,

who throws his weight against the side of the wagon to prevent it from toppling.

The poet Goethe noticed in an engraving of Rubens's *Return from the Fields* (Palazzo Pitti, Florence) a similar inconsistency of sunlight casting shadows in opposite directions. Goethe approvingly concluded that Rubens, like Shakespeare, had freed himself from artistic constraints and the laws of nature.[21] His *Landscape with Carters* transcends its natural boundaries in order to convey a broader cosmological principle. The inherent tension and dynamism illustrated in the descending cart and in the animistic twisting limbs, roots, and tree trunks evoke a classical resolution of opposites and a balancing of conflicting forces, a concept that was central to Renaissance and seventeenth-century natural philosophy. The world itself—corruptible, ever changing, charged with life—was seen as set in precarious balance, like the cart.

"Mixed is the origin of this world," wrote the ancient poet Juvenal, "and its frame composed of contrarious powers." According to Ovid, "fire may fight with fire, but heat and moisture generate all things, their discord being productive."[22] Rubens here included all four elements—earth, air, fire, and water—of which the universe was thought to be composed. The campfire is juxtaposed with the cool reflection of the moon, a passage that recalls Elsheimer's nocturnal *Flight into Egypt* (fig. 15), a small masterpiece purchased by Rubens and later emulated in several of his landscapes. The evocation of opposing forces is heightened by the contrary directions of movement: cart and landscape descend from right to left, in contrast to our natural reading of the composition, from left to right, a progression broken by the sharp caesura of the rightmost tree, which, defying gravity, grows at a forty-five-degree angle into the composition. We almost feel the wagon's weight, reinforced by the parallel lean of the tree. Yet the landscape, like its author's world view, is essentially optimistic: the center holds—a reaffirmation of cosmic unity—as day descends into night.

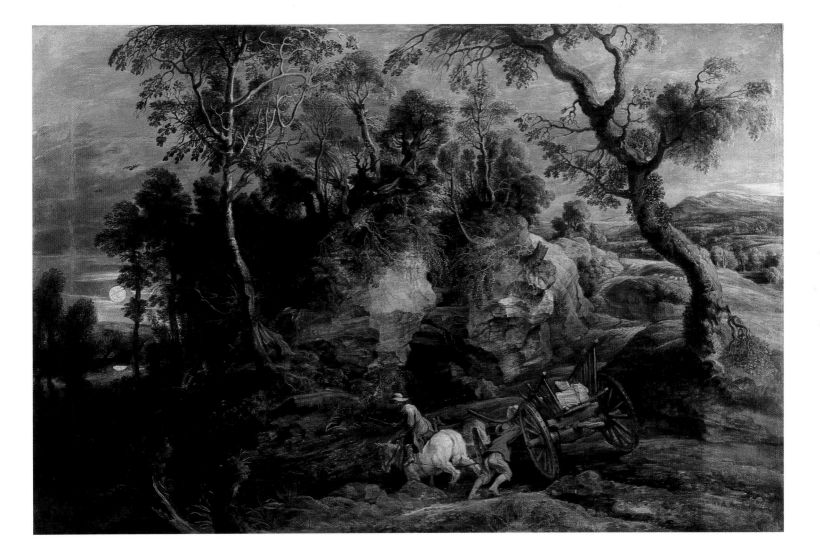

THE BATTLE OF THE AMAZONS AND GREEKS

c.1616–1618
Oil on panel, 47½ × 65" (121 × 165 cm)
Alte Pinakothek, Munich

During the years 1616 to 1618 Rubens recreated three legendary battles, one Roman, one Hebrew, one Greek: the *Death of Decius Mus* (Liechtenstein Collection, Vaduz, fig. 38), the *Defeat of Sennacherib, King of the Assyrians* (Alte Pinakothek, Munich), and this *Battle of the Amazons and Greeks*, his undisputed masterpiece in the genre. In its own day, it held the place of honor within the picture gallery of Antwerp's leading patron of the arts, Cornelis van der Geest, for whom it was probably painted.[23] Protected from the sun by a curtain, Rubens's *Amazons* was displayed closest to the window overlooking the river Scheldt—most appropriately, in view of its subject, the battle at the Thermodon River. There the Athenians under Theseus (identifiable at the upper left by his red-plumed helmet) beat back the race of female warriors from Asia Minor led by the Amazon Queen Hyppolite (at Theseus's right, dressed in a red tunic and peacock-plumed helmet and looking back apprehensively at the victor apparent).

This mythologically staged battle of the sexes was commonly depicted on ancient sarcophagi but was extremely rare in Renaissance art. Rubens here gave full rein to his powers of invention, creating a swirling mosaic of violence and passion, of warriors and animals, bound together as though caught up in a tidal wave. His sources included motifs from sarcophagi, his own earlier treatments of the subject—the Potsdam panel (fig. 5) and a pen-and-ink sketch (c.1600–1601, British Museum, London)—and Renaissance battle frescoes such as Leonardo's *Battle of Anghiari* (fig. 7), Giulio Romano's *Battle of the Milvian Bridge* in the Vatican's Sala di Costantino, and Titian's *Battle of Cadore* painted for the Doge's Palace in Venice.[24] If Leonardo provided the inspiration for the central group of warriors, Giulio and Titian contributed the broader battlescape. (Titian's fresco, like Leonardo's, had been destroyed. Rubens probably knew it through a print or copy.) In the early Potsdam panel (fig. 5),

Rubens located the battle on dry land—perhaps to accommodate his collaborator, the landscapist Jan Brueghel—with the Thermodon River and bridge barely visible in the distance. In the Munich panel, the bridge and the river, which recedes to the vanishing point, define the axes of the battle, itself an oval chain of bodies around the bridge. Rubens's powerful expression of continuous, cyclical movement represents a horizontal variation on the *Large Last Judgment* (fig. 32). It seems fitting that both his reformulations of High Renaissance prototypes are defined by an oval, that quintessentially Baroque form that displaced the Renaissance circle as the compositional and architectural *leitmotif* of the seventeenth century.

The magnificent rearing—and riderless—horses at the upper right conjure up Virgil's epic imagery: "Straight up reared the steed, its hooves whipping the air, and threw its rider headlong" (*Aeneid* X, 895). Especially striking is the configuration of a partially nude Amazon and horse at the lower right, which is described in counterpoint to the charging Amazon at the other side and highlighted with a splash of red drapery. Having toppled off the bridge and just hit the surface of the water, the inverted pair rounds the corner of the panel and leads the eye back to retrace the left-to-right cavalry charge. The origin of the motif in Rubens's work appears in one of his earliest mythologies and seascapes, the tumultuous *Hero and Leander* (Yale University, New Haven), in which the drowning figures are underscored by a similar glistening sweep of the brush: no painter was ever to surpass Rubens in transmuting oil into water.

Certain works are definitive. Rubens never returned to this subject. Yet a few years later, when designing his *Battle of the Milvian Bridge* for the Constantine tapestry cycle, he once again revived Giulio Romano's fresco of the battle (Vatican Stanze) to produce a variation upon his own *Battle of the Amazons*, thus completing the bridge of associations.

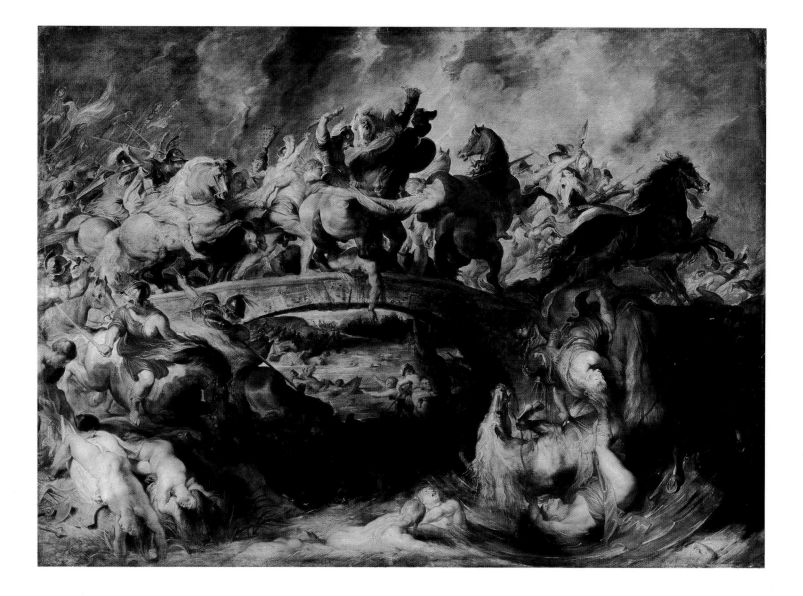

THE RAPE OF THE DAUGHTERS OF LEUCIPPUS

c.1618
Oil on canvas, 88 × 82⅞″ (224 × 210.5 cm)
Alte Pinakothek, Munich

Rubens's mythologies from the decade 1610–1620 may be bracketed, or embraced, by two "rapes": his *Ganymede* (plate 7) and his *Daughters of Leucippus*. While the underlying meaning remained constant—divine rape as a metaphor of the soul's heavenly ascent—its formal expression underwent dramatic metamorphosis from a frontal, iconic image to a dynamic contrapposto, a projection onto canvas of freestanding statues with multiple views. The myth of the rape of the daughters of King Leucippus of Messene by the demigods Castor and Pollux is recorded in ancient literature (Theocritus, Hyginus, and Ovid) but appears to be unprecedented in painting. The twins, Castor and Pollux, were better known as calmers of the sea and as horse-tamers: the famous equestrian statues on the Quirinal Hill in Rome are here recalled by Rubens's inclusion of their spirited steeds.

The unusual scene of the daughters' abduction was found on ancient sarcophagi as an allegory of the soul's salvation.[25] Rubens's visual source of inspiration was Giovanni Bologna's famous *Rape of the Sabines* in the Piazza della Signoria in Florence. The Mannerist sculpture was conceived as a tour de force, an exploitation of multiple viewpoints. Rubens in turn created with his brush a geometric coordination of opposites, like the revolving spokes of a wheel, the painter's version of a *perpetuum mobile*. The contrasting hues and textures of male and female flesh are mirrored in the juxtaposition of red and gold drapery and dark and light horses. Gravity is seemingly suspended as Hilaeira is raised heavenward, her eyes upturned like a Baroque saint in ecstasy. Her pose is drawn from Rubens's early *Leda* (Gemäldegalerie, Dresden), itself based on Michelangelo's *Leda*, an apt quotation since Leda—seduced by Jupiter disguised as a swan—was the mortal mother of the demigods Castor and Pollux. Phoebe's twisted pose and expansive gestures originated with the *Laocoön* (fig. 11), the antique touchstone for so many of Rubens's figures, both secular and sacred (plates 7 and 8 and fig. 25). The

poses appear more rhetorical than reactive, for the "rape" was benign. Castor and Pollux married the princesses and were model husbands, a happy outcome that Rubens here conveyed by the two winged cupids holding the reins. Brute passion is bridled. Lust has been reined in by Love.

The upward sweep of gestures and rearing horse is heightened by the unusually low vantage point, with over two-thirds of the backdrop given to sky. The landscape, a sensuous carpet of undulating hills and plains, is punctuated by deep foliage and shadows, nature's reflection of the central subject and a harmonization of opposites that recalls Rubens's *Landscape with Carters* (plate 10). Even the horizon line gently rises from the left. No painting of this period invites closer analysis. From the perfectly choreographed feet of Pollux and Phoebe—his toes precisely intervening between hers and the ground—to the multiple parallel gestures, the implied sensation is closer to an ecstatic dance than a violent abduction. Even its immediate predecessor, *Boreas Abducting Orithyia* (Academy, Vienna), appears comparatively chilling, as befits a bracing abduction by the god of the North Wind. In the *Daughters of Leucippus*, warm colors and golden hues illuminate Rubens's classic, Mediterranean vision.

The origins of the painting are unknown; its primary meaning remains speculative. Is it, like the *Ganymede* (plate 7), an allegory of salvation, of the soul's transport, in keeping with its iconographic derivation from sarcophagi? Or, based on Rubens's knowledge of its literary sources, is it an allegory of marriage and conjugal harmony? Perhaps it is even a political allegory, as has more recently been proposed.[26] The solution, if indeed there is but one, must encompass the internal evidence: the pervasive themes of conflict and consummation, discord and harmony, abduction and elevation. The key, perhaps, is offered by the cupid holding the rein who alone looks out of the picture toward the viewer and ensures the felicitous union of heavenly and earthly love.

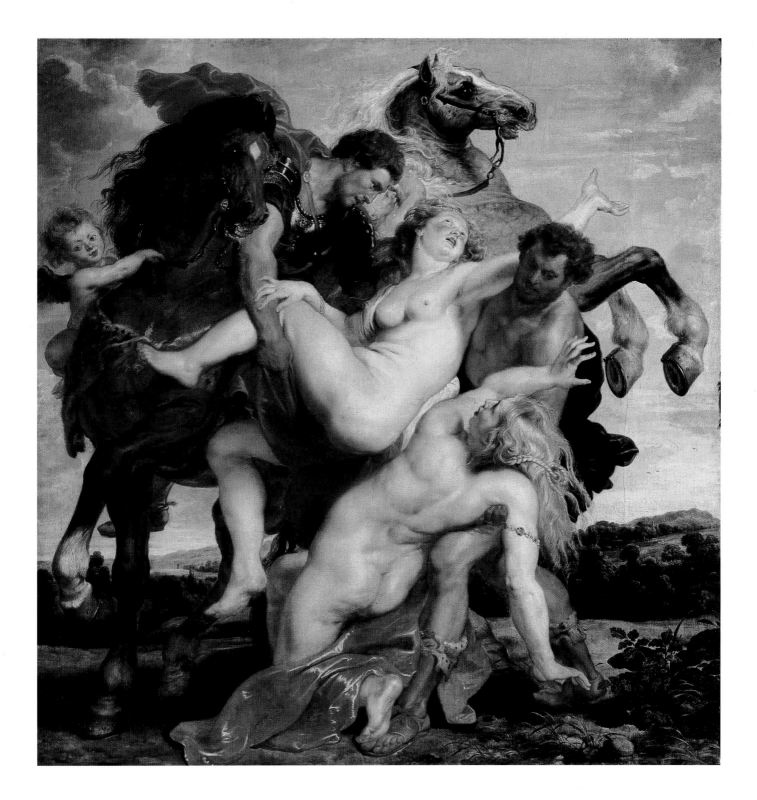

MADONNA AND CHILD WITH GARLAND AND PUTTI

(Flowers by Jan Brueghel I)
c.1618–20
Oil on panel, 72⅞ × 82⅝" (185 × 210 cm)
Alte Pinakothek, Munich

Rubens's coproductions with Jan Brueghel the Elder mark the zenith of collaboration in Flemish Baroque painting. Distinct from his workshop assistants, such collaborators were masters in their own right, specialists in a particular genre: Frans Snyders and Jan Fyt in animal painting, Jan Wildens in landscape, Osias Beert and Daniel Seghers in floral still life. Jan Brueghel stood apart: his various nicknames "Flower-," "Velvet-," and "Paradise-Brueghel" reflect the range of his talent. Nine years older than Rubens, he was born in Brussels in 1568, the son of the foremost Flemish landscapist and painter of peasant life, Pieter Bruegel. Like Rubens after him, Jan Brueghel made an Italian sojourn. Returning to Antwerp in 1596, he joined the painters' Guild of St. Luke in 1597 and the brotherhood of Romanists in 1599. Unlike Rubens, Brueghel was not transformed by Italy but remained quintessentially Flemish and conservative in his adherence to the northern tradition of detailed naturalism, which he applied to landscapes and floral still lifes. Following Rubens's return to Antwerp and his establishment of a workshop, the two artists—fellow Romanists and court painters to the archdukes—renewed their friendship and collaboration, which had begun in the studio of Van Veen (fig. 5). During the decade before Brueghel's untimely death in the cholera epidemic of 1625, they painted approximately a dozen works together. The Munich panel is especially striking in its evenhandedness—as perfect a balance between the two masters as it is between art and nature, or illusion and reality.

In the center, Mary displays her infant Son; around them is hung a wreath—a Baroque floral extravaganza—supported by eleven frolicking putti. Brueghel's encyclopedic array of flowers, a botanist's paradise, is rendered with painstaking naturalism. In the tradition of his early Netherlandish forebears, he holds, as it were, not a mirror but a magnifying glass to nature. The tight brushwork and precise arrangement of roses, tulips, lilies, narcissi, peonies, daisies, irises, carnations, hollyhocks, *ad paradisum*, are punctuated by the alternation of colors

and by the occasional sprig that breaks out of the circle. To Brueghel's virtuosic performance, Rubens introduced an illusionism of a different order. He dissolved the barrier between representation and reality in his joyous fugue of putti, who encircle the garland just as the flowers frame a *painting* of the Virgin and Child (which in turn is framed in dark wood)—a picture within a picture. This motif recalls Rubens's first altarpiece for the Chiesa Nuova (plate 4), in which he placed at the top of a triumphal arch a similarly framed icon of Madonna and Child adorned by sprightly putti with floral garlands. For his collaboration with Brueghel, a decade later, he adapted the upper portion of the altarpiece in a visual contest between art and nature. The triple-framed (quadruple, if we count the painting's own frame) image of the Christ Child is described as vividly and sculpturally as the "real" flowers and putti outside it. The Child has traditionally been identified with Rubens's second son, Nicolaas, born in 1618—if so, the work must date from 1619–20.[27] The facial similarities to Rubens's 1619 drawing of Nicolaas (Albertina, Vienna) are enticing—especially in view of the picture's celebratory emphasis on children—but they are by no means conclusive. As the Romantic critic Eugène Fromentin observed, Rubens seems to have incorporated the features of his second wife, Helena, into his paintings long before he met her, indeed before she was born![28] In Rubens's oeuvre, the type precedes the individual: nature imitates art.

This superlative devotional picture represents not only the joining of Antwerp's two leading painters, but of two traditions: Flemish flowers and Italianate putti whose derivation from antique sculpture recalls a concurrent collaboration by Rubens, the cartouche with the "Name of Jesus" surrounded by putti (fig. 40) on the façade of the Antwerp Jesuit Church. There, Rubens was at the mercy of his sculptor-translators, the De Noles. Here, in a common medium, he and Brueghel composed levels of illusion in a Baroque duet of unsurpassed harmony.

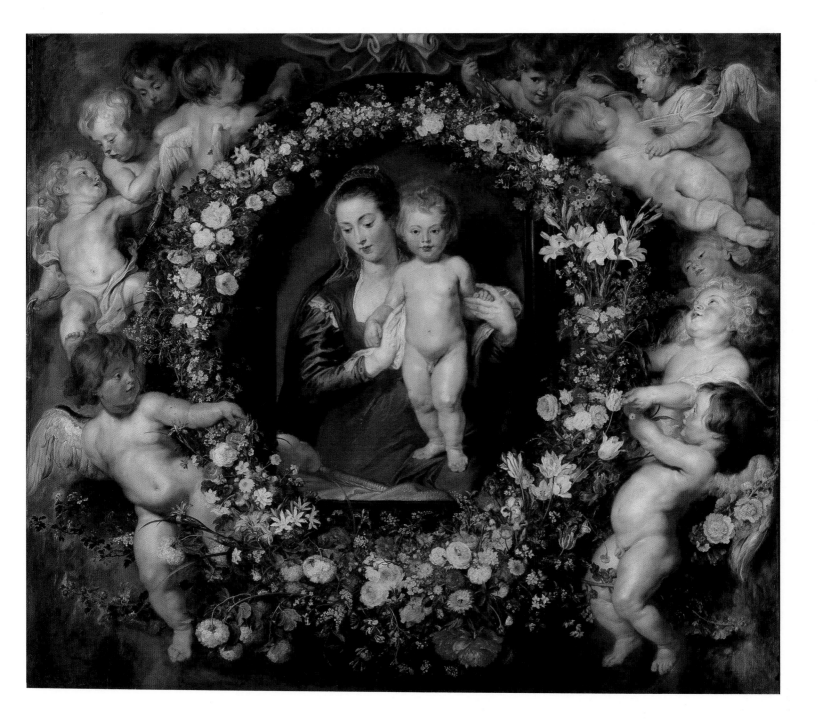

CHRIST AND THE PENITENT SINNERS

c.1618–1620
Oil on panel, 58 × 51¼" (147.4 × 130.2 cm)
Alte Pinakothek, Munich

After the Eucharist, the sacrament of Penance—the ritual confession and absolution of sins—was of foremost concern to Catholics during the Counter-Reformation. The rejection of sacramental confession by Protestantism had resulted in its insistent promotion by Catholics through every available means—sermons, treatises, and the visual arts. Following the doctrine's reaffirmation at the Council of Trent, images of penitent saints proliferated in altarpieces, in prints, and in paintings for private devotion.[29] In this painting, Rubens combined two of the most popular penitents, Mary Magdalene and St. Peter, together with the less frequently illustrated Good Thief and King David in a *sacra conversazione* of extraordinary grace and lyricism. This glowing picture represents the culmination of the artist's early Antwerp decade (1609–1620) of religious painting for public commissions and private patrons.

The composition is defined by the diagonal S-curve of the radiantly blond Mary Magdalene kneeling before the risen Christ, recalling their previous juxtaposition in the *Descent from the Cross* (plate 8). In both works, he emphasized the Magdalene's long, Titianesque tresses, with which she had dried the Savior's feet before the Passion. Christ is presented in classical perfection like a Greco-Roman god—a combination of Apollo and Jupiter. His brilliant red toga contrasts with the Magdalene's yellow white garment. Arms crossed over her breasts, she is identified as the woman taken in adultery whom Jesus saved and admonished to "go and sin no more." Behind Mary stand three biblical penitents, bridging both testaments and beckoned by Christ. Closest to the Savior is Peter, who, weeping and with hands clasped, reenacts his repentance for thrice denying his Master. The background rock symbolizes Christ's promise to him: "You are Peter and upon this Rock I shall build my church," an image and text invoked by the Roman Church in defense of the primacy of Peter and his papal successors. Identifiable by his crown is David—king, psalmist, and penitent adulterer. At the far left, holding a cross parallel to Christ,

is the Good Thief, to whom Jesus at the Crucifixion promised a place in Paradise. His pose is an evocative quotation of Michelangelo's *Risen Christ* (Sta. Maria sopra Minerva, Rome).[30]

Rubens's unusual grouping of several penitents before Christ recalls Otto van Veen's 1608 altarpiece of the same subject (now in Mainz), but his dual emphasis upon Christ and Mary Magdalene was derived from the iconography of the *Noli Me Tangere* ("Do not touch me"), the Risen Christ's first appearance to Mary Magdalene on Easter morning. Close as they are, they do not physically touch. As in the *Incredulity of St. Thomas* for the Rockox tomb (fig. 29), Rubens's stress upon the visual experience reaffirmed the function of religious art as prescribed by the Council of Trent: to evoke a lively sense of faith in the beholder. The comparison with the *Incredulity of St. Thomas* reveals the extent of Rubens's stylistic development from 1615 to 1620. The figure of Christ (in virtual mirror image) has evolved from a sculptural, polished Michelangelesque form to a more fluid, painterly description. The composition has opened from half-figure to three-quarter view. The softening of forms combined with greater lyricism in religious sentiment anticipates Van Dyck's transformation of his Rubensian models. Indeed, the iconographically related altarpiece of *Penitent Saints Before the Virgin and Child* (Gemäldegalerie, Kassel) of the same period has been ascribed jointly to Rubens and Van Dyck and raises the possibility of reciprocal influences between the two artists.

The circumstances and original function of Rubens's *Christ and the Penitent Sinners* are unknown, but similarities to the *Incredulity of St. Thomas* suggest that it too may have funerary significance as a panel designed for a tomb or epitaph. Indeed, Rubens's emphasis is not so much on the act of penance as on the receptive gesture of the Risen Christ, a visual confirmation of Job's faith: "I know that my Redeemer liveth." Rubens's heroic forms and sensuous surfaces are here combined in one of his most inviting affirmations of salvation.

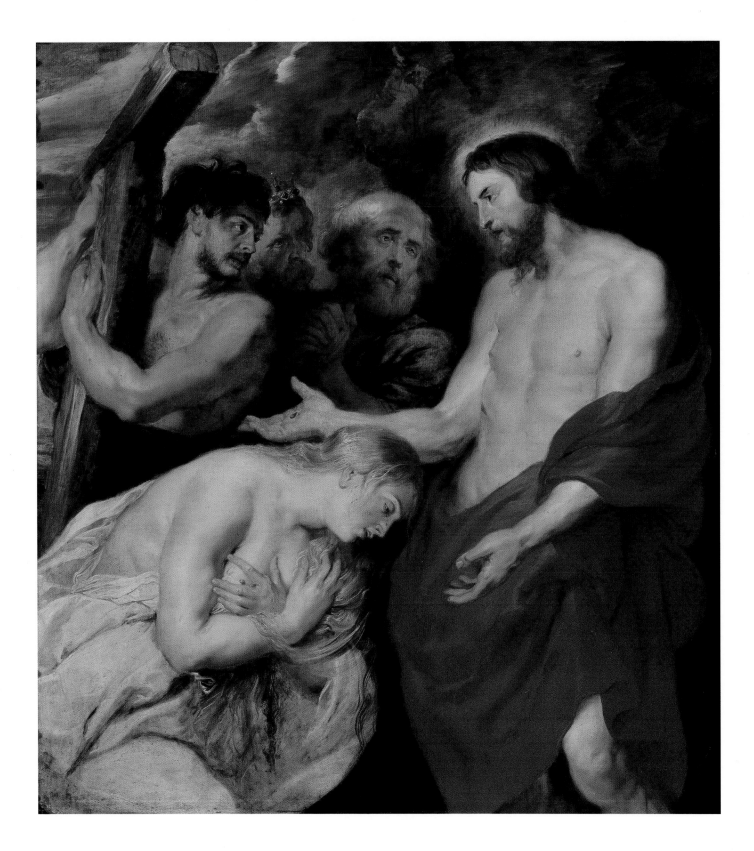

ABRAHAM AND MELCHIZEDEK

1620

Oil on panel, 19⅜ × 25⅜" (49 × 64.5 cm)

The Louvre, Paris

THE LAST SUPPER

1620

Oil on panel, 17⅛ × 17¼" (44 × 44.5 cm)

Seattle Art Museum, Seattle

Samuel H. Kress Foundation 61.166

On March 29, 1620, Rubens signed a contract with the Reverend Jacobus Tirinus, superior of the Jesuit House in Antwerp, in which he promised to deliver by the end of the year thirty-nine ceiling paintings to decorate the aisles and galleries of the new Jesuit Church. The contract obliged him to "make with his own hand the design of all the aforesaid thirty-nine paintings in small size and to have them executed by Van Dyck as well as some of his other pupils."[31] These colorful *modelli* were generally preceded by very rapid, lightly painted oil sketches in grisaille—demonstrating the validity of the French critic Roger de Piles's remark that "Rubens painted quite as much as he drew."[32] The ceiling paintings were destroyed by fire in 1718; our primary glimpses of them today are via Rubens's *modelli*, at least twenty-six of which have survived.

The ceilings of the two aisles, running from the entrance to the altar, were adorned with images of saints. The galleries on the upper level illustrated, in the words of the Jesuit father Michael Grisius, "the mysteries of our salvation in parallel fashion from the Old and New Testaments," a medieval iconographic program in which each New Testament scene was foreshadowed—or prefigured—by an Old Testament counterpart. The story of promise and fulfillment, covenant and redemption, unfolded in a didactic and literally straightforward fashion from the sanctuary to the narthex, a sequential arrangement that recalls Michelangelo's Sistine ceiling.

According to Genesis (XIV, 17–24), Abraham, "our father in faith," on his victorious return from battle was met by Melchizedek, "priest of God most high" and king of Salem, who gave him bread and wine. In return, Abraham offered him a tithe of all his booty. As both priest and king, Melchizedek was a traditional prefiguration of Christ; the bread and wine prefigure the sacramental elements of the Mass. In his overtly Catholic (sacramental) interpretation, Rubens emphasized the reception of the bread by Abraham, dressed in full Roman armor, as he ascends the flight of steps to Melchizedek, arrayed in high priestly vestments. The steps, on which rests an antique ewer of wine, both rationalize and dramatize the forty-five-degree viewpoint from below, *di sotto in su*, that Rubens adapted from the sixteenth-century Venetian ceilings of Titian, Tintoretto, and Veronese. The hierarchic placement of Melchizedek over the humbly bowing Abraham signifies the predominance of ecclesiastical over secular authority, church over state, a device Rubens had recently applied in his *Emperor Theodosius Before St. Ambrose* (Kunsthistorisches Museum, Vienna). The dominant crimson and golden yellow tonalities of this virtuosic oil sketch, together with the architectural staging, reinforce its symbolic connection with its adjacent New Testament counterpart, the *Last Supper*.

By contrast with the midday outdoor spectacle of the preceding subject, Rubens's *Last Supper* offers a view—again up a flight of steps—into the "upper room" where Jesus has gathered his disciples. A chandelier illuminates the scene; evening has fallen. Unlike Leonardo's famous fresco of this subject in Milan, Rubens's ceiling adaptation shows the group around a circular table, a formula that he perhaps derived from Van Veen's *Last Supper* altarpiece for the Antwerp cathedral (1594). The focus on the institution of the sacrament, rather than the dramatic announcement of betrayal, provides a clear Counter-Reformation thrust. Rubens has isolated St. Peter, first apostle and pope, as the first recipient of the sacrament; his juxtaposition with Christ is symbolically paralleled by Abraham before Melchizedek. The confidence and conviction conveyed in these masterly oil sketches, so appropriate to the Jesuits' new bastion of papal authority in the Netherlands, confirm the artist's own claim that "no undertaking, however vast in size or diversified in subject, has ever surpassed my courage."[33]

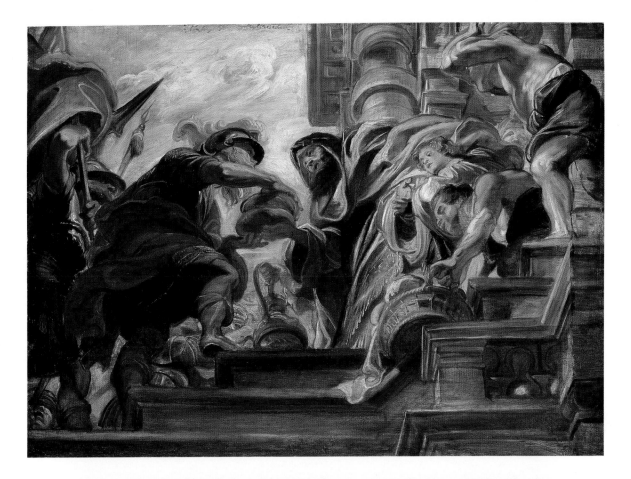

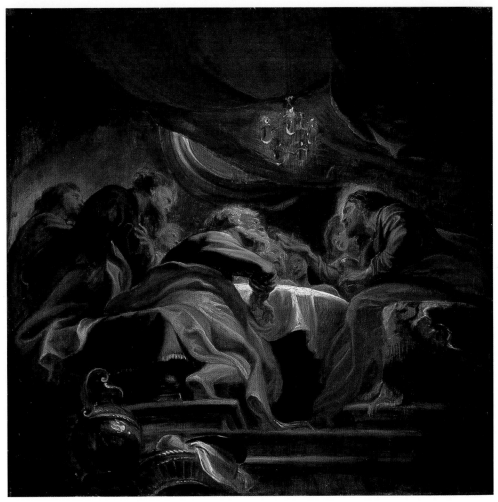

LION HUNT

1621
Oil on canvas, 8'2" × 12'4⁷⁄₁₆" (249 × 377 cm)
Alte Pinakothek, Munich

According to the English eighteenth-century painter and critic Sir Joshua Reynolds, Rubens's "animals, particularly lions and horses, are so admirable that it might be said they were never properly represented but by him."[34] Beginning about 1615, Rubens undertook commissions, with the help of his studio, for vast hunting scenes. The earliest documented works in this genre are a series of four hunts painted for the Elector Maximilian of Bavaria about 1615–1616: a *Wild Boar Hunt*, a *Tiger Hunt*, a *Hippopotamus and Crocodile Hunt*, and a *Lion Hunt*. Except for the first, a common pastime of European nobility, the subjects were wildly exotic, set in far-off lands with turbaned Arabs and Africans joining in the fray; the combined exoticism and zoological naturalism of Rubens's allegorical *Four Continents* (fig. 34) were charged with dramatic intensity. His animals reflect both nature and art, based as they were on Renaissance prints and bronzes as well as on life studies made in the archdukes' zoo in Brussels. The hunting scenes themselves were similarly derived from sixteenth-century engravings by Stradanus and Tempesta and from Leonardo's *Battle of Anghiari* (fig. 7). Rubens elevated the genre to a classical plane of battles between man and beast, climaxing in this final *Lion Hunt*, painted in 1621 for the English ambassador at Brussels, Sir John Digby, who in turn presented it to the marquess of Hamilton. Rubens considered this autograph ("entirely by my hand") canvas "in my opinion one of my best," a verdict upheld through three and a half centuries.[35]

The definitive composition evolved from a sheet of chalk sketches, followed by two oil sketches (in Leningrad and London) and several figure studies in chalk drawn from life, at least two of which have survived. These preparatory stages—as thorough as for an altarpiece—belie the French painter Eugène Delacroix's contention that "the whole effect is one of confusion, the eye does not know where to rest . . . as though art had not taken control sufficiently to enhance the effect of so many brilliant inventions by careful arrangement or by sacrifices."[36] (Despite his reservations, Delacroix was the chief beneficiary and Romantic heir to Rubens as artistic master of the hunt.) The extraordinary violence of the scene, its aura of visual dissonance, is controlled by the axial construction. The diagonals, reinforced by the spears, swords, and daggers, converge at the center as if drawn by some centripetal force. The evocation of imminent crisis focuses on the foreground figure who has been dismounted by the lion (its previous victim lying dead at the right). He is counterbalanced by the two Arabs, seen in complementary views—like the two daughters of Leucippus (plate 12)—who drive in their lances. At the left, two hunters on foot battle a lion. In the center, set off by a flourish of pink drapery, a knight in Roman armor and plumed helmet—like a *deus ex machina*—prepares to deliver the decisive blow. The hero is a quotation from Rubens's early *St. George Slaying the Dragon* of 1603 (Prado, Madrid). His reintroduction in this hunt emphasizes the picture's quasi-religious, humanistic status as "history painting."

Since the time of the ancient Greek author Xenophon (fifth century B.C.), hunting was regarded as a proper preparation and substitute for war, a view that survived through antiquity and the Middle Ages and into the seventeenth century. Though profoundly dedicated to peace—in fact, he undertook this commission for a known sympathizer of rapprochement between England and Spain—and disdainful of dueling ("the mania of the French"), Rubens infused his hunting scenes with noble heroism by pitting man against beast on equal footing, so to speak. His hunts evoke such classical encounters as the *Battle of the Amazons* (plate 11) and the *Death of Decius Mus* (fig. 38), not the grim warfare of his own century, with cannon, muskets, smoke, and ruin. On the brink of his diplomatic career, he pointedly—perhaps even prophetically—inserted into this English commission a reference to England's patron saint, the knight St. George, as he translated Leonardo's *Battle of Anghiari* into the ancient, civilized substitute for war. A decade later, Rubens himself would be knighted, and England and Spain would at last be at peace.

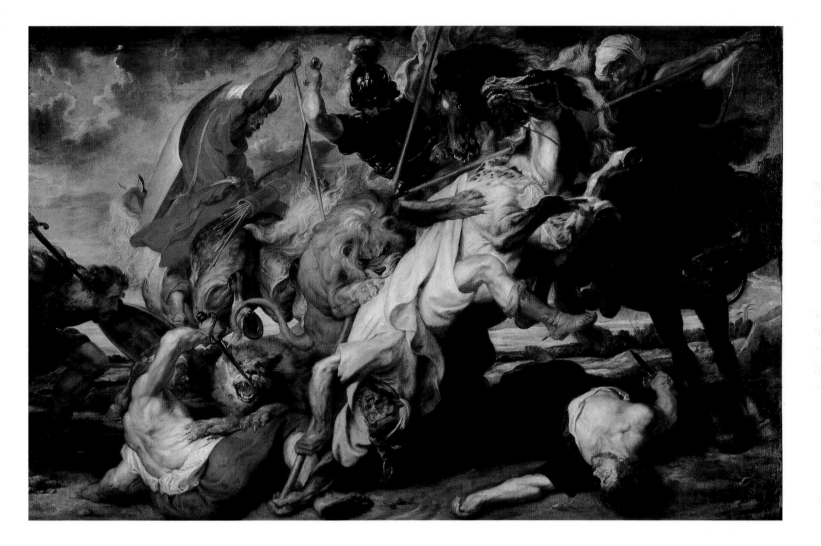

THE MARRIAGE OF CONSTANTINE

Designed 1622 (woven 1623–1625)
Tapestry, 16'1" × 17'11" (490 × 546 cm)
Philadelphia Museum of Art, Philadelphia
Given by the Samuel H. Kress Foundation

Like Shakespeare, Rubens took liberties with history. His second tapestry cycle, the Life of Constantine, first Christian emperor of Rome, was culled from several sources, ranging from the fourth-century Church historian Eusebius of Caesarea's *Vita Constantini* to the sixteenth-century Cardinal Baronio's *Annales ecclesiastici*. Rubens's series of twelve episodes opens with this double wedding of Constantine to Fausta, daughter of the Emperor Maximianus, and of Constantine's Christian sister Constantia to the pagan Licinius—despite the fact that the two weddings had taken place six years apart. The reason for such historical conflation was Rubens's (or his French adviser Nicolas-Claude Fabri de Peiresc's) evident desire to evoke, from the very start of the epic, analogies to the life of the reigning King Louis XIII, for whom the tapestries were intended—in this scene, the double wedding in 1615 of Louis XIII to Anne of Austria and of Louis's sister Isabelle de Bourbon to the future King Philip IV of Spain.[37]

Rubens has described the pagan ceremony with Roman splendor and a pious dignity that anticipates the scene of Constantine's Christian baptism. Set within the temple of Jupiter and Juno, the two Olympian gods constitute a sculpture invented by Rubens. Their expressiveness recalls the sculpture of Gaia in the *Discovery of Erichthonius* (fig. 28) and foreshadows the magnificent pietà designed by Rubens for Maria de' Medici's *Marriage by Proxy* (fig. 47). Their conjugal pose reflects Rubens's self-portrait with Isabella Brant (plate 6), as does the ceremonial joining of right hands (*iunctio dextrarum*) by the imperial participants. Constantine's dual role in the ceremony is stressed by his placement beneath the statue of Jupiter: Constantine gestures toward his sister, whom he gives away in matrimony while, a bridegroom himself, his right arm is supported by his father-in-law. Rubens's historical license is camouflaged by the archaeological precision, a reflection of his renewed study of antiquity with his friend Peiresc. Behind a sacrificial altar an acolyte carries the wedding torch and box of incense while another plays the flutes (*tibiae*). At the right, two ritual attendants, the axe-wielding *popa* and the kneeling *victimarius*, restrain a sacrificial beast. These classical details recall Raphael's *Sacrifice at Lystra* tapestry in the Vatican and Rubens's own scene of ancient sacrifices in his Decius Mus cycle, which he was later to revise for an episode in his Eucharist tapestries (fig. 54).

As in the Decius cycle, Rubens first painted *modelli* (fig. 46), to be enlarged into cartoons. Now lost, the latter were worked up in tempera on paper (not oil on canvas, as before) by his assistants. Comparisons between the *modelli* and the definitive tapestries reveal the extent to which the weavers faithfully interpreted Rubens's original designs. His inimitable touch was inevitably lost in the costly translation into woven silk threads; yet the successful—if painstaking and mechanical—magnification by the studio assistants and weavers into a scale twice lifesize attests to the underlying power and structure of Rubens's inventions. His figural scenes dominate the decorative borders, which were supplied by the tapestry workshop, and are emblazoned with Constantine's *labarum* and Louis's fleur-de-lis. In his next two tapestry cycles (plates 26 and 30) Rubens was to design his own borders, fully incorporating them into the compositions they enframe.

The Constantine series marks the transition from the early Antwerp commissions to Rubens's High Baroque fusion of history and allegory in the Medici cycle (plate 20). Constantine's triumph *all'antica* (fig. 46) was later adapted to the triumphs of the Eucharist (plate 26) and of Henry IV (fig. 60). But in Paris the incomplete Constantine tapestries were soon eclipsed by Rubens's Medici cycle for the queen mother. The seven finished hangings were given by King Louis to the papal legate, Cardinal Francesco Barberini, who took them back to Rome. There, eventually completed by the artist Pietro da Cortona and the Barberini weavers, this imperial cycle of tapestries magnificently adorned the great hall of the Palazzo Barberini—a triumphal reentry into Rome for Rubens, via Constantine.

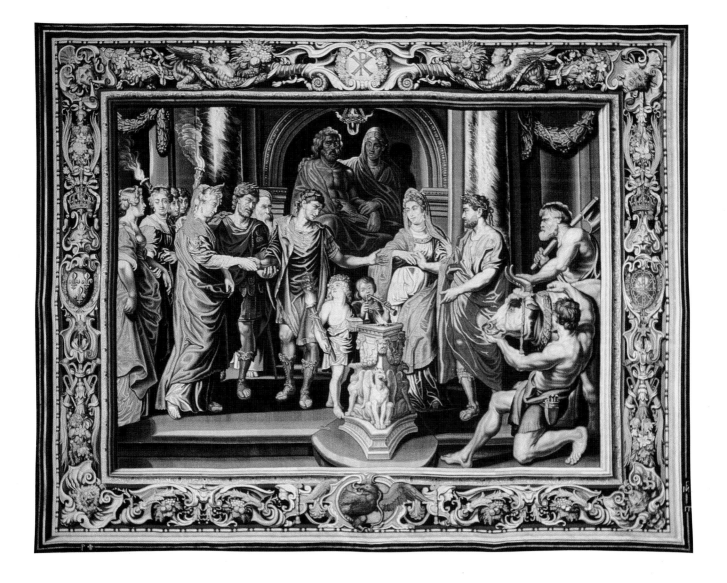

PORTRAIT OF SUSANNA FOURMENT ("LE CHAPEAU DE PAILLE")

c.1622–1625

Oil on panel, 31¹/₁₆ × 21¼" (79 × 54 cm)

The National Gallery, London

The title by which this stunning portrait has been known since the eighteenth century, *Le Chapeau de Paille* ("The Straw Hat"), is a misnomer; its origin, a mystery. The hat is of beaver, not straw. Only Rubens's authorship and the sitter's identity are not cast in doubt.[38] The third daughter of the silk and tapestry merchant Daniel Fourment, Susanna was the sister-in-law of Rubens's first wife, Isabella Brant. (Susanna's brother Daniel had married Isabella's sister Clara.) First married to Raymond del Monte in 1617, she was widowed in 1621. The following year, at the age of twenty-three, Susanna married Rubens's friend Arnold Lunden. Rubens later married her younger sister Helena in 1630, by which time Susanna had been dead two years. In Rubens's estate, four portraits of Susanna were cataloged, which gave rise to the entirely fanciful nineteenth-century legend that she had been his mistress.

Stylistically this portrait appears to have been painted sometime between 1622 and 1625, soon after the sitter's marriage to Lunden. While the matrimonial significance of her prominent ring has recently been questioned, the fact that Rubens featured a ring similarly worn on Isabella's right forefinger in their *Honeysuckle Bower* wedding portrait (plate 6) and on Maria de' Medici in her *Marriage by Proxy* (fig. 47) suggests that it here denotes Susanna's recent remarriage. She is shown holding a gray shawl with her arms demurely crossed below a décolleté black dress with open chemise. The composition was expanded twice during the painting, with strips of wood added to the right side and bottom of the panel: the result is one of Rubens's airiest and most ethereal conceptions, the distant ancestor of Renoir's portraits.

Sunlight streaks across Susanna's right cheek, long slim neck, and bosom. Her face, shaded by her hat, is softly illumined by reflected light. The problematic plumed hat has prompted several theories of its famous misidentification. One early explanation was that the

French title was a corruption and mistranslation of the Flemish *"Spaensch-Hoedeken,"* a reference to the hat's Spanish style that later devolved into "straw" (*spaenen*). By the mid-nineteenth century the standard exegesis was that it resulted from a corruption of its presumed original title, *"Chapeau de Poil,"* with *poil* (fur) becoming *pail*, and finally *paille* (straw). The German art historian H. G. Evers, on the other hand, maintained that Rubens himself gave the work its title but had in mind the alternate seventeenth-century meaning for *paille*: a parasol (from the Latin root *pallium*) or a hat providing shade.[39] The most likely explanation is that the title derived from eighteenth-century descriptions of another portrait of Susanna belonging to the Lunden family, now in a Belgian private collection, in which she is dressed as a shepherdess and does indeed wear a straw hat. The title, along with the description, was then later mistakenly transferred to the present picture in old guidebooks.

In the final analysis it is the face, not the description of the hat, that sets this portrait apart, particularly the extraordinary handling of flesh tones and pigments. According to Sir Joshua Reynolds, Rubens's figures "look as if they fed upon roses." Some roses! Susanna's face reflects the crimson hues of the silk sleeves so dramatically set off by the black dress, gray shawl, and blue slate background. The almost incandescent glow of her skin — as radiant as her two pendant pearls — emerges from Rubens's miraculous effect of thin oil glazes, which he applied to a surface of smooth gesso (plaster of paris) after lightly streaking it with a layer of gray charcoal to create a varied, reflecting base for the translucent layers of pigment. Later in life, Rubens promised to write for his friend and correspondent Peiresc a scientific treatise on the effect of colors. The manuscript — if completed — has been lost.[40] But in his paintings, above all *Le Chapeau de Paille*, Rubens offered more vivid and enduring observations than any essay, however learned, might contain.

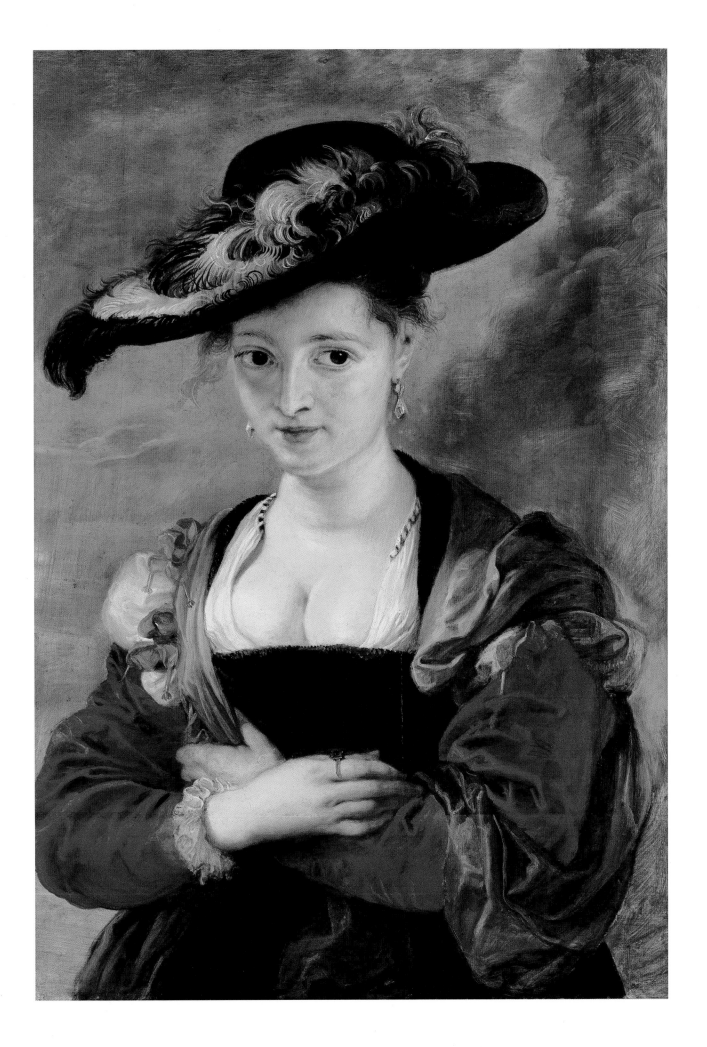

HENRY IV RECEIVING THE PORTRAIT OF MARIA DE' MEDICI

1622–1625
Oil on canvas, 12'11¹/₁₆" × 9'8¹/₈" (394 × 295 cm)
The Louvre, Paris

Maria de' Medici's marriage was not made in heaven; it was the usual political match arranged between two people who had never set eyes upon each other. She was the twenty-five-year-old daughter of the Medici grand duke of Tuscany. Her husband was the king of France, Henry IV, who had divorced the childless Marguerite de Valois in the hope of a more fruitful and lucrative remarriage. It was Maria's weighty dowry, not her pronounced Medici features, that captured Henry's heart—an awkward fact (and face) that Rubens artfully transfigured in his epic account of Maria's life for the gallery of her new Luxembourg Palace. The contract signed on February 26, 1622, specified that Rubens paint twenty-four scenes of "the very illustrious life and heroic deeds of the Dowager Queen." In view of her erratic—at times, pathetic—career at the French court, Rubens was obligated to unleash his most creative powers of invention.[41]

The fourth scene in the cycle, the presentation of the portrait, immediately precedes the *Marriage by Proxy* (fig. 47). Since the betrothed couple had not met in life, Rubens staged their initial meeting through art. Henry receives the portrait of his future bride air-messengered by Hymen (god of marriage) on the left and Cupid (god of love) on the right, who directs the king's gaze to Maria's visage. Gallia (the personification of France), in plumed helmet and adorned with fleurs-de-lis, gently prompts the king. Like Tamino before the portrait of Pamina in Mozart's *The Magic Flute,* Henry is clearly enchanted. Above, seated on clouds, the Olympian couple Jupiter and Juno gaze approvingly upon the scene, their hands joined in the emblem of concord, recalling Rubens's self-portrait with his bride (plate 6) and his more recent *Marriage of Constantine* (plate 18). The conjugal gods embody the divine alter egos of Maria and Henry—although in fact neither couple was blessed with marital tranquillity. (Henry, like the ruler of Olympus, was notorious for his roving eye.) Juxtaposed with Jupiter's farsighted eagle, Juno's more domesticated peacock cranes its neck to admire the bride's portrait. Direct

rapport with the viewer is established by Maria's engaging glance from the portrait, dissolving the boundary between what is real and what is depicted. Rubens's picture within a picture offers a variation on his *Gonzaga Family Adoring the Holy Trinity* (fig. 14), the two Chiesa Nuova altarpieces (plate 4 and fig. 19), and the *Madonna and Child with Garland and Putti* (plate 13).

The propaganda of the cycle is conveyed by disarming details. In the distant landscape the smoke of battle rises, a reference to the war in Savoy that Henry was pursuing at the time. Still dressed in ceremonial armor, Henry has removed his helmet and shield, with which two carefree putti play. Through the power of love, the warrior is already transformed into the peaceful monarch: *omnia vincit amor.* The antimartial emphasis reflects a key motivation of the cycle as an apologia for the queen mother's policies. Unlike her son's bellicose ministers—above all, Cardinal Richelieu—Maria had advocated rapprochement with France's potential adversaries. Maria believed in diplomacy by marriage. Indeed, the Medici cycle was rushed to completion in time for the "English Marriage" of her daughter Henrietta Maria to King Charles I. Unfortunately for both Rubens the diplomat-painter and his royal patroness, Richelieu now dominated the political stage; Maria's legacy was to be found in art, not statecraft.

To execute a cycle of such size in so short a time required the full employment of Rubens's studio, but the final surfaces proclaim the master's brush, a consummate performance by the impresario of the High Baroque. Rubens's greatest difficulty was in getting paid. He later confessed that the whole experience had been most unprofitable ("*dannosissima*"). Yet future generations of painters were greatly enriched by these canvases. Their response down through the centuries may be summed up by the American Romantic painter Washington Allston: "Rubens was a liar, a splendid liar, I grant you; and I would rather lie like Rubens than to tell the truth in the poor, tame manner in which some painters do."[42]

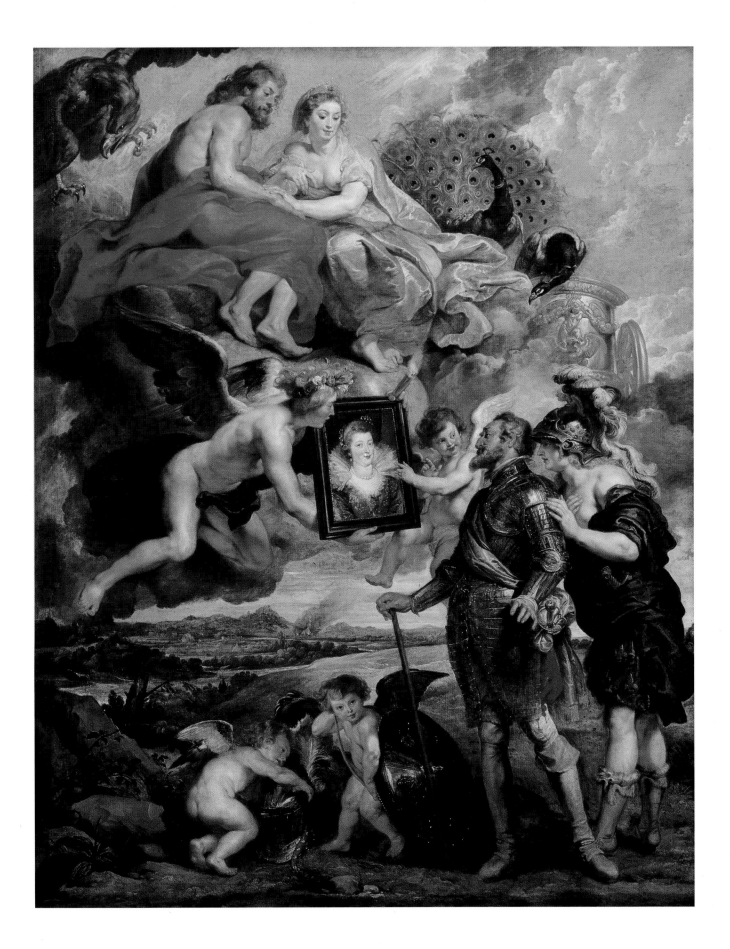

THE ADORATION OF THE MAGI

1624

Oil on panel, 14'8⅛" × 11'4³⁄₁₆" (448 × 346 cm)
Koninklijk Museum voor Schone Kunsten, Antwerp

Perhaps nowhere does Rubens offer more elaborate variations on a religious theme than in the several Adorations of the Magi he painted from 1609 to 1624. In retrospect they present a series of epiphanies that reach a High Baroque climax in the panel painted for the high altar of the Norbertine (Praemonstratensian) Abbey of St. Michael in Antwerp. The subject itself provided an opportunity to indulge in grandiose pageantry, which Rubens exploited to the fullest. His first version, commissioned for the Chamber of States (*Staatenkamer*) in Antwerp's town hall (fig. 23), was a nocturnal procession with shades of Caravaggio, Tintoretto, Veronese, and Elsheimer—a stately backdrop for the signing of the Twelve Years' Truce between the two Netherlands. For the high altar of St. Michael's, where Rubens had placed his first Chiesa Nuova altarpiece over his mother's tomb, he shifted the time to midday for his most joyous—and liturgical—interpretation of the biblical subject.

The commission for this magnificent altarpiece came in 1624 from the Abbot Matthaeus Yrsselius; Rubens is said to have painted it in a week—surely an exaggeration. Yet the lively brushwork does reveal a new fluidity and breadth, as though after the Jesuit ceiling, the early tapestry cycles, and work on the Medici cycle, he had adapted the style of the oil sketch to a full-scale painting. However rapid the execution, the composition was carefully prepared by an oil *modello* (Wallace Collection, London), wherein he introduced the centripetal grouping around the visually arresting Moorish king, whose pose he adapted from an exotic portrait of the Antwerp merchant Nicolaas de Respaigne (Gemäldegalerie, Kassel). The host of worshipers descends in a reverse S-curve from camels whose prominence, as Julius Held has observed, alludes to the liturgy for the Feast of the Epiphany: "The multitude of camels shall cover thee, the dromedaries of Midian and Epha" (Isaiah, LX, 6).[43] In general the iconography reflects the liturgical function of the altarpiece as backdrop to the celebration of the Mass. Unlike Rubens's earlier versions and preliminary

modello, the foremost king in the definitive altarpiece no longer offers gold; now robed in splendid ecclesiastical vestments, he swings a censer of frankincense as though he were a priest kneeling before the sacrament exposed on the altar. The Virgin is rotated to a frontal view as she displays the body of Christ, whose reclining pose prefigures a pietà. The close association of nativity and death was common throughout early Netherlandish altarpieces, which likewise employed "disguised symbolism" in the straw (bread), the ox (sacrifice), and the wooden crate with white cloth (altar), together referring to the Eucharistic sacrifice of the Mass.

Rubens's Counter-Reformation imagery extended to the original marble frame and sculptures that, dismantled in 1802, are today preserved in the parish church of St. Trudo in Groot Zundert (Netherlands). The pediment was originally crowned by three alabaster statues carved by Hans van Mildert after designs by Rubens. Each symbolizes the triumph over evil and heresy. St. Michael defeats Satan (fig. 50); the Virgin crushes the Serpent underfoot; St. Norbert stands victorious over the twelfth-century heretic Tanchelm, who had denied the sacrament, church hierarchy, the paying of tithes, and ritual. It is precisely those proto-Protestant denials by Tanchelm that Rubens reversed in this resolutely Catholic epiphany. Ancient Rome is represented by the two soldiers beside a Corinthian column entwined with ivy, symbolizing its supplanting and renewal by the Church; the universality of the new Roman (Catholic) Empire is embodied in the assembly of witnesses—including an African, an Indian, and an Asian—from the knightly figure on horseback to the beggar directly below him.

Rubens's *Adoration of the Magi* represents a masterly translation of his Netherlandish heritage and Italian influences into a Flemish Baroque feast. Yet for all its operatic grandeur, there is nothing redundant or confused. As Jacob Burckhardt observed, "Anyone who finds such works overcrowded might consider which figures could be eliminated as superfluous."[44]

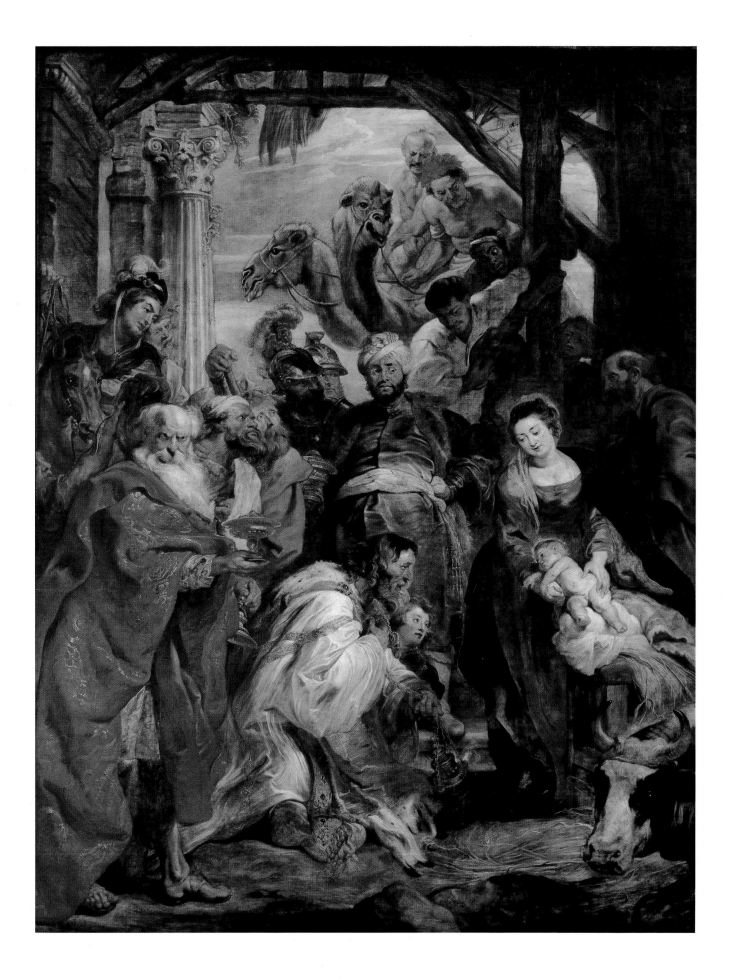

ALBERT AND NICOLAAS RUBENS

c.1625
Oil on panel, 62¼ × 36¼" (158 × 92 cm)
Collections of the Prince of Liechtenstein, Vaduz

Portraits of children are rare in Rubens's work—despite the fact that he was the devoted father of seven children (his eighth was born eight months after his death). Several chalk studies suggest that he frequently used his children as models, but no painting is known of his first wife, Isabella, together with any of their three children, Clara Serena, Albert, and Nicolaas. This is the only full-length double portrait of children that Rubens painted. In view of the apparent ages of the boys, the date 1625 seems likely—Albert and Nicolaas would then have been eleven and seven years old, respectively. In 1623, their sister, Clara Serena, died, a personal tragedy for Rubens that may have elicited this extraordinary portrayal of fleeting youth.

Seventeenth-century children were conventionally pictured as miniature adults—poised and precocious. Rubens, the master of cupids and putti, here conveyed the lively, spontaneous impression of childhood while also suggesting its transience and the anticipation of adulthood. The striking contrast in the dress, expressions, and attributes of the boys reflects not only the difference in their ages but also the duality of body and mind, of activity and contemplation, which Rubens so successfully combined in his life and art. Albert is shown leaning against a stone column, legs crossed, holding a book in one hand and dangling a fur-trimmed glove in the other. The somberness of his black suit and hat is relieved by the slashes of white appearing through the slits in the jacket and by the bright ruff collar and starched cuff that accentuate his head and hand. The calculated casualness of his pose recalls the mode of aristocratic portraiture established by Rubens and later developed by Van Dyck. Albert gazes out confidently at the viewer: the schoolboy already suggests the budding scholar and alter ego of his proud father. In a most touching and revealing letter to his friend and fellow scholar, Jan Caspar Gevaerts, Rubens wrote from Madrid three years later: "I beg you to take my little Albert, my other self, not into your sanctuary but into your study. I love this boy, and it is to you, the best of my friends and high priest of the Muses, that I commend him."[45]

In contrast to his elder brother, Nicolaas is festively dressed in a bright blue silk jacket with slit sleeves, tan breeches, and a profusion of orange bows, reflecting the colors of the goldfinch he holds on a string and gazes upon reflectively. A common amusement of children—later included in Rubens's *Helena Fourment with Clara Johanna and Frans* (plate 36)—such birds are found in both pagan and Christian iconography as emblems of death, symbols of the soul in flight. Deriving initially from Roman tombstones of children, the image of the Christ Child playing with a goldfinch frequently appears as a prefiguration of the Passion.[46] Its prominence here raises the possibility that Rubens intended it as a reference to the loss of Clara Serena. At the very least, the bird's flight symbolizes the swift passage of youth, an idea reinforced by Nicolaas's pensive expression.

For all its vigor and immediacy, the portrait was not painted directly from life. Instead, Rubens relied on chalk drawings of the two heads. The poses were normally worked out in a series of pen-and-ink sketches. The drawing of Nicolaas's head is preserved in the Albertina in Vienna; Albert's (now lost) is recorded in a studio copy. That the evocative contrast in expression and dress may reflect underlying aspects of the boys' personalities is suggested by Nicolaas's later appearance in the *Walk in the Garden* (fig. 62) painted around 1631: by then aged thirteen, he is dressed in a bright red suit as he walks spiritedly behind his father and young stepmother.

The boys did not long outlive their father. Nicolaas died in 1655 at the age of thirty-seven; Albert, two years later, at forty-three. Albert fulfilled Rubens's scholarly ambitions for him by becoming a distinguished antiquarian and archaeologist. Nicolaas became a successful businessman—another career in which his father had excelled. But more than three centuries later, both sons remain perpetual youths in this timeless image of boyhood.

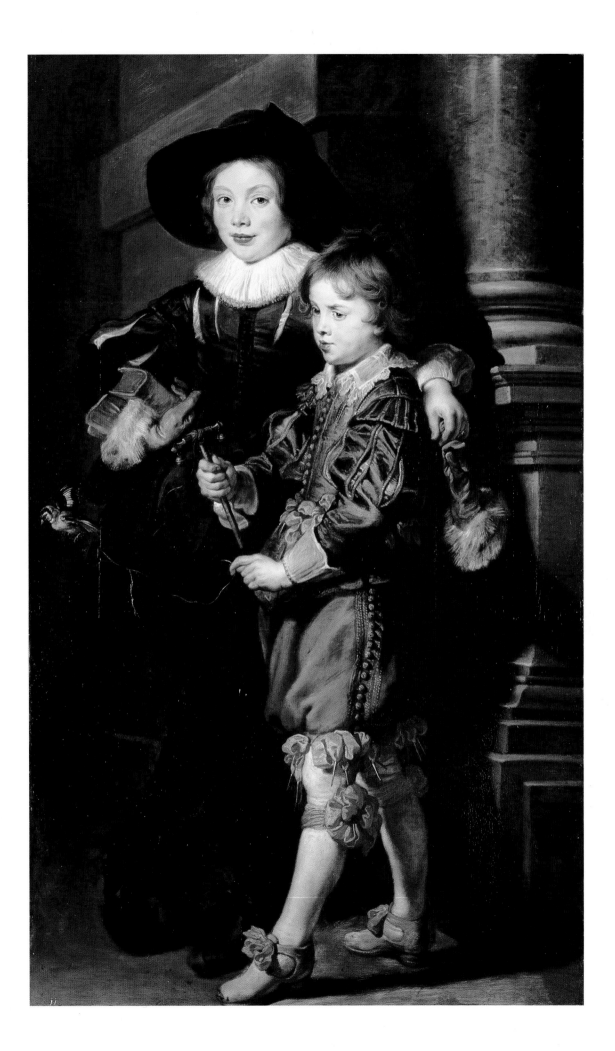

GEORGE VILLIERS, DUKE OF BUCKINGHAM

1625

Oil on panel, 17½ × 19½" (44.3 × 49.2 cm)
Kimbell Art Museum, Fort Worth

The king's favorite: George Villiers, first duke of Buckingham, achieved this chancy privilege twice. The handsome cavalier was the court favorite of both King James I of England and of his son and successor Charles I. Ever since Rubens's early diplomatic mission to Madrid in 1603, where he encountered the duke of Lerma, the artist was aware of the extraordinary power that accompanied such favoritism. Rubens first met this swashbuckling courtier in Paris in May 1625, following the marriage-by-proxy of the French princess Henrietta Maria to the new King Charles I of England — in time for which Rubens had hastily put the finishing touches on his Medici cycle (plate 21). During the three weeks the duke spent in Paris before escorting the new queen to England, he met with Rubens and commissioned this self-glorifying portrait.

Though he admired Buckingham's genuine love of art, Rubens labored under no illusions. Buckingham's diplomatic purposes were then directly opposed to the artist-diplomat's. The duke was lobbying for French support to wage war against Spain and Austria; but his amorous attention to the young French queen, Anne of Austria — later romanticized in Dumas's *The Three Musketeers* — left Cardinal Richelieu decidedly unimpressed. Rubens was later to confide his own reservations: "When I consider the caprice and arrogance of Buckingham, I pity this young king [Charles] who through poor advice throws himself and his kingdom needlessly into such peril."[47] Yet none of Rubens's private views is reflected in this heroic portrait of Buckingham. Completed in 1627, the painting — a milestone of Baroque equestrian portraiture and the first of its kind to enter England — perished in a fire in 1949. This surviving *modello* for the full-scale canvas is equally monumental in all but its dimensions.

In Rubens's early equestrian portrait of Lerma (fig. 13) only the canopylike palm introduced an allegorical flourish. In the Medici cycle the artist adapted Lerma's pose to Maria's *Victory at Juliers* and added a flying Victory overhead. Having just seen the cycle unveiled, Buckingham evidently desired a similar allegorical portrayal of himself as a military commander — he had recently been appointed admiral of the royal fleet. Rubens duly included a forest of ships' masts in the background and the sea god Neptune with his trident and a naiad with pearls and shell as foreground footnotes. Fame, carrying trumpets, scatters flowers on the duke and blows a favorable wind. Between this *modello* and the final canvas, a winged Victory with laurel crown was added to the airborne retinue — no doubt at Buckingham's insistence.[48] He is shown in full ceremonial armor, red cape flying, his mount rearing in a levade, which Rubens adapted from a (now lost) equestrian portrait of the Archduke Albert and subsequently applied to those of King Philip IV (a copy is in the Uffizi, Florence) and the Cardinal-Infante Ferdinand (Prado, Madrid). This quintessentially Baroque formula was further developed by Van Dyck and Velázquez.

For the definitive canvas, Rubens based Buckingham's head on a vivid chalk study (fig. 49) probably drawn in Paris.[49] That his likeness already appears in this preliminary but detailed *modello* — an independent masterpiece in miniature — suggests that Rubens intended it to be a demonstration piece to show the duke on his visit to the painter's studio in November 1625. By the time the portrait was finished and shipped to England in 1627, Buckingham was prepared to reverse his hostile policy toward Spain and to begin the negotiations that eventually led to Rubens's great diplomatic achievement — the exchange of ambassadors (and subsequent peace treaty) between England and Spain in 1630. But the duke himself was felled by an assassin in 1628. As was true of so many adventurers of his time, Buckingham's legacy was not to be found in military or political glory, but in art, as a collector and patron. In addition to Rubens's collection of antiquities, Buckingham owned thirteen paintings by the Flemish master, a "dukedom large enough."

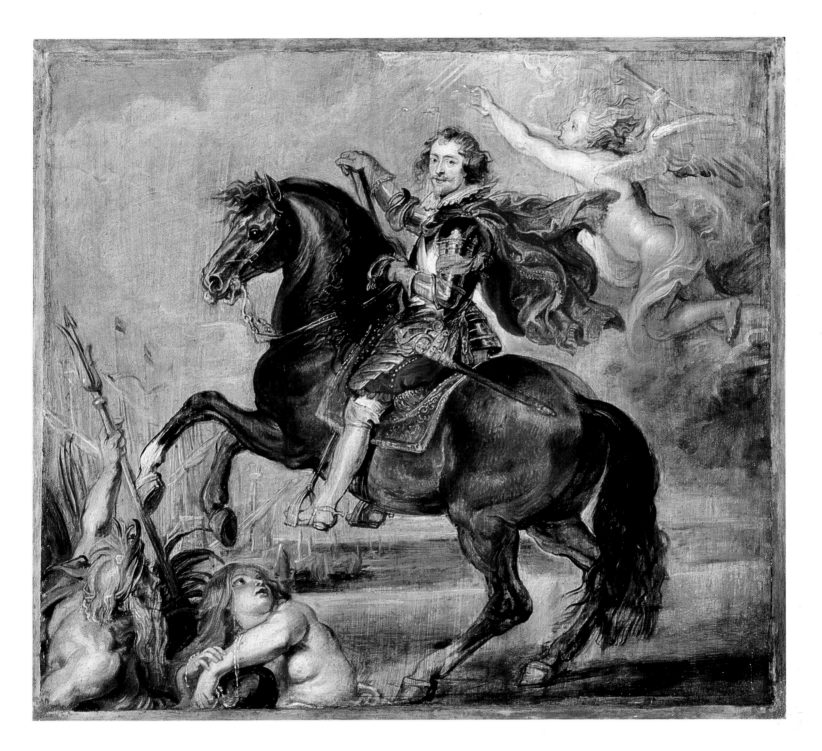

LANDSCAPE WITH PHILEMON AND BAUCIS

c.1625
Oil on panel, 57½ × 82" (146 × 208.5 cm)
Kunsthistorisches Museum, Vienna

Ut pictura poesis: "as painting is, so is poetry." Renaissance art theory reversed Horace's formula by establishing a humanistic theory of painting as the emulation of poetry. Within this tradition, Rubens cultivated several literary landscapes deeply rooted in classical verse: the Homeric *Landscape with Odysseus and Nausicaa* (Palazzo Pitti, Florence); the Virgilian *Shipwreck with Aeneas* (Staatliche Museen, Berlin-Dahlem); and this Ovidian *Landscape with Philemon and Baucis* in Vienna. The last two represent the genre of stormy landscapes that evoke the ancient traditions—both biblical and classical—of flood literature and its religious, philosophical, and political connotations of nature in revolt.[50]

Ovid's story in the *Metamorphoses* (VIII, 611–724) tells of a pious old couple showing hospitality to the gods Jupiter and Mercury, who had appeared in human disguise as wayfarers seeking shelter. The couple were consequently spared destruction in the flood Jupiter sent to purge the land of its impious inhabitants. Accompanied by the gods and "leaning on their sticks," Philemon and Baucis "struggled up the long slope. When they were a bow-shot's distance from the top, they looked around and saw their entire country drowned in marshy waters."

The cataclysmic landscape displays its inherent power and tension as the viewer's eye travels from foreground to background against the full force of the current, tracing the flood—with its impossible water levels—to its source in the violent downpour from storm clouds sun-streaked by Jupiter's flaming bolts. Rubens expanded his original composition by adding panels to the top, bottom, and sides: the thunderstorm has swollen into a cosmic deluge. Trees are uprooted, houses swept away. One man seeks refuge on a rock; another climbs a falling tree (at the left); an ox is impaled on a tree trunk lying across the waterfall, while at the lower left corner two dead bodies suggest the larger landscape of human wreckage.

The German art historian H. G. Evers noted in the panorama a duality, a topography of good and evil.[51] Constructed like a late medieval diptych, the two symbolic halves recall a similar division in the *Landscape with Carters* (plate 10). The left side descends into deluge and death; the right half rises onto higher ground—both geographically and morally—where the gods stand with the pious couple "a bow-shot from the top of the hill." Jupiter is shown in the pose of the *Apollo Belvedere*. The antique quotation is significant, for Apollo's pose as *alexikakos* ("warder-off of evil") defines precisely the meaning of Jupiter's gesture as he points—with the arm, that in the statue originally extended to hold a bow—to a *rainbow* emerging at the far side over the dead figures. A symbol of divine covenant, it recalls God's promise to Noah after the Flood: "I set my bow in the cloud, and it shall be a sign of the covenant between me and the earth . . . the waters shall never again become a flood to destroy all flesh" (Genesis IX, 11–15).

The aged couple prayed that they might live out their days as priests of Jupiter, that their house be transformed into his temple, and that they might die together. The prayer was fulfilled through a final metamorphosis: "Each saw the other put forth leaves; Philemon watched Baucis changing, Baucis watched Philemon. . . . The peasants in that district show the stranger the two trees close together, and the union of oak and linden in one." Rubens prefigured this happy outcome, naturalistically, in the two trees already intertwined behind Philemon and Baucis. A decade later, Rubens translated Ovid's *Metamorphoses* into a huge series of mythologies for King Philip IV's hunting lodge, the Torre de la Parada (plates 38 and 39). At the same time, the idyllic promise suggested here by the first signs of a rainbow was brought to fruition in such pastoral odes as Rubens's *Landscape with a Rainbow* (fig. 73) and his *Landscape with Het Steen* (plate 37)—by which point the literary and classical roots had firmly taken hold in his unified vision of nature.

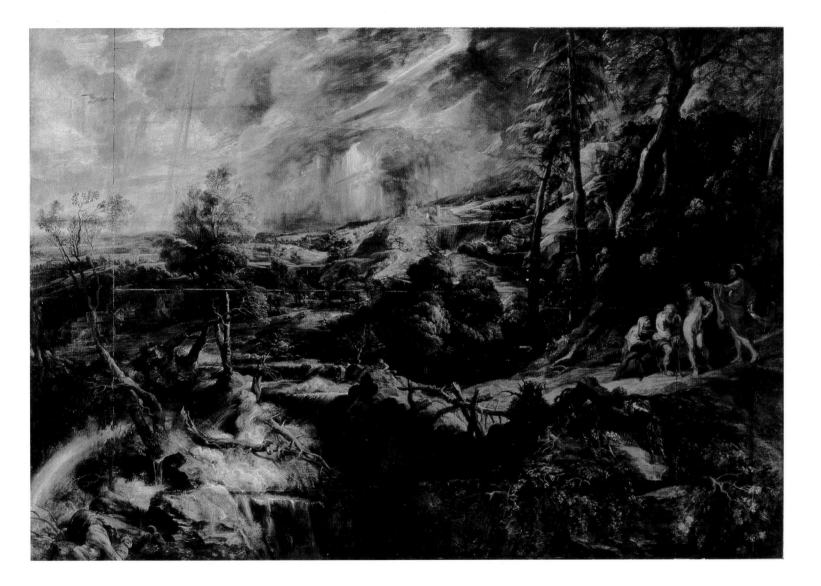

THE ASSUMPTION OF THE VIRGIN

1624–1627
Oil on panel, 16' × 10'8" (490 × 325 cm)
Cathedral of Our Lady, Antwerp

The zenith of Rubens's High Baroque altarpieces is found, appropriately, at the high altar of the Antwerp cathedral. There he painted his most spirited interpretation of Mary's physical assumption into heaven. Completed and unveiled in 1627, the altar had the longest gestation period of all his religious commissions; its conception may be traced back to 1611. Along with Otto van Veen, Rubens had been invited by the cathedral chapter to submit two *modelli* for an altarpiece representing a combined Assumption and Coronation of the Virgin. One of Rubens's two submissions has been identified as the oil sketch today preserved in Leningrad (fig. 31), in which Christ proffers a crown to his ascending mother. Rubens won the commission over his former teacher, but owing to the cathedral's financial difficulties work on the altar was suspended.[52]

In 1618 Rubens was again invited to submit two *modelli* to the cathedral wardens, and a year later a contract was drawn up with the dean, Johannes del Rio, who eventually endowed the altarpiece as a family memorial. By this time Rubens had designed and painted several other Assumptions, ranging from a small engraved illustration in the 1614 *Missale Romanum* to the high altar of 1616–17 (Kunstmuseum, Düsseldorf) for the Brussels Kapellekerk. In the latter, an Italianate portico altar, the painted Virgin soared toward a sculpted God the Father represented on a marble relief overhead—an integration of painting and sculpture that Rubens developed further for the high altars of Antwerp's Jesuit Church (figs. 41 and 42) and the Abbey of St. Michael (fig. 50), before raising it to supreme illusionistic heights at the Antwerp cathedral.

The sculptors Jan and Robert de Nole were commissioned in 1621 to erect the altar frame; the foundation stone was laid on May 2, 1624. Sometime thereafter Rubens began work on the full-scale painting, which was interrupted in August 1625 when the artist and his family left Antwerp to escape the plague. Upon his return in February 1626, he was given permission to close off the sanctuary and—as at the Chiesa Nuova—work on the altarpiece in situ. A year later, in March 1627, he received his final payment. The definitive masterpiece, a distillation of his previous interpretations, represents his most ethereal and poetic response to Titian's great *Assunta* (Frari, Venice). Rubens's Virgin, like Titian's, is borne aloft by a cloud of putti, who form a rhythmic grouping of celestial grace notes; four full-grown angels surround her, two of whom hold a crown of flowers. On the ground, female disciples ponder the empty sarcophagus and linen shroud, while some of the apostles already look heavenward, led by St. John in the left foreground, whose gesture links the upper and lower halves of the composition. The reds, golds, and lavenders of the disciples' draperies reverberate above in the angels swirling in a powder blue sky: Rubens's Venetian palette already foreshadows the lighter pastel colors of the Rococo, of Tiepolo and Boucher.

The marble altar frame was dismantled by the French in 1794, but Rubens's magnificent design for it is preserved in an engraving (fig. 51). On the pediments angels proffer palms and laurel crowns, recalling their counterparts in the Jesuit altar (fig. 42). At the top, God the Father looks down, arms extended in welcome; below the dove (Holy Spirit), a freestanding statue of Christ in a niche holds out a crown to his mother, the object of her ecstatically upturned eyes. By combining the painting and sculpture, Rubens recapitulated the dual theme of the Leningrad *modello*: a unified Assumption and Coronation (fig. 51). The sculpted Christ above the altarpiece extends the crown into the viewer's own space; the Virgin, by implication, is shown about to ascend *beyond the painting* in order to receive it. In this total fusion of architecture, sculpture, and painting, Rubens anticipated Bernini's church of S. Andrea al Quirinale in Rome by spiritually charging the surrounding space with illusionistic drama. The Virgin's bodily assumption into heaven was finally pronounced—ex cathedra—as infallible doctrine by Pope Pius XII in 1950, more than three centuries after Rubens had celebrated and clothed the ancient belief in Baroque splendor.

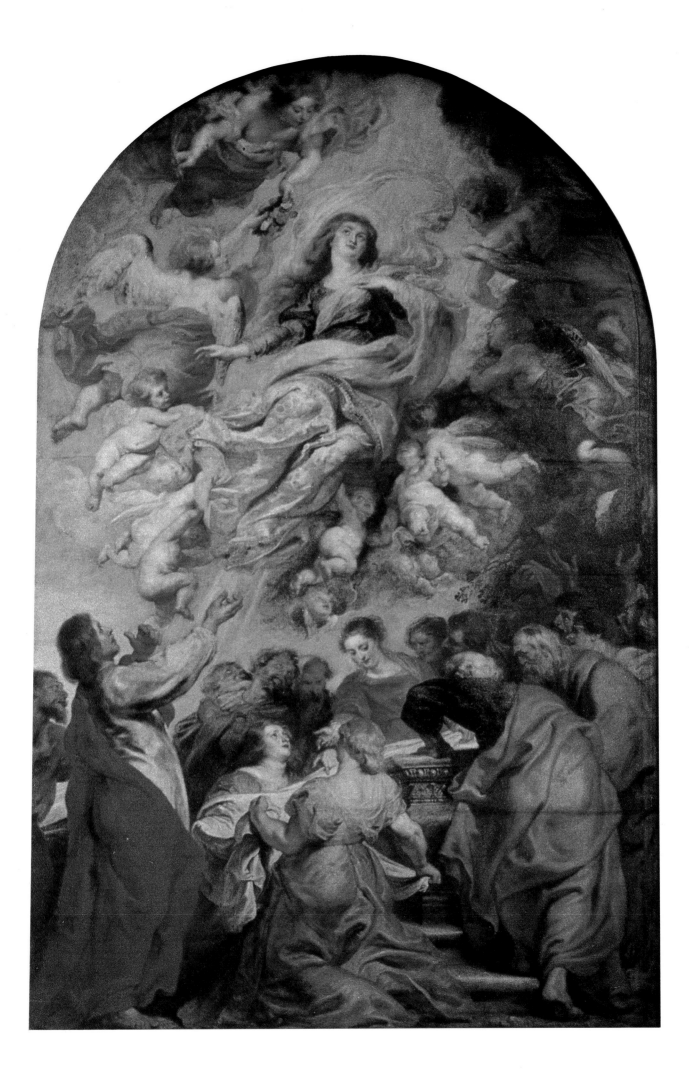

THE VICTORY OF EUCHARISTIC TRUTH OVER HERESY

c.1626

Oil on panel, 25⅜ × 35⅞" (64.5 × 91 cm)

Museo del Prado, Madrid

THE TRIUMPH OF FAITH

c.1626

Oil on panel, 25 × 35¼" (63.5 × 89.5 cm)

Musées royaux des beaux-arts, Brussels

Bequest of Mr. and Mrs. Tournay-Solvay, Brussels, 1967

Commissioned in late 1625 by the Infanta Isabella, the Triumph of the Eucharist represents not only Rubens's largest tapestry cycle (of some twenty separate hangings) but also his most sumptuous and complex program of church decoration. The tapestries (fig. 54) remain today at their original destination, the convent of the Descalzas Reales in Madrid. The program, an epic history of the Sacrament, comprises eleven large hangings illustrating Old Testament prefigurations (as in the Jesuit ceiling), allegorical victories, a triumphal procession, and a retinue of saints. The allegorical narrative is completed by an apotheosis at the high altar (fig. 55). The eleven narrative scenes feature fictive tapestries hung within illusionistic architecture—in other words, tapestries within tapestries. Both this double illusion and the bilevel architectural enframement were unprecedented in tapestry design. Each tapestry was prepared in three stages: an autograph *bozzetto* (demonstration piece), a finished oil sketch (*modello*), and a cartoon (in oil on canvas, executed largely by assistants). Throughout these stages, Rubens consistently applied his architectural formula: the upper tapestries, framed by Solomonic columns, were designed to be viewed from below; the lower, framed by banded Doric columns, at eye level.[53]

In the present reconstruction of *modelli*, a Eucharistic victory is coupled with an allegorical triumph. On top, Father Time, brandishing his scythe, raises his daughter Truth over an ecclesiastical battlefield strewn with defeated heretics: Luther, Calvin, Arius, and Tanchelm, among others. Surrounded by smoke and fire-breathing monsters, she points to a banderole inscribed (in the final tapestry) with the words of consecration, *Hoc est Corpus meum* ("This is my Body"). The image of Naked Truth uplifted by Time was common currency in seventeenth-century political and religious propaganda and constituted the concluding scene in the Medici cycle (fig. 48). Here *religious* Truth is shown more modestly clothed. The scene is related iconographically to the

preceding *Victory of the Sacrament over Paganism* (fig. 54), recalling Constantine's proclamation after the Council of Nicea: "The splendor of Truth has dissipated at the command of God those dissensions, schisms, tumults, and so to speak deadly poisons of discord."[54]

Directly below, the personification of the Catholic Faith (*Fides*) raises her chalice and host, a dramatic gesture paralleling Truth's directly above. In the air, putti carry emblems of the Passion. Behind the angel-drawn carriage march Faith's captives in tow: Science (with an astrolabe), Philosophy (with the features of Socrates), multibreasted Nature, Poetry (with laurel crown), and exotic heathen. These personify some chief concerns of the era: the proper relationships between Faith and Science, Faith and Nature, Faith and Reason, here described hierarchically as sacred victor leading a retinue of profane captives. Rubens's revival of antique triumphs represents the Baroque culmination of a Renaissance tradition—beginning with Petrarch's poem *I trionfi*—that pervaded art, literature, liturgy, and civic celebrations such as the *Pompa Introitus Ferdinandi* (plate 34 and figs. 70 and 71).

Rubens's unique framing device of fictive tapestries hanging within simulated architecture reveals different levels of illusion and reality. The tapestry of Truth is shown draped over "real" animals that are emblematic footnotes: a lion (Faith) clutching a fox (Heresy). The tapestry of Faith is hung by "real" putti, who cast actual shadows against the woven sky. Assembled within the convent chapel, these eleven fictive tapestries recall the eleven curtains surrounding the Holy of Holies in the ancient Jewish Temple, an allusion reinforced architecturally by the Solomonic columns. Beyond their decorative function as conspicuously extravagant liturgical wall hangings, Rubens's Eucharist tapestries created nothing less than a unified vision of sacred architecture within which he staged his most triumphal affirmation of his Catholic faith.

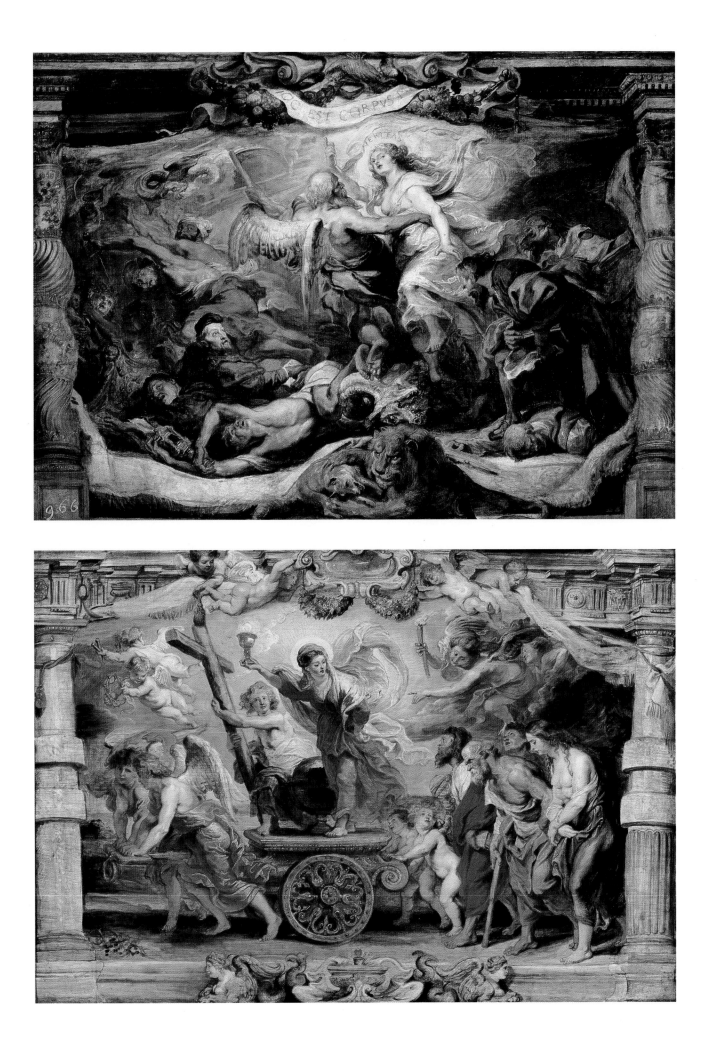

LUDOVICUS NONNIUS

c.1627
Oil on panel, 49 × 39½″ (124.4 × 100 cm)
The National Gallery, London

Like Rembrandt, Rubens enjoyed friendships with eminent doctors. In Rubens's case, these physicians were not only medical specialists but fellow humanists in the tradition of Justus Lipsius and his circle (plate 9): men of intellectual distinction, authors, and scholars in classical philology and antiquities with whom Rubens felt a natural kinship. Ludovicus Nuñez (latinized as Nonnius) was born in Antwerp in 1553, the son of a doctor who was a Portuguese "Marrano" (a Catholic convert from Judaism). He studied at Louvain and began his successful medical practice in Antwerp. His scholarly interests centered—like Nicolaas Rockox's—on ancient coins. Editions of his numismatic commentaries were published by the Plantin-Moretus Press with title pages designed by Rubens. His medical publications included a major work on health and diet, *Diaeteticon*, one of the first contributions to the field of food hygiene. It was perhaps in connection with its publication in 1627 that Rubens painted this emphatically bookish portrait. A year earlier, Nonnius had been among the four doctors called to the bedside of Rubens's wife, Isabella Brant, who died on June 20, probably of the plague: Rubens surely felt a close personal bond with the subject he portrayed here so sympathetically.[55]

In modern times, the sitter's identity remained in question until 1950, when the German scholar Ludwig Burchard recognized Nonnius from a later, inscribed portrait painted for the latter's publisher, Balthasar Moretus. But his *profession* had already been clearly established by Rubens in the antique bust inscribed (in Greek letters) "Hippocrates," the father of medicine. On the shelf, at the base of a marble column, rest several volumes; behind Nonnius there is a stone niche. The doctor looks up momentarily as he points to a passage in a book. These elements—classical bust, books, column, niche, expository gesture—were adapted from Rubens's humanist group portrait, the *Four Philosophers* (plate 9). In the revival of this formula for Nonnius, Rubens intensified the immediacy of this speaking likeness by animated brushwork in the face and hands, offset by the white ruff collar and loosely sketched cuffs. Nonnius's eyes—the "windows of the soul"—sparkle with intelligence. The implied spontaneity is underscored by the placement of the heavy folio volume. Propped on the sitter's knee, it seems about to tumble out of the picture and into the viewer's space. The bust of Hippocrates, like Seneca's in the *Four Philosophers*, is based on an antique model and infused with an antisculptural liveliness of expression. But whereas the bust of Seneca was placed within a stone niche behind Justus Lipsius, here the empty niche enframes the head of Nonnius, visibly enshrined as both physician and author.

A year later, Rubens returned to the *Four Philosophers* as a similar point of departure for his humanistic portrait of Jan Caspar Gevaerts in his study (Koninklijk Museum, Antwerp). Juxtaposed with a Roman bust of Marcus Aurelius, the sitter raises his quill pen as if about to write in an open folio (like Philip Rubens in plate 9), but he turns instead to look out at the viewer. It is such fleeting, momentary interaction between subject and viewer that marks the High Baroque phase of Rubens's portraiture and prefigures Van Dyck's portrait of Lucas van Uffel (Metropolitan Museum of Art, New York) and, later, Rembrandt's *The Syndics* (Rijksmuseum, Amsterdam).

In 1634, several years after the painting of their portraits, Gevaerts and Nonnius collaborated with Rubens as fellow humanists in planning the *Pompa Introitus Ferdinandi* (plate 34), for which Rubens created a series of triumphal monuments adorned with Gevaerts's Latin inscriptions—with one notable exception: the Arch of the Portuguese was designed by Ludovicus Nonnius. Its restrained, conventional classicism was inevitably overshadowed by Rubens's dynamic structures; yet its architectural elegance and harmonious inclusion within Rubens's citywide program of monumental decoration revealed the common ground shared by Antwerp's premier painter and her illustrious physician, the Apelles and Hippocrates of their age.

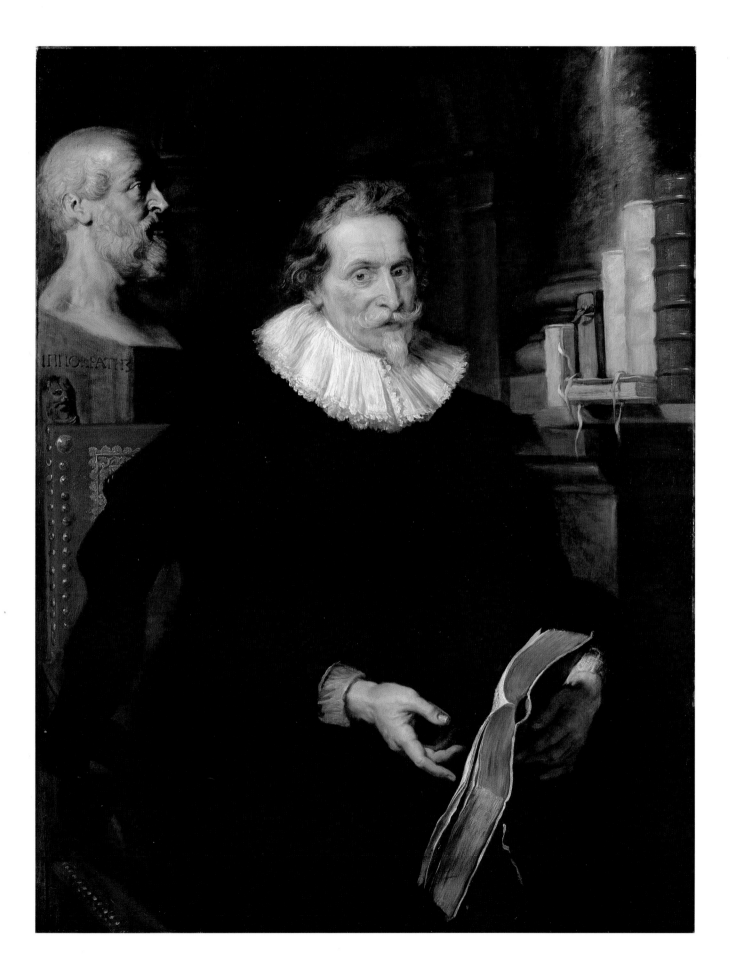

THE GARDEN OF LOVE

c.1630–1632
Oil on canvas, 77⅛ × 111⅜" (198 × 283 cm)
Museo del Prado, Madrid

Following his marriage to Helena Fourment, Rubens composed one of his noblest—and most personal—celebrations of life and love. His figural variations on the theme of love's cultivation are here played out in harmony with an idyllic landscape, architectural cadences, sculptural counterpoints, and a descant of putti, the painter's version of lyrical coloratura. Yet probably no painting of Rubens's has—like Shakespeare's sonnets—evoked so many conflicting scholarly interpretations, ranging from the autobiographical to the arcane; from slice-of-life genre painting to the most complex allegory. To one scholar, it illustrates a Flemish garden party around Rubens and his recent bride, Helena, complete with sisters- and brothers-in-law. To another, it represents an intricate Neoplatonic allegory of love: one woman's initiation into the three stages of love (represented by the three seated women), sensual, earthly, and celestial love; a cinematic progression through love's initiation, maturation, and culmination in matrimony. Still another interpretation, based on the painting's first recorded Flemish title, *Conversatie à la Mode* (a garden party, in vogue), considers it a visual commentary on social gallantry, fashion, and aristocratic courtship as mirrored in contemporary English Cavalier poetry and French manuals of love etiquette.[56] Yet the picture's pervasive spirit is that of the *haute bourgeoisie*, and the work finds its place somewhere between the artist's domestic *Walk in the Garden* (fig. 62) and his fanciful *Couples Playing Before a Castle* (fig. 74).

The tradition of love gardens originates in late medieval art, where it was often associated with matrimony. The keys to Rubens's *Garden of Love* lie in the iconographic sculpture and emblematic putti. At the right, the sculptured goddess Venus, astride a dolphin, presides over her realm; she is literally expressive—her breasts functioning as fountains—recalling Rubens's grisaille sculpture of Mother Earth in the *Discovery of Erichthonius* (fig. 28). Like Rubens's Helena/Venus of *Het Pelsken* (fig. 67), Venus was also a mother: her son

Cupid, god of love, stands at the opposite end of the composition, insistently prompting the couple who enter at the left. The pavilion of rusticated columns recalls Rubens's contributions to his Antwerp house and garden. Within the grotto hidden water jets surprise cavorting couples, a sixteenth-century, Italian Mannerist garden amusement, more clearly visible in the derivative woodcut by Christoffel Jegher (fig. 63). The statue of the Three Graces, a favorite triad of Rubens (as of Raphael) denotes the prevailing civility of this highly cultured garden. Above all, the flying cupids signify the nature of the love here celebrated. The flaming torch, doves, floral crown, and yoke are all traditional marriage symbols, as are the dog and peacock beside the couple entering at the far right. It is not "free love" but *conjugal* love that is fostered by Venus and her minions. (The yoke, held over the couple at the left, refers to the Latin *coniungere*, "to yoke together"—in wedlock.)

Thus Rubens celebrated his recent marriage not in anecdotal portraiture but by allegorical reflection. He thoroughly transformed the pictorial tradition of love gardens—transfiguring it with Titianesque luminosity, infusing it with psychological depth, and raising it to a new poetic plane. Among seventeenth-century love gardens it stands apart. Its true artistic descendants are the Rococo *fêtes galantes* of Antoine Watteau, who derived from Rubens not only his painterly technique and color values, but also the theme of the refined love garden dedicated to (a sculptural) Venus—with a telling difference: Watteau introduced within the gaiety a melancholy strain, like a Mozartian countertheme—a sense of the ephemeral nature of love and happiness.[57] In his *Departure from Cythera* of 1717 (fig. 64), the lovers already begin to withdraw from temporal bliss. Nothing could be further from Rubens's expansive vision and gathering crescendo of conjugal fulfillment. Full of optimism, vitality, and joie de vivre, the fifty-three-year-old Rubens embarked on the last decade of his career rejuvenated by marriage to his sixteen-year-old bride.

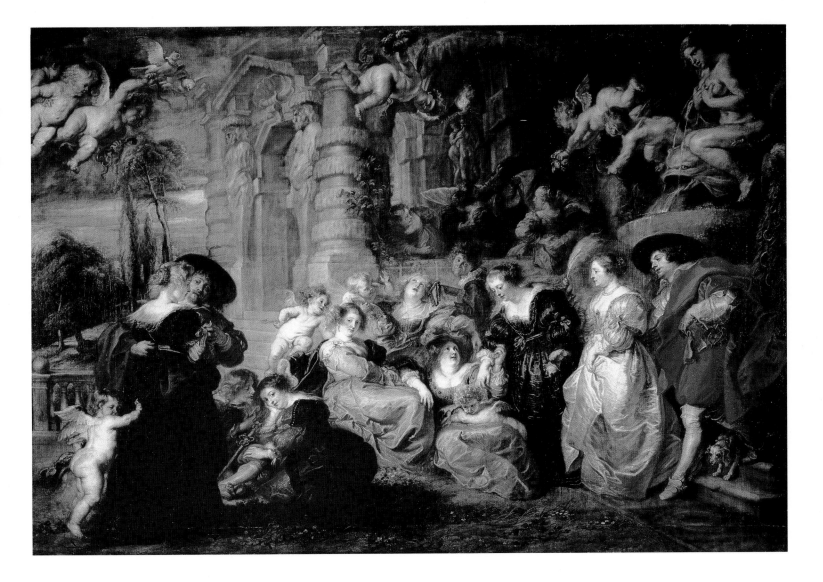

BRISEIS RETURNED TO ACHILLES

c.1631–1632
Oil on panel, 17⅜ × 26⅞" (44 × 68.5 cm)
Detroit Institute of Arts, Detroit
Bequest of Mr. and Mrs. Edgar B. Whitcomb

"And so they meet, the Ionian and the Fleming, the two greatest storytellers our earth has ever borne—Homer and Rubens." Thus concludes Jacob Burckhardt's *Recollections of Rubens* (1898). In his fourth and final tapestry cycle, the Life of Achilles, Rubens translated—for the first time in painting—Homer's epic into a series of eight monumental wall hangings, the mythological counterpart to his Decius, Constantine, and Eucharist cycles. The circumstances of the commission are unknown. Rubens probably designed the series shortly after his marriage in December 1630, in collaboration with his new father-in-law, the silk and tapestry merchant Daniel Fourment (in whose shop the artist's oil sketches were inventoried in 1643). Having recently returned from his successful diplomatic mission to the English court of Charles I, Rubens may have had his new royal patron in mind as the intended purchaser, if not the original commissioner, of the tapestries.[58]

For each of the eight scenes Rubens painted an autograph oil sketch. These were subsequently enlarged by studio assistants into finished *modelli* in oil on panel for the cartoons, which (now lost) were painted in tempera on paper, perhaps with the assistance of Jacob Jordaens. This captivating sketch of *Briseis Returned to Achilles*, the sixth scene in the sequence, follows the *Wrath of Achilles* and illustrates the joyous consequences of Achilles's decision to avenge the death of Patroclus and to resume battle on behalf of the Greeks. As a reward King Agamemnon turned over to Achilles the captive Briseis along with "seven women, seven tripods, twenty cauldrons, and twelve horses" (*Iliad* XIX, 243–81). In the interest of artistic economy, Rubens condensed the booty and focused on Achilles's joyous welcoming of Briseis; in the background tent, women mourn the dead Patroclus. This romantic reunion was not described by Homer, but is Rubens's own invention—colored no doubt by his recent marriage to Fourment's daughter. Posed modestly like the *Venus pudica* (see figs. 65 and 67), Briseis is shown escorted to Achilles by the aged Nestor, while

Ulysses, at her left, points heavenward, perhaps attesting on behalf of Agamemnon that she has remained untouched. The masts of the Greek ships are visible at the left. The prominent foreground detail of the golden tripod being set in place reflects Rubens's antiquarian interests mentioned in his famous letter to Peiresc: "[The ancients] made a combination of the *lebes* [a basin] and tripod, much like our iron and bronze pots with three feet. But the ancients gave it the most beautiful proportions and, in my opinion, this was the true tripod mentioned by Homer. . . ."[59]

The framing device of cartouche, garlands, and paired herms is a variation on Rubens's Eucharist series, a translation from architectural into sculptural symbolism. The emblematic herms derive from his title pages (fig. 27) and ultimately from Carracci's Farnese ceiling (fig. 8). They offer pithy allegorical commentaries: at the left, Mercury holds his caduceus, as "harbinger of peace"; opposite, the herm of Peace is adorned with an emblem of concord (clasped hands in a wreath), recalling the conclusion of the Medici cycle (fig. 48). In front of the plinth Rubens arranged, as in the Eucharist tapestries, symbolic footnotes: two overflowing cornucopias flank a palm and caduceus, alluding to the anticipated victory and peace for the Greeks guaranteed by the reconciliation of Achilles and Agamemnon.

The Achilles cycle represents the finale of Rubens's career as a tapestry designer—a combination of the classical, heroic narrative of the Decius cycle, the collaborative origins of the Constantine series (with its emphasis on archaeological details), and the High Baroque illusionism and symbolic structure of the Eucharist tapestries. Delacroix, who had occasion to admire the original set of "*tapisseries sublimes*" at the estate sale of King Louis-Philippe in 1852, commented at length on Rubens's élan: "Like Homer, Rubens goes to the heart of the matter," he wrote of the *Briseis*, concluding: "Here is Homer, and more than Homer; because the poet makes me see only in my mind's eye, but here I see with my actual eyes."[60]

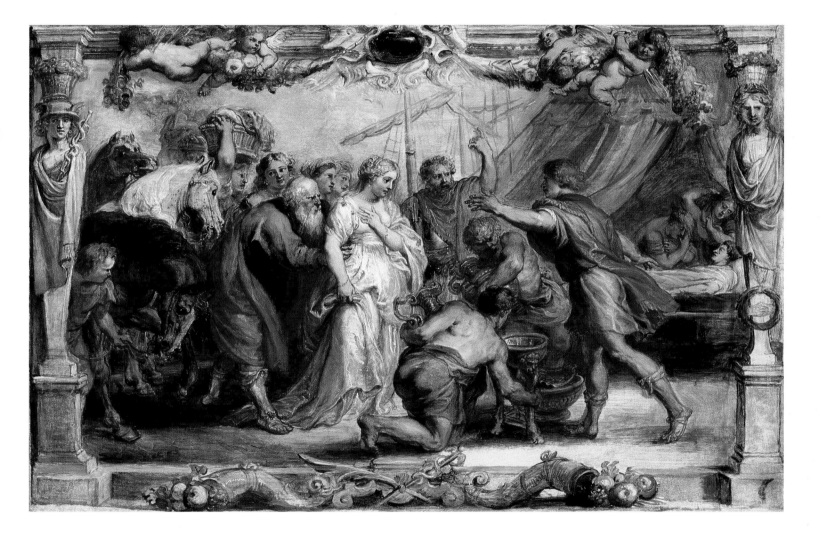

ST. ILDEFONSO TRIPTYCH

1630–1632

Oil on three panels, central panel: 138½ × 92⅞″
(352 × 236 cm); each wing: 138½ × 42⅞″ (352 × 236 cm)
Kunsthistorisches Museum, Vienna

Ildefonso, archbishop of Toledo, was a seventh-century Spanish saint much revered during the Counter-Reformation for his devotion to the Virgin Mary. In 1588, the Archduke Albert, then governor of Portugal, founded a religious brotherhood in honor of the saint; he established a second such fraternity at his court in Brussels in 1603. Upon returning from his diplomatic mission to England in 1630 Rubens was engaged to paint this sublime altarpiece (which was endowed by the Infanta Isabella in memory of her husband) for the church of St. James on the Coudenberg, where the brotherhood held its services.[61]

For this late archducal commission, Rubens revived the old-fashioned triptych format that had served him so well early in his career (plate 8 and fig. 25). The central panel illustrates the apparition of the Virgin to St. Ildefonso, who entered his cathedral one night to find the Virgin seated on his throne, bathed in celestial light and surrounded by female saints. Reciting the "Hail Mary," he humbly approached and knelt, whereupon she presented him with a chasuble (an outer vestment worn by a priest celebrating the Mass). Ildefonso is dressed in black episcopal robes as he kneels to kiss the chasuble. The Virgin wears her traditional red and blue; the rest is a sunburst of golden radiance, a blaze of heavenly light accompanied by three putti bearing roses. Hands held, the putti form a cherubic baldachin over the Virgin's throne, itself aglow in gilded splendor. Two saints on the right bear martyrs' palms; the faint pentimento of a third saint is visible directly to their left, which Rubens has edited out. At the left, two more saints look down on Ildefonso. The figure at the far left is posed in a quotation of an antique *Pudicitia* (Chastity) sculpture.

On the right wing, the Infanta Isabella kneels at a prie-dieu, holding a rosary. She is accompanied by her patron saint, Elizabeth of Hungary, who carries a crown full of roses and is dressed in the robes of a tertiary (lay) Franciscan, the very habit that the infanta had donned in 1621 as a sign of perpetual mourning for the Archduke Albert. Rubens has turned back the clock: Isabella is here shown in her royal robes and old-fashioned neck ruff of

two decades earlier as she faces her late husband on the opposite wing. His archducal crown at his side, Albert is accompanied by his patron saint, Albert of Louvain. Only the saint's vestments (purple instead of cardinal's red) and the silvery moonlight between darkened columns suggest a posthumous portrayal. Like Rockox and his wife on the wings of the Doubting Thomas triptych (fig. 29), Albert and Isabella are included as spiritual witnesses meditating on the divine miracle while remaining spatially—and iconographically—segregated. Their placement on separate wings is reinforced by a different application of architecture—marble columns adorned with swags of red drapery, recalling Rubens's use of a similar device as a backdrop to his own anachronistic presence in the *Four Philosophers* (plate 9). The parted curtains in the altarpiece may additionally refer to Early Netherlandish triptychs in which the motif signified divine revelation.

Corresponding to the mystical interior is the external *Holy Family Under the Apple Tree*: the two outside panels (now joined together) were designed to reveal a single composition when the shutters were closed. The Virgin and Child are enthroned beneath an apple tree, symbols of the Tree of Life, Christ's identity as the New Adam, and the Virgin's as the New Eve. The impromptu red canopy overhead corresponds to the festooned drapery of the interior. At the left, the infant St. John and his parents Elizabeth and Zacharias approach in adoration. The prominent apples ("fruit") coordinate the iconography of the shutters with the central apparition of the Virgin perhaps as meditations on the "Hail Mary" (prayed simultaneously by the infanta on her rosary and by the kneeling Ildefonso): "Blessed art thou amongst women" (altarpiece opened) and "Blessed is the fruit of thy womb Jesus" (closed). In this final revival of the Flemish triptych, Rubens exploited the tripartite form, including its movable shutters, to unify—symbolically, functionally, and compositionally—the veneration of a saint and the personal commemoration of his royal patrons. A year after the painting's installation in 1632, the infanta finally rejoined her spouse—in death, as in art.

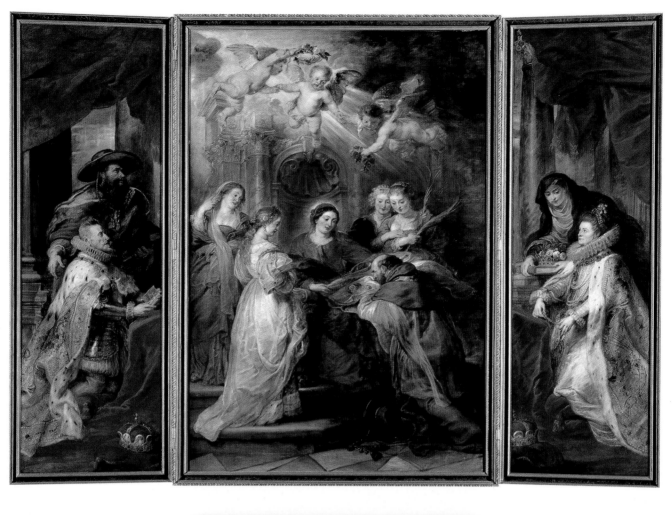

THE KERMESSE

c.1630–1635
Oil on panel, 4'10⅝" × 8'6¾" (149 × 261 cm)
The Louvre, Paris

Rubens is not known for his genre paintings. While Flemish peasants appear occasionally in his landscapes—from the *Landscape with Carters* (plate 10) to the *Landscape with Rainbow* (fig. 73) and *Landscape with Het Steen* (plate 37)—they are rarely cast in leading roles. There is one glorious exception: the *Kermesse,* which Burckhardt considered "the most famous of all pictures of Flemish folk life." This glowing masterpiece takes its place beside the *Garden of Love* (plate 29) as the summation of an artistic tradition deeply rooted in Flemish soil; it stands as Rubens's enduring tribute to the master of sixteenth-century genre painting, Pieter Bruegel, a dozen of whose paintings Rubens owned. It was principally as a collector that Rubens, the Italianate history painter, revealed his hearty Flemish appetite for genre, which he here, for once, indulged in a village feast.

The handling of the figures suggests the painting be dated between 1630 and 1635, following Rubens's return from London, his marriage and retirement from diplomatic service, and his renewed attachment to Flanders. A human landscape of colorful variety and arresting detail ascends from the lower left in a strong diagonal of accelerating rhythms toward the open vista and raised horizon at the upper right. The background landscape—and perhaps also the foreground still life—may be the work of a collaborator, Cornelis Saftleven: the smooth, detailed rendering of foliage, rustic architecture, and utensils are admittedly uncharacteristic of Rubens's last decade.[62] The left side of the panel is replete with anecdotal incidents that Rubens had improvised from a series of spirited sketches (fig. 66) of peasants drinking, carousing, passing out, nursing infants—and filling the older ones with beer!—and lovemaking.

Despite the expressive naturalism, Rubens's robust and raucous peasants avoid the comic uncouthness of their Bruegelian ancestors. They are caricatures—in the original seventeenth-century sense, "charged images"—but they are not crude. For all its teeming energy and earthy passion the scene is carefully composed as an alternating pattern of complementary colors and reciprocal gestures. The peasants may dance wildly to bagpipes, but they have been choreographed by a master draftsman. On the verso of that same sheet of pen-and-ink sketches (fig. 66) he captured in rapid, accented strokes the extraordinary tempo of the dance. Its origins in the ancient bacchanal are confirmed by Rubens's subsequent *Feast of Venus* (fig. 65), in which his peasants were transformed into satyrs and nymphs. Underlying Rubens's revival of Bruegel's Flemish festival is his profoundly classical, idealizing vision of a harmonious world where man's animal passions are attuned to nature and a benevolent cosmos. Perhaps, as Julius Held has suggested, the imagery may have been prompted by Horace's ode (I, 37): *nunc est bibendum, nunc pede libero/pulsanda tellus* ("Now is the time for drinking, for stamping the ground with an unrestrained foot").[63]

During Antwerp's steady decline as a center of commerce, the Flemish economy shifted from trade to agriculture. Its peasantry was idealized in literature and art as the new foundation for the country's economic survival. For the signing of the Twelve Years' Truce in 1609, Abraham Janssens had painted a mercantile allegory of Antwerp and the river Scheldt, which was hung opposite Rubens's *Adoration of the Magi* (fig. 23). Twenty-five years later, Rubens's *Temple of Janus* (fig. 71) for the Archduke Ferdinand's triumphal entry elevated not mercantile but agricultural tools as the new "trophies of peace" in a land still ravaged by war. Within such an economic and political context Rubens's painterly celebration of peasants and the fertility of Flemish country life, suffused with golden light, may be read as an allegory of hope and faith: hope for peace in Flanders and faith in the essential vitality of nature. "As for me," Rubens wrote in 1627, "I wish we lived in a golden age rather than an age of iron."[64] Throughout the following decade, he was to illustrate that bellicose "age of iron" in a series of allegories culminating in the *Horrors of War* (plate 41) for the grand duke of Tuscany. In the *Kermesse,* he translated his earlier, brighter vision of the classical "golden age" into an earthy Flemish dialect.

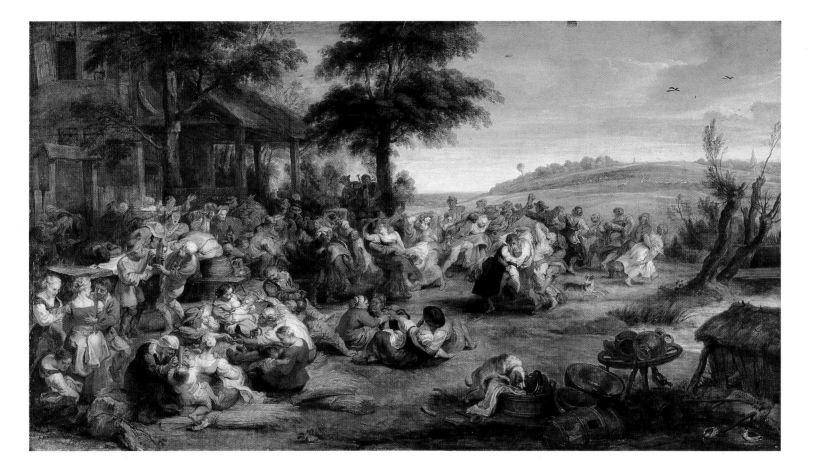

THE WHITEHALL CEILING

1632–1634

Oil on nine canvases, 110 × 55' 6" total ceiling (33.5 × 16.9 m)

Banqueting House, Whitehall, London

On the day after the dedication of Antwerp's Jesuit Church, in September 1621, Rubens set his sights on a new ceiling commission—the Banqueting House in Whitehall, London, designed by Inigo Jones in 1619. After a hiatus of several years, the royal commission finally proceeded in earnest at the conclusion of Rubens's diplomatic mission to the court of Charles I in 1629–30. Set in a rich, gilded field of carved moldings, Rubens's nine canvases—reminiscent of works by Tintoretto, Titian, and especially Veronese—represent the finest Venetian ceiling recreated north of the Alps. The Banqueting House had been designed for concerts, masques, and other court festivities; its main hall also served as the room where the king received foreign ambassadors, a function most clearly reflected in Rubens's program celebrating the Stuart monarchy and the glorious reign of King Charles's father, James I. The paintings were designed to be viewed from various points along a ceremonial axis from entrance to throne—a discovery by Julius Held that has finally resulted in their correct reinstallation.[65]

Over the entrance the *Unification of the Crowns* (fig. 68) offers a variation on the biblical Judgment of Solomon: King James—"The New Solomon," as he was hailed by panegyrists—presides over two contending "mothers," England and Scotland. Instead of commanding that the child they each claim be divided, the enthroned monarch effects their reconciliation; over the infant's head they extend two crowns, united by Minerva (Wisdom) below the coat of arms of the United Kingdom, which James (as the first king of both Scotland and England) had proclaimed in 1604. The triumphant child standing on a pile of armor alludes both to the new kingdom and the future sovereign (Charles) who, viewing the scene from his throne at the end of the long hall, embodied the realm in his person. The architectural setting, reminiscent of the Pantheon in Rome, represents a classical temple of Concord. Flanking the scene are smaller ovals, the allegories *Hercules Defeating Discord* and *Minerva Vanquishing Sedition.*

At the opposite end, above Charles's throne, is the *Peaceful Reign of King James,* whose identification with Solomon is here reinforced by Solomonic columns that recall their symbolic function in the Eucharist tapestries (plate 26). In a reference to Christ at the Last Judgment (whom Solomon prefigures), James gestures toward Peace embracing Plenty; at the judge's left (sinister) side, Mercury wields his caduceus as Minerva (like a St. Michael) casts armed Rebellion into hell—perhaps a political reference to the Gunpowder Plot of 1605. The two ovals offer allegorical glosses: *Temperance Vanquishes Wantonness* and *Liberality Overcomes Avarice.*

"God hath given us a Solomon," the English Bishop Montague had proclaimed, "and God above all things gave Solomon Wisdom. Wisdom brought him Peace. Peace brought him Riches."[66] On two long, narrow canvases are Bacchic processions of putti, with harnessed wild animals, garlands, and cornucopias symbolizing the fruits and riches of James's peaceful reign. The large central oval presents the climax: James's *Apotheosis* (fig. 61), a secularized adaptation of Christ's ascension into heaven. Swirling about the king, borne aloft on a globe and imperial eagle, are Religion, Faith, Justice, Victory, and Minerva, who descends from above to proffer a laurel crown. A host of putti carry royal oak leaves, a jeweled crown, and roses. Rubens foreshortened his figures for the viewer, who must literally raise his sights to behold the apparition.

The canvases—executed largely by studio assistants—were finished in August 1634, but owing to the king's financial problems they were not shipped until December 1635. Rubens added his finishing touches in Antwerp and sent the paintings by courier, since by then he had developed a "horror of courts." Charles, who sent the artist a gold chain in gratitude, ordered that henceforth no masques were to be performed in the hall, lest candle smoke obscure the brilliance of Rubens's heavenly creations. Years later, with poignant irony, Charles passed under this triumphal ceiling of royalist propaganda en route to his beheading on a scaffold erected by Cromwell's republicans immediately outside.

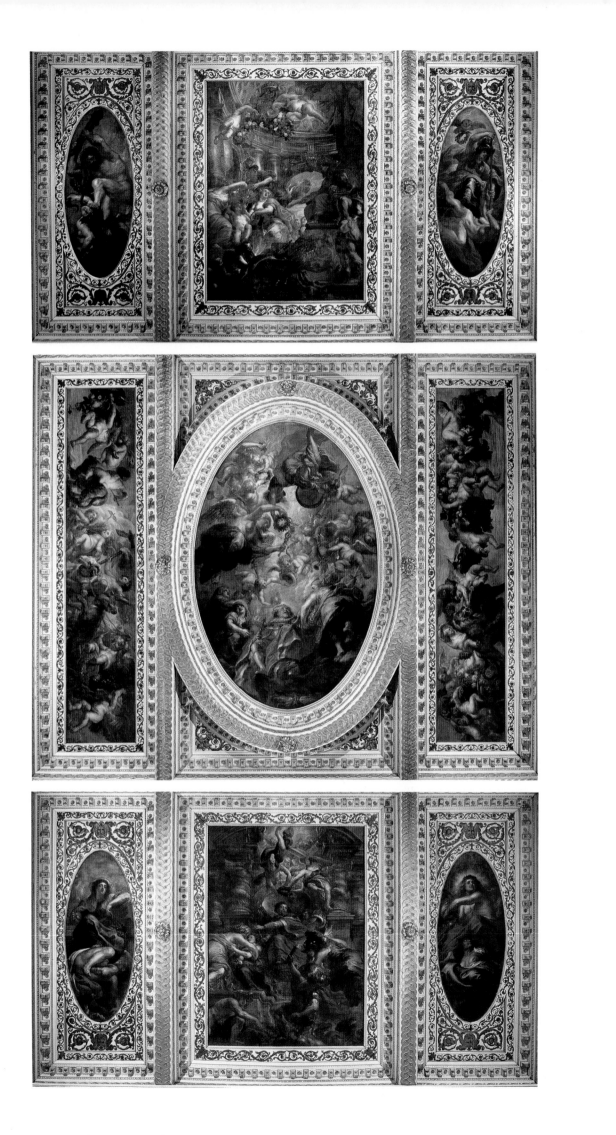

THE ARCH OF FERDINAND

1634
Oil on canvas (transferred from panel), 41 × 28½" (104 × 72.5 cm)
The Hermitage, Leningrad

The most monumental commission of Rubens's career was a rush job. "I am so overburdened with the triumphal entry of the Cardinal-Infante (which takes place at the end of this month) that I have time neither to live nor to write," the artist reported to Peiresc on December 18, 1634. A month earlier, Rubens had begun designing nine magnificent structures (arches and stages) to decorate the streets of Antwerp for the official entry of the new governor of the Spanish Netherlands, the Cardinal-Infante Ferdinand, younger brother of King Philip IV and successor to his late aunt, the Infanta Isabella. This celebration of the new ruler as a military hero contained, at the same time, an undisguised plea for relief from the economic distress caused by the prolonged war in the Netherlands. The first six monuments glorifying the cardinal-infante and his imperial Hapsburg family concluded with the *Arch of Ferdinand*, which immediately followed the *Stage of Isabella* (fig. 70). Rubens's detailed *modello*, painted in oil on panel, here suggests in miniature the effect of its full-scale translation into painting, sculpture, and architecture by a virtual army of assistants.[67]

The front of the triple arch illustrated Ferdinand's recent victory at Nördlingen for the Catholic Hapsburg forces over the Protestant Swedes. On the rear face, visible to the cardinal-infante turning back after the procession had passed through the central arch, Rubens staged a classicized reflection of the triumphal procession, here raised—both physically and allegorically—a story higher than the street. Ferdinand stands, dressed in ceremonial armor and red cape, in a quadriga with four white horses. On the road march trumpeters, standard-bearers, and soldiers leading captives and carrying trophies. In the sky, allegorical Victories—one of whom crowns Ferdinand with a laurel wreath—are accompanied by Hope, silhouetted against a blaze of heavenly light. This imagery represents the culmination of a long development of the classical triumph *all' antica* from the Constantine series (fig. 46) through the Eucharist (plate

27) and Henry IV (fig. 60) cycles. Crowned by the Spanish coat of arms and lions, the scene is flanked by two grisaille sculptures: Honor (holding scepter and cornucopia) on the left; and Virtue (with Hercules's lion skin and club) on the right. Both turn inward toward the scene they epitomize, recalling Rubens's similar application of framing grisaille herms in the Achilles cycle (plate 30). To the left and right of these statues, respectively, are illusionistic paintings of Liberality and Providence described as live figures standing within two openings above the smaller arches. At each side are sculptured satyrs holding candelabra and festive putti holding wreaths. Below, over the small arches, are wreathed medallions of Nobility (left) and Youth (right), celebrating Ferdinand's association—in age as well as royal stature—with Alexander the Great.

The triumphal imagery is raised to its allegorical peak in the sculpture and "cutout" figures crowning the pediment. In the center (now barely visible from overpainting), mounted on a winged horse, is Lucifer Laureatus, the morning star, symbolizing "the heavenly light of victory" at Nördlingen and the hope it inspired for the Spanish Netherlands. On each side, winged Victories display wreathed shields; beside them are repeated counterpoised trophies and bound prisoners. At each end, winged Fame sounds a fanfare. Occasional lettering suggests, in Rubens's shorthand, the extensive Latin inscriptions composed by Gevaerts to adorn the monuments and to explain the recondite iconography, much of which was surely missed during the two-hour procession on April 17, 1635.

Though festive and temporary from the outset, Rubens's creations were "bound to last" in a folio volume of Theodoor van Thulden's etchings (figs. 70 and 71) accompanied by Gevaerts's erudite commentary. By the time of the book's publication in 1642, both Rubens and the cardinal-infante were dead. Antwerp's commercial decline was not reversed, but the city had already achieved, through art, its greatest civic triumph.

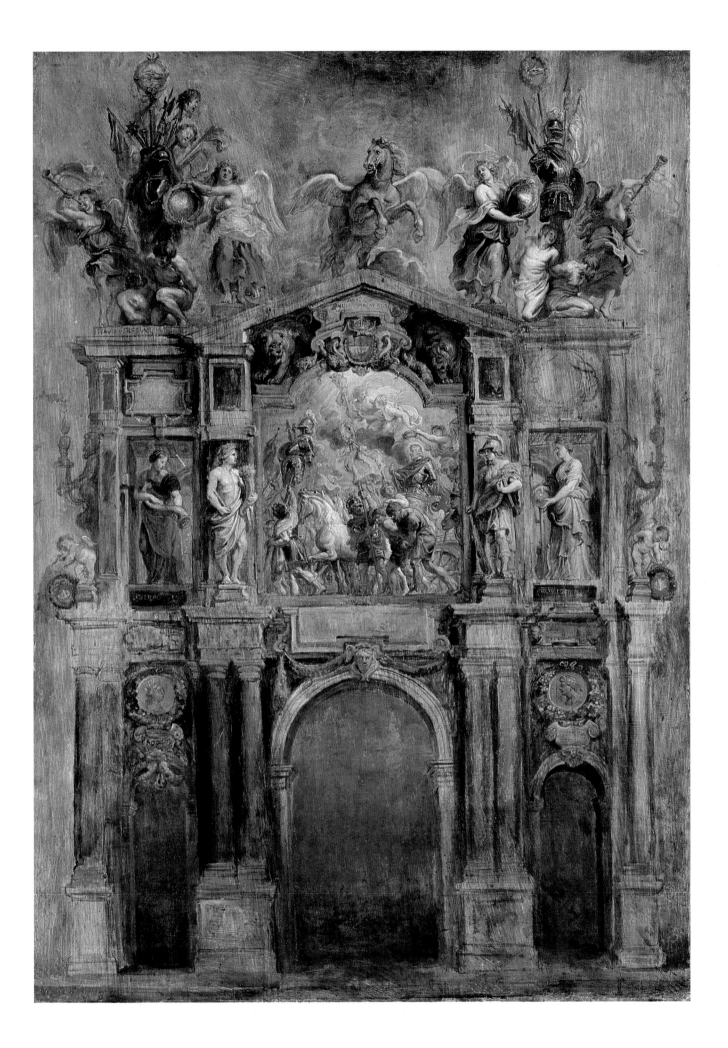

VENUS AND ADONIS

c.1635

Oil on canvas, 77³⁄₄ × 95⅝" (197.4 × 242.8 cm)
Metropolitan Museum of Art, New York
Gift of Harry Payne Bingham, 1937

According to Velázquez's father-in-law, Francisco Pacheco, Rubens copied "all the Titians" in the royal collection during his eight months in Madrid in 1628. Pacheco's probable exaggeration notwithstanding, the inventory of Rubens's estate included some thirty-three copies after Titian. Rubens's renewed study of the Venetian colorist—a respite from the tedium of snail-paced Spanish diplomacy—was extraordinarily fruitful. He found in Titian's technique the brilliant confirmation of his own painterly ideal: a shimmering of pigments, composed of small patches of color and broken brush strokes, like a liquid mosaic. Among the mythological scenes that the Flemish master copied in Madrid was Titian's *Venus and Adonis*, now in the Prado (fig. 58), which illustrated—indeed, *invented*—the scene of the lovers' impassioned parting as Venus vainly seeks to dissuade the young huntsman from his fatal pursuit. While Rubens's copy has unfortunately been lost, his consummate variation on the theme is here preserved in a canvas painted several years later.[68]

According to Ovid (*Metamorphoses*, X), Venus fell in love with the handsome mortal as a result of being accidentally grazed by one of Cupid's arrows. Captivated by Adonis's beauty, "she cared no more for her sea shores. . . . She even stayed away from heaven, preferring Adonis to the sky." Although she took up recreational hunting with her beloved, Venus adamantly warned him against pursuing wild animals, "otherwise your valor will be the ruin of us both." Adonis failed to heed her and was gored to death by a wild boar. Finding his body, the distraught Venus changed him into a flower "the color of blood." But like their tragic romance, Ovid notes, "enjoyment of the flower is of brief duration: for it is so fragile, its petals so lightly attached that it quickly falls, shaken by the same wind that gives it its name, *anemone*."

Rubens had earlier painted Adonis's poignant farewell (Gemäldegalerie, Düsseldorf) and Venus's lamentation over his body (Steinberg Collection, New York), both works dating from the early 1610s. In Rubens's return to the subject two decades later, the sculptural figures and compressed heroic drama yield to an elegiac lyricism. Venus sits gracefully on a rock covered by conveniently discarded drapery as she gently restrains Adonis and caresses his back. She looks pleadingly into his eyes, her flowing blond tresses suggesting her distraught emotional state. Adonis, bronzed and muscular, clad in a bright red tunic, is a Hellenistic sculpture incarnate; he appears silhouetted against the luminous sky that Venus had abandoned for love of him. Adonis looks down and extends his right arm in a gesture of reassurance while his other arm firmly plants his spear in the ground. At his feet, little Cupid grabs his leg. Cupid's quiver of arrows and bow lie on the ground pointing at Venus, an iconographic reminder of the original—and accidental—cause of this heartbreaking affair.

The two counterpoised bodies of the star-crossed lovers recall Rubens's *contrapposto* in his *Rape of the Daughters of Leucippus* (plate 12). The stance of Adonis may in fact be derived from one of the statues of the Dioscuri on the Quirinal. His pose, as he turns into the landscape already streaked with dawn, suggests the finality of the parting. But for a lingering moment it is love, not the thrill of the chase, that dominates: even the hunting dogs echo their master's double passion. The face of the goddess reflects Rubens's own "Venus," Helena Fourment, and foreshadows her reappearances in this role in *Het Pelsken* (fig. 67) and the *Judgment of Paris* (plate 40). The background landscape is symbolically divided—as in the *Landscape with Philemon and Baucis* (plate 24)—between the secure right half, the rocks and trees behind Venus, and the open, unprotected expanse into which Adonis is about to venture. Through the poetics of landscape, Rubens evokes the Ovidian metamorphosis—Adonis's ultimate transformation into a part of cyclical nature as a brilliant crimson perennial, "an everlasting token" of Venus's grief.

112

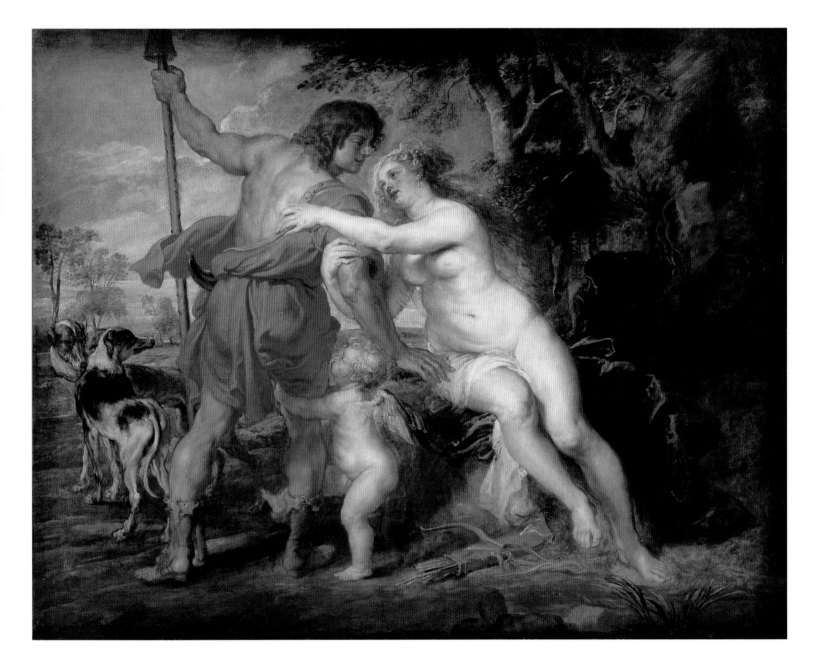

HELENA FOURMENT WITH CLARA JOHANNA AND FRANS

1636
Oil on panel, 44½ × 32¼" (113 × 82 cm)
The Louvre, Paris

Unlike Van Dyck, who married a member of the English nobility, Lady Mary Ruthven, Rubens resisted pressure to "make a court marriage." Instead he chose a young woman of good middle-class background—"one who would not blush to see me take my brushes in hand."[69] Their first son, Frans, born on July 12, 1633, was painted naked on his mother's lap sometime in early 1635 (Alte Pinakothek, Munich). A year or so later, in this magnificent, unfinished group portrait in the Louvre, Frans again appears in a similar setting, now festively clothed and accompanied by his elder sister, Clara Johanna, who was born on January 18, 1632. Rubens's family portraits of the 1630s reveal a poetic combination of aristocratic formulas of portraiture and intimate, seemingly spontaneous glimpses of the artist at home. The unfinished background contributes—as in an oil sketch—an impression of freshness and informality, conveying a lively sense of the artist at work. Nevertheless, enough is sketched in to reveal an outdoor setting. The positioning of Helena's chair beside a massive marble column and splash of red drapery recalls the formula Rubens first established in his Genoese aristocratic portraiture and continued in court portraits such as the *Countess of Shrewsbury* (c.1620, Alte Pinakothek, Munich). Helena wears a plumed beaver hat, as her sister Susanna did in *Le Chapeau de Paille* (plate 19). Frans, too, has donned a festive hat and plays with a bird on a string—like his elder half brother Nicolaas (plate 22) a decade earlier. Unlike Nicolaas, however, his attention has been distracted; he turns and looks out toward the viewer (and, implicitly, his father). Clara Johanna gathers her skirt in her hands and looks toward her mother; a mask dangles at the side of her face: perhaps she is dressed for a children's party.

The downcast gaze of Helena, who sits with hands folded around Frans, imparts an air of maternal pensiveness—a secular Madonna and Child. (She may already be carrying her fourth child, Peter Paul, who was born on March 1, 1637.) Her third child, Isabella Helena, born May 3, 1635, was originally to be included at the far right:

the pentimento of her diminutive, outstretched left hand (just above the chair seat at the edge of her mother's white gown) corresponds to a preparatory chalk drawing (fig. 72) where the artist's daughter appears to be taking her first steps, dressed in a gown with sash and padded cap and wearing a harness.

It has been suggested that Rubens considered widening the portrait to include the child but later changed his mind. The *partial* incorporation of Isabella Helena, however, argues in favor of her intended inclusion from the start and suggests that this unfinished section was later cut off—probably by the artist himself.[70] Perhaps the harness created a difficulty: who was to hold it? It is hard to imagine a governess introduced into such an intimate setting. On the ground, under the chair, are the faint outlines of a dog curled up, asleep—a final domestic detail and traditional symbol of marriage and fidelity, both of which Rubens warmly evoked in this serene and glowing portrait.

Rubens revived the figural motif of Isabella Helena's preparatory drawing—including the costume—for a portrait of his next child, Peter Paul, the last born during the artist's lifetime. In his *Self-Portrait with Helena and Peter Paul* (fig. 77) the one-and-a-half-year-old boy walks in a garden ahead of his parents, on a tether held by his mother—a logistical solution precluded in the Louvre painting. Helena once again gazes down pensively at her child, who reciprocates with a toddler's eagerness. At the time of their wedding, in 1630, Rubens's lifelong friend Jan Caspar Gevaerts wrote a Latin poem celebrating "Helena of Antwerp": unlike her Homeric counterpart, Helen of Troy, he proclaimed, she would prove to be a perfect wife, through whom Rubens would regain his youth. Rubens's subsequent tributes to Helena in paint offer vivid confirmation of Gevaerts's prophecy. While Rubens's surviving letters rarely reveal the artist's inner life, the evocative powers of his brush clearly overcame his innate reticence in these final, unqualified expressions of domestic happiness.

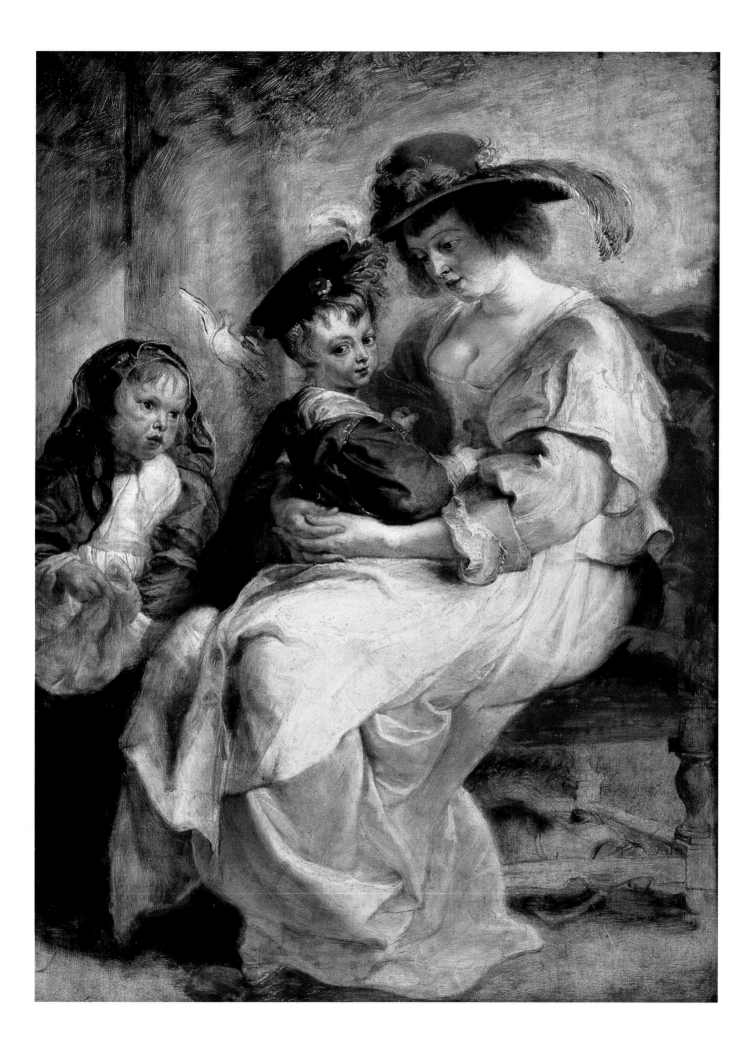

LANDSCAPE WITH HET STEEN

1636
Oil on panel, 51⅝ × 90¼" (131.2 × 229.2 cm)
The National Gallery, London

"In no other branch of the art is Rubens greater than in landscape." So wrote John Constable, whose early Romantic landscapes—above all, the *Haywain*—proclaim his debt to the Flemish master and especially to Rubens's *Landscape with Het Steen,* which the young Constable saw during a visit to the artist and academician Benjamin West in 1804.[71] A century and a half earlier, Philip Rubens had observed that his uncle's landscapes, though relatively few in number, "even surpass in esteem the figure paintings," and connected them with his purchase of the castle of Steen in Elewijt, between Malines (Mechlin) and Brussels, in 1635: "He took great pleasure living there in solitude, in order to paint vividly and au naturel the surrounding mountains, plains, valleys, and meadows, at the rising and setting of the sun, up to the horizon."[72] This splendidly proprietary—almost autobiographical—landscape was probably painted toward the end of Rubens's first summer in residence at Elewijt, in 1636.

The manor house survives today, restored and embellished, minus the crenellated tower that Rubens here frames with tree branches and highlights with the golden reflections of the early morning sun. Outside the château Rubens minutely includes himself and Helena promenading under the trees at the far left; seated beside them is a woman holding a child—probably a nurse with Isabella Helena (fig. 72). These are but footnotes to the panoramic view and description of the life of the land. A farmer with his wife drives a cart across a stream. Unlike Rubens's *Landscape with Carters* (plate 10), in which a similar motif was included to create narrative tension, here the wagon laden with goods for market conveys the essence of rural—and domestic—stability. In the foreground, a huntsman and dog stalk partridges. X rays have revealed that there originally was a second, younger hunter and two dogs that the artist later painted out. The tree trunk with blackberry brambles functions as a *repoussoir* recalling Rubens's early pen-and-ink studies of fallen trees (fig. 35). The landscape, which rolls up to a distant horizon in a series of earthen waves, teems with wildlife. The viewer's eye follows a row of trees to the covey of partridges, deliberately out of scale with the surrounding trees and bridge. The eye then plunges into the distance, where a farm girl tends cattle, a detail which, along with the wagon at the left, iconographically links the scene with its likely pendant *Landscape with a Rainbow* (fig. 73).

The high placement of the horizon line, two-thirds up the panel, maximizes the tactile sense of extraordinarily lush, rolling terrain stretching almost infinitely, beyond all natural optical boundaries. The close correspondences with the pendant scene of haying suggest, according to Lisa Vergara, that the two landscapes were conceived as complementary views of summer activities, deriving from such sixteenth-century seasonal pairings as Pieter Bruegel's *Haymaking* (National Gallery, Prague) and *Harvest* (Metropolitan Museum of Art, New York).[73] Rubens's pair originally reflected, side by side, a dual aspect of life at Het Steen—sport and farming—and two times of day: early morning and late afternoon, the latter with a brilliant overarching rainbow (fig. 73).

Rubens's unified, panoramic vision conceals the essential artificiality of this late landscape construction—a formal complexity that corresponds to the painting's physical support, an assemblage of no fewer than seventeen separate oak panels. While Constable admired its naturalism and close observation of natural phenomena, Kenneth Clark, following Baudelaire, cataloged it among the "landscapes of fantasy."[74] For Rubens, the two were uniquely compatible. His landscapes are viewed through a filter of classical humanism. Virgil's *Georgics* and *Eclogues,* Horace's lyric poetry, and Pliny's descriptions are among the ancient sources of Rubens's classical evocation of rural harmony, the Roman ideal of villa life. This widely optimistic landscape, which the new Lord of Steen ultimately bequeathed to his wife, Helena Fourment, represents, in the final analysis, *two* landscapes: an external view and an interior reflection.

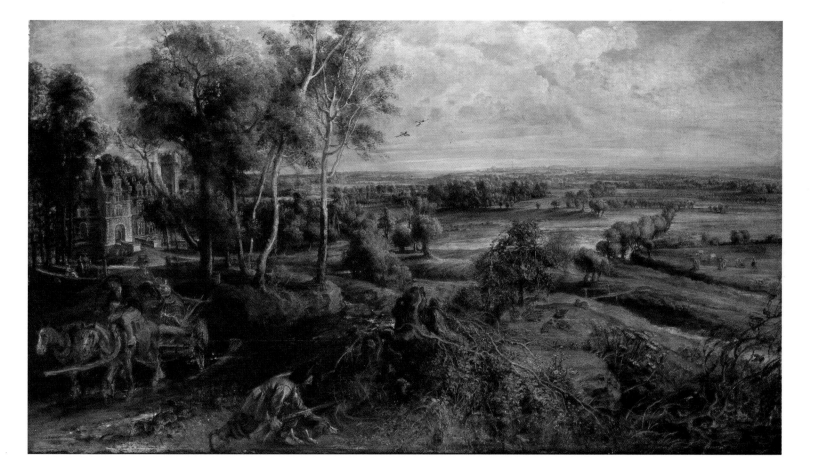

THE FALL OF PHAËTHON

1636
Oil on panel, 11¹/₁₆ × 10¹³/₁₆″ (28.1 × 27.5 cm)
Musées royaux des beaux-arts, Brussels
Bequest of Comtesse de Valencia de Don Juan, Paris, 1919

ARACHNE PUNISHED BY MINERVA

1636
Oil on panel, 10½ × 15″ (26.7 × 38.1 cm)
Virginia Museum of Fine Arts, Richmond
The Williams Fund, 1958

An English visitor to Rubens's studio, Sir William Sanderson, recorded: "Rubens would (with his arms across) sit musing upon his work for some time; and in an instant, in the liveliness of spirit, with a nimble hand would force out his overcharged brain into descriptions, as not to be contained in the compass of ordinary practice but by a violent driving on of the passion. The commotions of the mind are not to be cooled by slow performance."[75] Nowhere is Rubens's virtuosity—his *"furia del pennello"*—more demonstrable than in his late commission from King Philip IV of Spain for some sixty-odd mythologies from Ovid's *Metamorphoses* to adorn the king's new hunting lodge, the Torre de la Parada outside Madrid. Rubens first designed each scene in an oil sketch, over fifty of which have survived; the vast majority were painted *within two months*, from November to December 1636. These were then worked up (with the help of collaborators) into the definitive canvases, which were shipped to Spain in April 1638. Rubens's sketches convey his unique powers of invention and interpretation—nothing less than a monumental "illustrated Ovid." While no iconographic scheme has yet been identified for the specific episodes selected, their rustic context, a royal hunting lodge, suggests they may have been intended to celebrate the proper place of man within nature and a divinely ordered cosmos—a Baroque variation on the medieval *Ovide moralisé*, or Christianized interpretation of the Roman poet's myths.[76] Among Rubens's most dramatic scenes of retribution are the fates of mortals guilty of hubris, of presuming equality with the gods, found in this series.

"Down, down I come like glistening Phaëthon, wanting the manage of unruly jades," exclaims Shakespeare's Richard II at his dethronement. Rubens's oil sketch captures with comparable poetic economy the spectacle of pride's fall. The mortal Phaëthon had rashly extracted from his horrified father, Phoebus Apollo, permission to drive the sun god's chariot across the heavens. Unable to control the four spirited horses, he pursued a wild, fiery course that threatened to destroy the earth until Jupiter finally intervened and launched his lightning bolt: "The horses, dismayed, leaped apart, broke free from the yoke, and escaped from among the broken reins . . . but Phaëthon, with flames searing his glowing locks, was flung headlong, and went hurtling down through the air. . . ." As a young man, Rubens had first painted the subject during his Italian sojourn and was familiar with Michelangelo's famous formulation, as well as with contemporary illustrated editions of Ovid. But this pyrotechnical sketch is unprecedented in its concentrated *contrapposto*—a pinwheel of choreographed limbs, juxtaposed with the wheel of the golden chariot. With striking economy of brushwork and palette (browns, whites, golds, and reds) Rubens evokes imminent chaos exploding out of a delicately balanced construction.

Arachne Punished by Minerva surely had special significance for the master designer of four monumental tapestry cycles. The mortal Arachne, famed as the most talented tapestry weaver on earth, rashly challenged the goddess Minerva (Athena) to a weaving contest. Added to this display of hubris was Arachne's further mockery of the gods in weaving scenes of their most rakish exploits. In Rubens's painting, Arachne's background tapestry reproduces Titian's *Rape of Europa* (Gardner Museum, Boston), which Rubens had copied in Madrid in 1628–29. The furious Minerva attacks Arachne with a weaver's shuttle, before transforming her into a spider condemned to hang from its own web. Rubens added a witty exchange between the mythological realm of the tapestry and the mundane workshop. A young weaver looks up as Europa, carried to sea on the back of Jove's bull, turns to call back to her companions on the shore. In Ovid's story, Minerva had found no *technical* fault in Arachne's weaving; at issue was the recognition of divine artistry, not human craftsmanship. In his creative outpouring for the Torre de la Parada, Rubens demonstrated his own supreme powers of inspiration and literary invention.

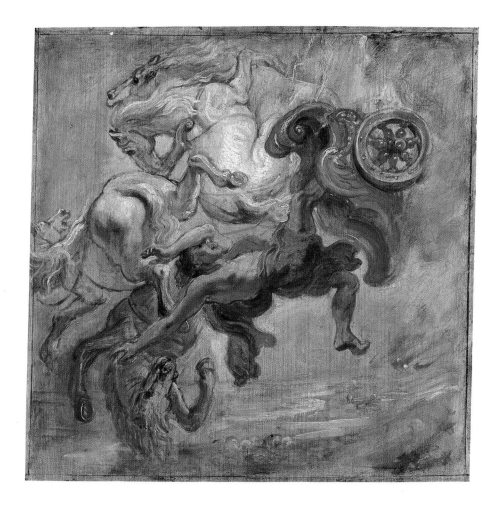

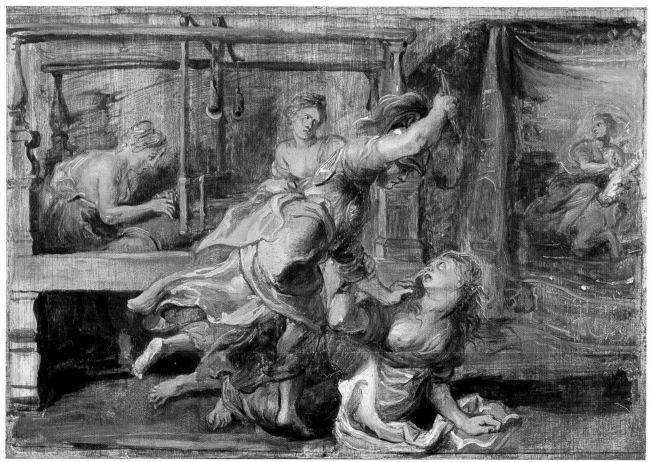

THE JUDGMENT OF PARIS

c.1635–1638
Oil on panel, 57 × 76¼" (144.8 × 193.7 cm)
The National Gallery, London

According to the Greek satirist Lucian's *Dialogues of the Gods,* Paris was a reluctant judge: "How can a simple herdsman like myself become an arbiter of divine beauty?" he implored Mercury. "I shall divide this apple among all three." But Mercury, invoking the will of Jupiter, insisted he must choose, using his "native intelligence," and the goddesses all agreed to abide by the final decision. "Will it be enough to judge them as they are—or should they be naked?" Paris queried.

"The rules of the contest are for you to decide," Mercury replied with a discreet smile.

"In that case, will they kindly disrobe?"[77]

Rubens first conceived this late *Judgment of Paris* as an illustration of the divine disrobing. Radiographs and pentimenti reveal that originally Minerva (left) and Venus (center) were assisted by putti in removing their clothes, as two satyrs lasciviously peered through the foliage, a detail that recalled Rubens's earlier version of the subject (plate 2). Mercury's right arm pointed forward; Paris's right leg was fully extended. A pair of doves hovered behind Venus's head; her robe was held lower while Juno's fur-trimmed cloak was far less concealing. Paris's hand with the golden apple rested on his left wrist. He wore a hat and his shirt covered both shoulders. In altering and suppressing poses, drapery, and details for the painting's final state, Rubens gave the sole remaining putto at the lower left a pair of wings and a quiver, thereby transforming him into Cupid.[78] Overall, he shifted the dramatic focus from the goddesses' initial disrobing and Paris's perusal of the Olympian lineup to the crucial moment of decision.

Paris looks at the radiantly fair Venus as he extends the golden apple. She returns his gaze as she covers herself modestly—a quotation of the ancient *Venus pudica.* Both in gesture and features she suggests Helena Fourment in *Het Pelsken* (fig. 67). The more active pose of Minerva standing before her owl, Medusa shield, and helmet was also derived from a classical type, the *Venus anadyomene.* Juno has likewise been passed over: her

peacock hisses at Paris's dog. The emphasis is now on the psychological—not physical—exchange between the two principals. In Rubens's youthful version of about 1600 (plate 2) Paris actually hands the apple to Venus; here the outcome is conveyed far more subtly by facial expression and nuances of gesture.

A comparison between the two interpretations reveals a profound change in Rubens's style and his approach to classical mythology over three and one-half decades. The early sculptural figures derived from Renaissance engravings have been replaced by luminous, painterly forms reflecting the renewed influence of Titian on the mature Rubens. The once Flemish landscape of crystalline, cool colors has opened into a broad, expansive, Italianate pastorale of golden hues. The incidental figures drawn from Marcantonio's engraving (river god, nymph, satyrs) have finally been eliminated. Paris is described no longer in exaggerated *contrapposto* but as an idealized young shepherd, awestruck by the power of beauty, while Mercury looks on in wonder, aimlessly dangling his caduceus.

No transcendental explosion of light rays and crown-bearing putti intrude from above to celebrate Venus's victory. Instead, a fiery personification bearing torch and serpent emerges from storm clouds above Juno, its expression mirroring the horrific face of the snake-haired Medusa on Minerva's shield. It is the Fury Alecto, harbinger of war and destruction. Placed above Juno, she personifies that goddess's internal fury—and Juno's inevitable revenge on Paris and Troy. Rubens views the *Judgment* no longer as a joyous triumph of Venus, but rather as a mellow overture to war, rendered all the more poignant by its lush pastoral setting. As the Fury's flight passes unnoticed below, it is here, as in his youthful *Samson and Delilah* (plate 5), the *anticipation* of conflict that creates dramatic tension beneath the lyrical surface. In this late recasting of one of his earliest subjects, Rubens reveals his undiminished power to breathe new life into ancient forms.

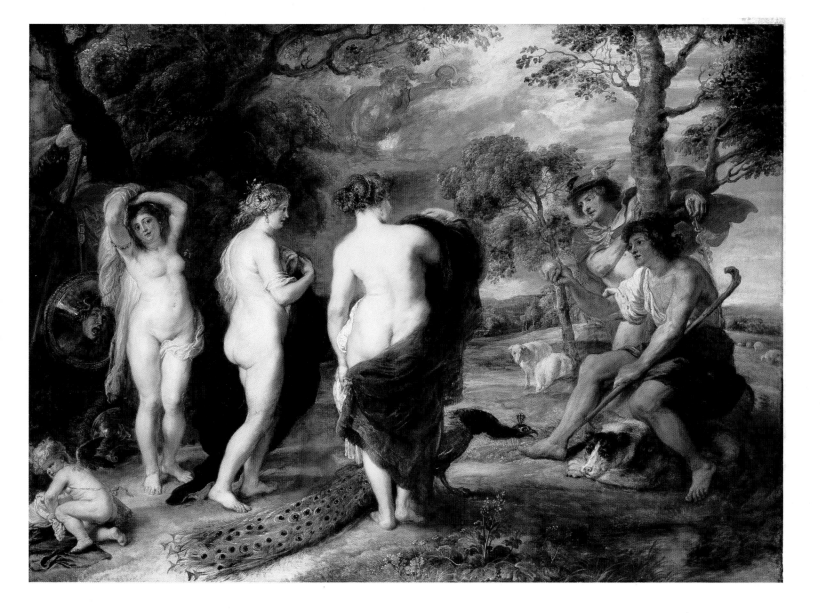

THE HORRORS OF WAR

1637

Oil on canvas, 6'9" × 11'4" (206 × 345 cm)

Palazzo Pitti, Florence

Rubens's quest for peace in Flanders is chronicled in his diplomatic career and eloquently expressed in his correspondence. "I am a peace-loving man," he wrote to Peiresc in August 1635, after his official retirement from international diplomacy: "I hope that His Holiness and the king of England, but above all the Lord God, will intervene to quench a blaze that (not put out in the beginning) is now capable of spreading throughout Europe and devastating it."[79] Two years later, with no prospect of peace in sight, Rubens translated his prophetic words onto canvas—a powerful and deeply personal allegory that Burckhardt aptly called "the immortal and unforgettable frontispiece to the Thirty Years' War."[80] Painted for the grand duke of Tuscany, it sums up a lifetime's mastery of allegorical expression. In his letter of March 12, 1638, to Justus Sustermans, court painter to the grand duke, Rubens supplied the libretto, a detailed explanation that confirms both his original authorship of the iconography and his powers of visual recollection:

> The principal figure is Mars, who has left the open temple of Janus (which in time of peace, according to Roman custom, remained closed) and rushes forth with shield and bloodstained sword, threatening the people with great disaster. He pays little heed to Venus, his mistress, who, accompanied by her Amors and Cupids, strives with caresses and embraces to hold him. From the other side, Mars is dragged forward by the Fury Alecto, with a torch in her hand. Nearby are monsters personifying Pestilence and Famine, those inseparable partners of War. On the ground, turning her back, lies a woman with a broken lute, representing Harmony, which is incompatible with the discord of War. There is also a mother with her child in her arms, indicating that fecundity, procreation, and charity are thwarted by War, which corrupts and destroys everything. In addition, one sees an architect thrown on his back with his instruments in his hand, to show that that which in time of peace is constructed for the use and ornamentation of the City, is hurled to the ground by the force of arms and falls to ruin. I believe, if I remember rightly, that you will find on the ground under the feet of Mars a book as well as a drawing on paper, to imply that he treads underfoot all the arts and letters. There ought also to be a bundle of darts or arrows, with the band which held them together undone; these, when bound, form the symbol of Concord. Beside them is the caduceus and an olive branch, attributes of Peace; these also are cast aside. That grief-stricken woman clothed in black, with torn veil, robbed of all her jewels and other ornaments, is the unfortunate Europe who, for so many years now, has suffered plunder, outrage, and misery, which are so injurious to everyone that it is unnecessary to go into detail. Europe's attribute is the globe, borne by a small angel or genius, and surmounted by the cross, to symbolize the Christian world.[81]

The iconography reflects a lengthy thematic development throughout the artist's oeuvre. The Temple of Janus was first introduced in Rubens's title page for Franciscus Haraeus's *Annales Ducum Brabantiae* (part 3, published 1623). In a similar context it reappeared a decade later in the *Pompa Introitus Ferdinandi* (fig. 71). The Fury Alecto (see plate 40) made her debut in the Medici cycle (*Council of the Gods*), before crossing the Channel to emerge again in the *Allegory of Peace and War* (fig. 59) and in the *Peaceful Reign of James I* (plate 33) for the Whitehall ceiling: in each case she was defeated by Minerva (Wisdom). But Minerva is no longer in sight; the champions of peace and reason have here vanished from the European stage. Only Venus is left to restrain her bloodthirsty consort, and the futility of her plaintive gesture—forcibly opposed by Alecto—is underscored by its derivation from Rubens's renderings of *Venus and Adonis* (plate 35). In his most painterly, broad brushwork—a dynamic sweep across the canvas—Rubens transmuted, as it were, the motifs of an antique sarcophagus frieze into the flesh and blood of contemporary horrors. Its successors are to be found in the Romantic tragedies of Delacroix and Géricault—and, ultimately, in Picasso's *Guernica*.

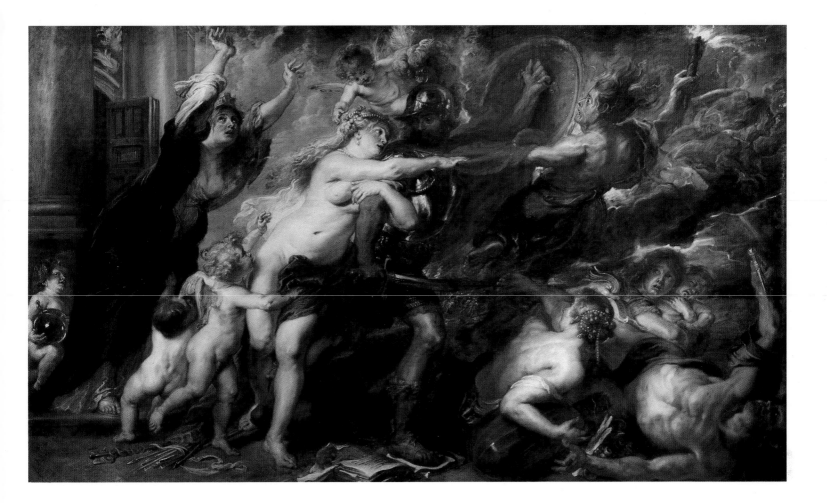

SELF-PORTRAIT

1638–1640
Oil on canvas, 43 × 33½″ (109.5 × 85 cm)
Kunsthistorisches Museum, Vienna

"I am not a prince, but one who lives by the work of his hands"—so Rubens wrote to Sir Dudley Carleton in 1618.[82] Yet unlike Rembrandt, Velázquez, and Poussin, Rubens left for posterity no masterly portrayal of himself as an *artist*. No attribute of his "beloved profession" is included in his double portrait with Isabella Brant (plate 6) or in the official *Self-Portrait* (frontispiece) he was requested to send to Charles I of England: there, in three-quarter profile, wearing a broad-brimmed hat, he confidently presented himself in paint—as he would soon in person—as a man of the world. It is this self-image that Rubens, a decade and a half later, expanded here into an aristocratic half-length *Self-Portrait* painted toward the end of his life.[83]

The dating of the work has ranged from 1633 to 1640, but a late date of 1638 to 1640 seems the most plausible—in comparison with *Het Pelsken* (fig. 67) and the *Self-Portrait with Helena and Peter Paul* (fig. 77). Rubens stands beside a stone column, a classical motif of aristocratic portraiture (plate 3) that he had earlier applied to members of his family: his sons (plate 22) and wife Helena (plate 36). His bare left hand rests on the hilt of his sword; in his gloved right hand he casually holds the second glove as he gazes out toward the viewer. His assured but visibly world-weary countenance reflects his age (early sixties) and, in the sagging flesh under the eyes, his chronic bouts of gout. In a letter of February 15, 1639, Rubens wrote that "the gout very often prevents my wielding either pen or brush—and taking up its usual residence, so to speak, in my right hand, hinders me especially from making drawings on a small scale." Yet he enjoyed periods of remission from the crippling ailment: the preparatory drawing for this late self-portrait (fig. 76) reveals no tentativeness or other signs of indisposition.[84] Both the directness of the facial expression and profusion of drapery were modified—and muted—in the final painting. Burckhardt's notion, generally followed by more recent commentators, that the gloved hand alludes to Rubens's gout is a sentimental misunderstanding of the

motif. It is gloved so as to emphasize the *other* hand, which rests on the jeweled sword, presented to him by Charles I when he knighted Rubens in 1630. Despite additional titles and honors—a patent of nobility from Philip IV in 1624, a Spanish knighthood in 1631, and the manorial "Lord of Steen" in 1635—Rubens suffered from deep-rooted aristocratic prejudices against anyone who lived "by his hand." In December 1630, at the successful conclusion of his diplomatic mission to London, Rubens was nominated to the new post of Spanish ambassador to England only to be passed over by Philip IV's Council of State "because he practices a craft that in the end is base and done by hand . . . [which] would seem to present difficulties if Your Majesty were to give him the title of one of your ministers."[85] When, in the following year, the State Council of Flanders petitioned King Philip to confer a knighthood on the artist, as King Charles already had done, it pointedly assured him that "this will not have the consequence of encouraging others of his profession to seek a similar favor. . . . The Emperor Charles V made Titian a Knight of Santiago, and thus it seems wise for Your Majesty to honor the nominee with the knighthood he pretends to."[86] In his knighthood, as in his paintings, it appears that Rubens owed an essential debt to his Venetian predecessor. Perhaps it was from Titian's *Man with a Glove* (Louvre, Paris) that Rubens derived this cavalier motif of offhanded poise.

"Of all his talents, painting is the least": While Rubens would surely have taken exception to General Spinola's hyperbole, he was fully conscious of the many levels of his own talent and professional activities. Unlike Rembrandt in his final years, Rubens did not approach self-portraiture as an avenue for introspection. It is the public visage—not the inner self—that Rubens here presents in his definitive self-portrait. Intended to be taken at face value, the image represents a generalized and all-embracing expression of a thoroughly cosmopolitan artist, one who confessed that he regarded "the whole world" as his country.

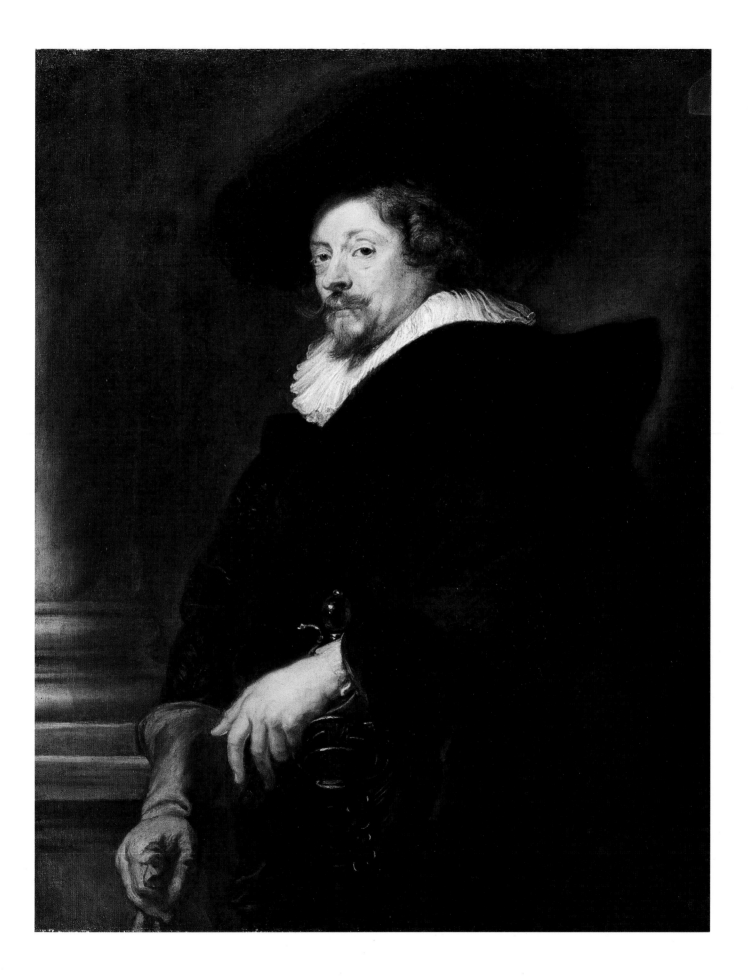

VIRGIN AND CHILD WITH SAINTS

c.1638-1640
Oil on panel, 83 × 76¾" (211 × 195 cm)
Jacobskerk, Antwerp

A few days before his death on May 30, 1640, Rubens was asked whether he would approve his family's wishes to have a burial chapel constructed in his memory. He replied that "if his widow, his grown sons, and the guardians of his children who were not yet of age considered that he had deserved such a monument, they could have the said chapel built without any further authorization on his part, and that they could use for it his picture of the Holy Virgin and Child surrounded by saints."[87] The burial chapel, behind the high altar of the parish church of St. James (Jacobskerk), was finished by the end of 1643 (fig. 79). The crowning niche contains a statue of Our Lady of Sorrows attributed to Rubens's protégé Lucas Fayd'herbe. The altarpiece Rubens designated for his memorial represents an enigmatic *sacra conversazione* bathed in twilight.

The Madonna sits enthroned on a loggia, holding her infant Son, who receives the kiss of an aged, kneeling (unidentified) cardinal-saint while a putto above extends a floral crown. Behind the cardinal-saint stand three female saints, the foremost of whom, with arms folded and holding a jar of ointment, is Mary Magdalene. At the far left, in full armor, stands St. George with a dead dragon at his feet. In balanced counterpoise, at the far right, St. Jerome kneels on top of his emblematic lion. Since the eighteenth century, tradition held that Rubens here incorporated portraits of his family accompanying his self-portrait as St. George. Jacob Burckhardt, who had initially followed this tradition, later had second thoughts: "Some happy interpreter may one day penetrate its secret meaning, but the first condition would be that he should cease to interpret the heads as 'Rubens and his family.'"[88]

The altarpiece may been seen as the conclusion of a long sequence of *sacre conversazioni* with pronounced memorial associations, beginning with Rubens's first Chiesa Nuova altarpiece (plate 4), later installed over his mother's tomb. The penitential emphasis of the Magdalene and St. Jerome harks back to Rubens's *Penitent Saints Before the Virgin and Child* (Gemäldegalerie, Kas-

sel) and *Christ and the Penitent Sinners* (plate 14). The Augustinian altarpiece of the *Virgin and Child Enthroned with Saints* (fig. 57) is recalled in the St. George-and-dragon motif and a saint (St. Catherine) kissing the Christ Child. More immediately it reflects the memorial *Ildefonso* triptych (plate 31) and the contemporaneous *Crowning of St. Catherine* (Museum of Art, Toledo), in which the Madonna and Child's arched throne, reminiscent of garden architecture, symbolizes the celestial paradise.

The seventeenth-century biographer Giovanni Pietro Bellori, whose sources were generally trustworthy, identified the otherwise elusive cardinal as St. Bonaventure, the great twelfth-century Franciscan theologian known as the "seraphic doctor."[89] The juxtaposition of Saints George and Jerome, who symbolically frame the central scene like the emblematic herms of the Achilles tapestries (plate 30), highlights two distinct sides of Rubens's personality and career. The active St. George, patron saint of knights, alludes to the twice-knighted diplomat-painter who crusaded so tirelessly in pursuit of peace. He is balanced by the contemplative scholar-saint Jerome, who translated the Holy Scriptures into Latin: the prominence given to the massive book testifies to Rubens's lifelong dedication to scholarship and Christian humanism. In the center, the aged St. Bonaventure serenely embodies the quiet but profound piety of the artist as he approached death.

For his own grave, Rubens did not paint a traditional epitaph with a self-portrait as "donor figure" (see fig. 29 and plate 31). Instead, he consigned perhaps the most lyrical requiem in the history of painting. Rubens's *literary* epitaph, composed by his old friend Jan Caspar Gevaerts, was finally set in place in 1755 by one of the artist's descendants: "To Almighty God: Peter Paul Rubens, knight; son of Jan, alderman of the city of Antwerp; Lord of Steen, who in addition to his outstanding knowledge of ancient history and all other fine and tasteful arts, deserved also to be called the Apelles not only of his own age, but of all time. . . ."

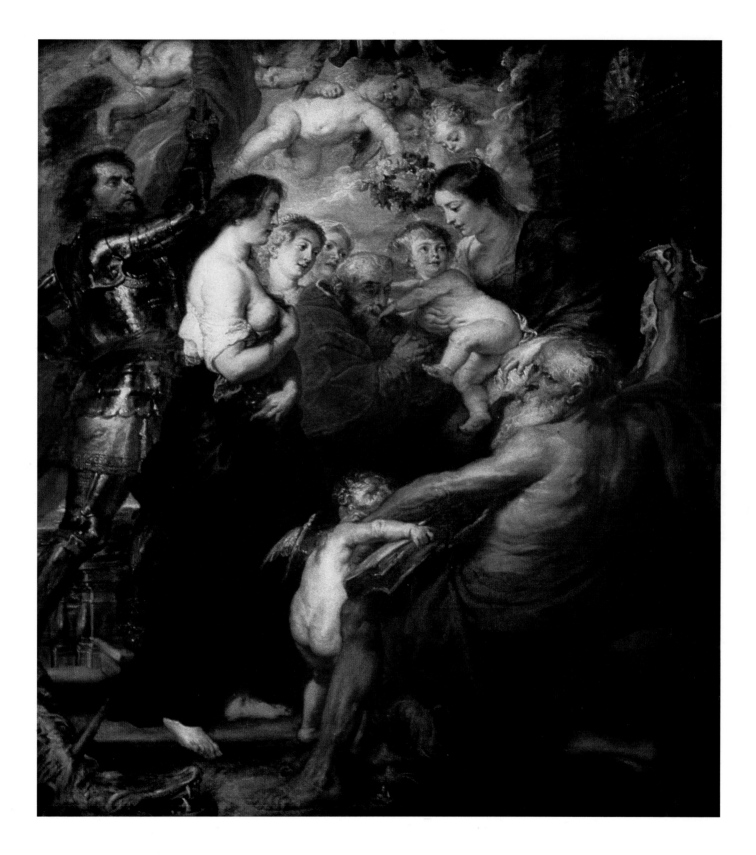

Text

1. For early biographies of Rubens: see R. de Piles, *Dissertation sur les ouvrages des plus fameux peintres,* 1681, facsimile reprint (Farnborough, Hampshire, 1968); and L.R. Lind, "The Latin Life of Peter Paul Rubens by his Nephew Philip," *Art Quarterly* IX (1946), pp. 37–44.
2. O. Sperling quoted in *Repertorium für Kunstwissenschaft* X (1887), p. 111.
3. J.S. Held, "Thoughts on Rubens' Beginnings," *Ringling Museum of Art Journal,* 1983, pp. 14–35.
4. C. Norris, "Rubens Before Italy," *Burlington Magazine* LXXVI (1940), pp. 184–194.
5. See M. Jaffé, *Rubens and Italy* (Oxford, 1977).
6. First published by R. de Piles (Paris, 1708): English translation reprinted in J.R. Martin, *Baroque* (London, 1977), pp. 271–273.
7. Rubens to Chieppio, 24 May 1603: R.S. Magurn, trans. and ed., *The Letters of Peter Paul Rubens* (Cambridge, Mass., 1955), p. 33. All subsequent citations of Rubens's letters refer to Magurn's edition.
8. Rubens to Chieppio, November 1603: *Magurn,* p. 38.
9. See J. Muller, *Rubens: The Artist as Collector* (Princeton, 1989).
10. Rubens to Johann Faber, 14 January 1611: Magurn, p. 53.
11. C. Scribner III, "Rubens and Bernini," *Ringling Museum of Art Journal,* 1983, pp. 164–177.
12. C. Norris, "Rubens' 'Adoration of the Kings' of 1609," *Nederlands Kunsthistorisch Jaarboek* XIV (1963), p. 129ff.
13. Rubens to Faber, 10 April 1609: Magurn, p. 52.
14. Reprinted in J.R. Martin, *Rubens: The Antwerp Altarpieces* (New York, 1969), p. 76.
15. J.R. Judson and C. Van de Velde, *Book Illustrations and Title Pages,* vol. XXI, *Corpus Rubenianum Ludwig Burchard* (London, 1978).
16. Rubens to Jacob de Bie, 11 May 1611: Magurn, p. 55.
17. Rubens to Faber, 14 January 1611: Magurn, p. 54.
18. O. Sperling, *Repertorium für Kunstwissenschaft* X (1887), p. 111.
19. G.P. Bellori, *Le vite de' pittore, scultori et architetti moderni* (Rome 1672: reprint ed., Rome, 1931).
20. Rubens to Carleton, 28 April 1618: Magurn, pp. 60–61.
21. F. Baldinucci, *The Life of Bernini* (Rome, 1682), trans. C. Enggass (University Park and London, 1966), p. 74.
22. Rubens to Archduke Albert, 19 March 1614: Magurn, p. 56. See F. Baudouin, *P.P. Rubens,* trans. E. Callander, rev. ed., (New York, 1977), pp. 143–171.
23. G.P. Bellori, *Vite,* p. 247.
24. Rubens to William Trumbull, 13 September 1621: Magurn, p. 77.
25. See C.V. Wedgwood, *The Political Career of Peter Paul Rubens* (London, 1975).
26. See J.S. Held, *The Oil Sketches of Peter Paul Rubens* (Princeton, 1980), p. 65ff.
27. *Ibid.,* pp. 89ff.
28. Rubens to Peiresc, 13 May 1625: Magurn, p. 109.
29. Rubens to Sieur de Valavez, 10 January 1625: Magurn, p. 102.
30. Rubens to Valavez, 26 December 1625: Magurn, p. 123.
31. Rubens to Valavez, 10 January 1625: Magurn, p. 101.
32. C. Scribner III, *The Triumph of the Eucharist: Tapestries Designed by Peter Paul Rubens* (Ann Arbor, 1982).
33. Rubens to Pierre Dupuy, 15 July 1626: Magurn, p. 136.
34. J. Brown, *Images and Ideas in Seventeenth-Century Spanish Painting* (Princeton, 1978), p. 105.
35. Rubens to Dupuy, 10 August 1628: Magurn, p. 279.
36. J. von Sandrart, *Teutsche Academie der Edlen Bau-, Bild-, und Mahlerey-Künste* (Nuremberg, 1675).
37. Rubens to Dupuy, 20 July 1628: Magurn, p. 276.
38. Rubens to Peiresc, 2 December 1628: Magurn, p. 292.

39. J.S. Held, "Rubens and Titian," in *Titian, His World and His Legacy,* ed. D. Rosand (New York, 1982).
40. R.S. Magurn, p. 285.
41. Rubens to Valavez, 10 January 1625: Magurn, p. 102.
42. Magurn, p. 286.
43. Rubens to Olivares, 30 June 1629: Magurn, p. 301.
44. Rubens to Olivares, 22 July 1629: Magurn, p. 314.
45. Rubens to Gevaerts, 15 September 1629: Magurn, p. 337.
46. Rubens to Dupuy, 8 August 1629: Magurn, pp. 320–321.
47. Rubens to Gevaerts, 23 November 1629: Magurn, p. 350.
48. Rubens to Dupuy, October 1630: Magurn, p. 369.
49. Rubens to Peiresc, August 1630: Magurn, 367.
50. Rubens to Dupuy, October 1630: Magurn, p. 369.
51. Rubens to Peiresc, 18 December 1634: Magurn, p. 393.
52. Rubens to Woverius, 13 January 1631: Magurn, p. 371.
53. Rubens to Olivares, 1 August 1631: Magurn, p. 374.
54. Rubens to Peiresc, 18 December 1634: Magurn, p. 392.
55. Rubens to Peiresc, 9 August 1629: Magurn, p. 322.
56. J.S. Held, *Rubens: Selected Drawings,* rev. ed. (London and New York, 1986), pp. 153–154.
57. Magurn, p. 503.
58. Rubens to Dupuy, 20 July 1628: Magurn, pp. 276–277.
59. Rubens to Peiresc, 18 December 1634: Magurn, p. 393.
60. See L. Vergara, *Rubens and the Poetics of Landscape* (New Haven and London, 1982).
61. See J.S. Held, *Oil Sketches,* pp. 251ff.
62. Rubens to Peiresc, 16 August 1635: Magurn, pp. 400–401.
63. See W. Liedtke, *Flemish Paintings in the Metropolitan Museum of Art* (New York, 1984), pp. 176–187; and review by C. Scribner III in *Burlington Magazine,* July 1985, pp. 515–516.
64. Rubens to Fayd'herbe, 17 August 1638: Magurn, p. 411.
65. Rubens to Fayd'herbe, 5 April 1640: Magurn, p. 413.
66. Rubens to Duquesnoy, 17 April 1640: Magurn, p. 413.
67. For new research on Rubens's tomb, see U. Söding, *Das Grabbild des Peter Paul Rubens in der Jakobskirche zu Antwerpen* (Hildesheim, Zurich and New York, 1986).
68. Watteau to his patron Julienne: quoted in P. Schneider, *The World of Watteau* (New York, 1967), p. 18.
69. From Sir Joshua Reynolds, *A Journey to Flanders and Holland,* reprinted in E. Lucie-Smith, *Rubens* (New York, 1961), p. 37.
70. H. Wellington, ed., *The Journal of Eugène Delacroix,* trans. L. Norton (Oxford, 1980), p. 406.

Colorplates

1. J.S. Held, "Rubens' Beginnings," pp. 14–35.
2. See W. Liedtke, *Flemish Paintings in the Metropolitan Museum of Art* (New York, 1984), pp. 187–191.
3. C. Norris, "Rubens Before Italy," *Burlington Magazine* LXXVI (1940), pp. 184–194.
4. See A. Blunt, "Rubens and Architecture," *Burlington Magazine* CXIX (1977), pp. 609–621.
5. See M. Jaffé, "Rubens in Italy (Part II)," *Burlington Magazine* CX (1968), pp. 174–180.
6. Ovid, *Heroides* (V. 12–30): see R. Graves, *The Greek Myths, II* (Harmondsworth and New York, 1960), p. 270.
7. See J. Müller-Hofstede, "Bildnisses aus Rubens' Italienjahren," *Jahrbuch der Staätliche Kunstsammlungen in Baden-Wurttemberg* II (1965) pp. 89–154.
8. See J.S. Held, *Oil Sketches,* 537ff; also M. Jaffé, *Rubens and Italy* (Oxford, 1977), pp. 86ff.
9. J.S. Held, *Oil Sketches,* pp. 430–432; see also

M. Kahr, "Delilah," *Art Bulletin* LIV (1972), pp. 193–205; and C. Scribner III, "Going for Baroque," *Christie's Auction News* (New York) VII (June 1986), pp. 1–5.
10. Rubens to Faber, 10 April 1609: Magurn, p. 52.
11. See W. Schöne, *Peter Paul Rubens: Die Geissblattlaube* (Stuttgart, 1956); also H. Kauffmann, "Rubens und Isabella Brant in der 'Geissblattlaube'," in *Peter Paul Rubens, Bildgedanke und Kunstlerische Form* (Berlin, 1976).
12. See W. Liedtke, *Flemish Paintings,* pp. 187–191.
13. See S. Alpers, "Manner and Meaning in Some Rubens Mythologies," *Journal of the Warburg and Courtauld Institutes* XXX (1967), pp. 273–276; also J. Saslow, *Ganymede in the Renaissance,* (New Haven and London, 1986), pp. 191–193.
14. J.R. Martin and C.L. Bruno, "Rubens's *Cupid Supplicating Jupiter,*" in *Rubens Before 1620,* ed. J.R. Martin (Princeton, 1972), pp. 3ff.
15. S. Alpers, "Manner and Meaning," pp. 273–276.
16. See J.R. Martin, *Rubens: The Antwerp Altarpieces* (New York, 1969).
17. *Ibid.,* pp. 74, 83.
18. See W. Prinz, "The 'Four Philosophers' by Rubens and the Pseudo-Seneca in Seventeenth-Century Painting," *Art Bulletin* 1973, pp. 410–428.
19. J.S. Held, *Selected Drawings,* pp. 111–112.
20. See L. Vergara, *Rubens and the Poetics of Landscape* (New Haven and London, 1982), pp. 48–55.
21. J.P. Eckermann, *Conversations of Goethe with Eckermann and Soret* (London, 1874), pp. 247ff.
22. See L. Vergara, *Landscape,* p. 52.
23. See J.S. Held, *Rubens and His Circle* (Princeton, 1982), pp. 35–64; also F. Baudouin, *Rubens,* pp. 283ff.
24. See J.S. Held, "Rubens' Beginnings," pp. 22–35.
25. S. Alpers, "Manner and Meaning," pp. 285ff.
26. M. Warnke, *Peter Paul Rubens, Life and Work,* trans. D.P. Simpson (New York, 1980), pp. 62–63.
27. *Ibid.,* pp. 10–11.
28. E. Fromentin, *Les maîtres d'autrefois* (1876), ed. J. Foucart (Paris, 1965), p. 83.
29. See E. Male, *L'art religieux après le Concile de Trente* (Paris, 1932), passim.
30. D. Freedberg, *The Life of Christ After the Passion,* Vol. VII, *Corpus Rubenianum Ludwig Burchard* (London and New York, 1984), pp. 55–88.
31. See J.R. Martin, *The Ceiling Paintings for the Jesuit Church in Antwerp,* vol. I, *Corpus Rubenianum Ludwig Burchard* (Brussels, 1968), pp. 76–83, 217, and *passim.*
32. R. de Piles, *Conversations sur la connaissance de la peinture* (1677), p. 220.
33. Rubens to Trumbull, 13 September 1621: Magurn, p. 77.
34. See D. Rosand, "Rubens's Munich *Lion Hunt:* Its Sources and Significance," *Art Bulletin* LI (1969), pp. 29–40.
35. Rubens to Trumbull, 13 September 1621: Magurn, p. 77.
36. H. Wellington, ed., *The Journal of Eugène Delacroix* (Oxford, 1980), p. 57.
37. See J.S. Held, *Oil Sketches,* p. 65ff.; also D. DuBon, *Tapestries from the Samuel H. Kress Collection at the Philadelphia Museum of Art. The History of Constantine the Great, Designed by Peter Paul Rubens and Pietro da Cortona,* 2 vols. (London, 1964).
38. See G. Martin, *Flemish School,* pp. 174–182.
39. H.G. Evers, *Rubens und sein Werk, Neue Forschungen* (Brussels, 1943), p. 286.
40. R.S. Magurn, *Letters,* pp. 505–506.
41. See J.S. Held, *Oil Sketches,* pp. 89ff.; also J. Thuillier and J. Foucart, *Rubens' Life of Maria de' Medici* (New York, 1967), and R. Millen and R. Wolf, *Rubens' Life of Maria de' Medici* (Princeton; forthcoming).
42. J.B. Flagg, *The Life and Letters of Washington Allston,* (New York, 1892), p. 184.
43. J.S. Held, *Oil Sketches,* pp. 455–457.
44. J. Burckhardt, *Recollections of Rubens,* trans. M. Hottinger (Basel, 1898), London, 1950, p. 72.
45. Rubens to Gevaerts, 19 December 1628: R.S. Magurn, p. 295.
46. See M. Warnke, *Rubens,* p. 12.
47. Rubens to Valavez, 26 December 1625: R.S. Magurn, p. 123.
48. J.S. Held, *Oil Sketches,* pp. 390–393.
49. See J.S. Held, *Drawings,* pp. 133–134.
50. See L. Vergara, *Landscape,* pp. 179–183.
51. H.G. Evers, *Peter Paul Rubens* (Munich, 1942), p. 401.
52. See F. Baudouin, in *Rubens Before 1620,* ed.

J.R. Martin, pp. 45ff.; also D. Freedberg, *Life of Christ,* pp. 172–178.
53. C. Scribner III, *The Triumph of the Eucharist,* pp. 55–74 and *passim;* also N. de Poorter, *The Eucharist Series,* vol. II, *Corpus Rubenianum Ludwig Burchard* (London, 1978), *passim.*
54. Quoted in A.A. Vasiliev, *History of the Byzantine Empire,* I (Madison, Wisconsin, 1973), p. 56.
55. See J.R. Martin, "Portraits of Doctors by Rembrandt and Rubens," *Proceedings of the American Philosophical Society* CXXX (1986), pp. 7–20; also F. Baudouin, *Rubens,* pp. 261–281.
56. See E. Goodman, "Rubens's *Conversatie à la Mode:* Garden of Leisure, Fashion, and Gallantry," *Art Bulletin* LXIV (1982), pp. 247ff; also J.S. Held, *Drawings,* pp. 150–151.
57. C. Scribner III, "The Garden of Love: Heaven-on-Earth in Baroque Art," in I.H. Shafer, ed., *The Incarnate Imagination* (Bowling Green, Ohio, 1988), pp. 124–149.
58. See E. Haverkamp Begemann, *The Achilles Series,* vol. X, *Corpus Rubenianum Ludwig Burchard* (Brussels, 1975), esp. pp. 15–56 and 123–129.
59. Rubens to Peiresc, August 1630: Magurn, p. 365.
60. E. Delacroix, *Journal,* ed. A. Joubin (Paris, 1932), pp. 444–446.
61. See H. Vlieghe, *Saints,* vol. VIII, no. 2, *Corpus Rubenianum Ludwig Burchard* (London and New York, 1973), pp. 82–111; also J.S. Held, *Oil Sketches,* pp. 568–572.
62. See J.S. Held, *Drawings,* pp. 145–146.
63. J.S. Held and D. Posner, *17th and 18th-Century Art* (New York, 1972), p. 210.
64. Rubens to Dupuy, 22 April 1627: Magurn, p. 178.
65. See J.S. Held, *Rubens and His Circle,* pp. 126–137; also *Oil Sketches,* p. 187ff.
66. Quoted in R. Strong, *Brittania Triumphans: Inigo Jones, Rubens, and Whitehall Palace* (London, 1980), p. 20.
67. See J.R. Martin, *The Decorations for the Pompa Introitus Ferdinandi,* vol. XVI, *Corpus Rubenianum Ludwig Burchard* (Brussels, 1972) p. 156 and *passim;* also J.S. Held, *Oil Sketches,* pp. 236–238.
68. See J.S. Held, "Rubens and Titian," pp. 283ff.; also W. Liedtke, *Flemish Paintings,* pp. 151–155.
69. Rubens to Peiresc, 18 December 1634: Magurn, p. 393.
70. See J.S Held, *Drawings,* p. 157.
71. See G. Martin, *The Flemish School c. 1600–c. 1900* 2 vols., National Gallery Catalogues (London, 1970), pp. 137–142; also N. MacLaren, *Peter Paul Rubens: The Château de Steen* (London, 1946).
72. Quoted in L. Vergara, *Landscape,* p. 12; see also pp. 99ff.
73. *Ibid.,* pp. 103–120.
74. K. Clark, *Landscape into Art* (New York and London), 1976, p. 100.
75. W. Sanderson, *Graphice* (London, 1658).
76. As in Carracci's *Farnese Ceiling:* see J.R. Martin, *The Farnese Gallery* (Princeton, 1965); cf. S. Alpers, *The Decoration of the Torre de la Parada,* vol. IX, *Corpus Rubenianum Ludwig Burchard* (Brussels, 1971), p. 166: I consider the hypothetical absence of an allegorical program unlikely. For the sketches, see J.S. Held, *Oil Sketches,* pp. 251ff.
77. Quoted in R. Graves, *Greek Myths,* vol. II, pp. 270–271.
78. See G. Martin, *Flemish School,* pp. 154–163.
79. Rubens to Peiresc, 16 August 1635: Magurn, pp. 400–401.
80. J. Burckhardt, *Recollections,* p. 114. See R. Baumstark, "Ikonographische Studien zu Rubens Kriegs und Friedensallegorien," *Aachener Kunstblatter* XLV (1974), pp. 125–234; also H. von Einem, " 'Die Folgen des Krieges' ein Alterswerk von Peter Paul Rubens," *Rheinisch-Westfälische Akademie der Wissenschaftlen, Vorträge* 199 (1975).
81. R.S. Magurn, pp. 408–409.
82. *Ibid.,* p. 62.
83. See J.R. Martin, "The Hand of Rubens," *Ringling Museum of Art Journal,* 1983, pp. 116–120.
84. Held prefers an earlier date; see his *Drawings,* p. 157.
85. See J. Brown, *Seventeenth-Century Spanish Painting,* p. 105.
86. *Ibid.,* p. 106.
87. See O. von Simson, "Das Letzte Altarbild von Peter Paul Rubens," *Zeitschrift des deutschen Vereins für Kunstwissenschaft* XXXVII (1983), pp. 61–72.
88. J. Burckhardt, *Recollections,* p. 91.
89. The great Jesuit theologian Robert Bellarmine (1542–1621) has most recently been proposed; see U. Söding, *Das Grabbild des Peter Paul Rubens in der Jakobskirche,* pp. 202–204.